DIGITAL

family photography

A step-by-step guide to creating perfect photos

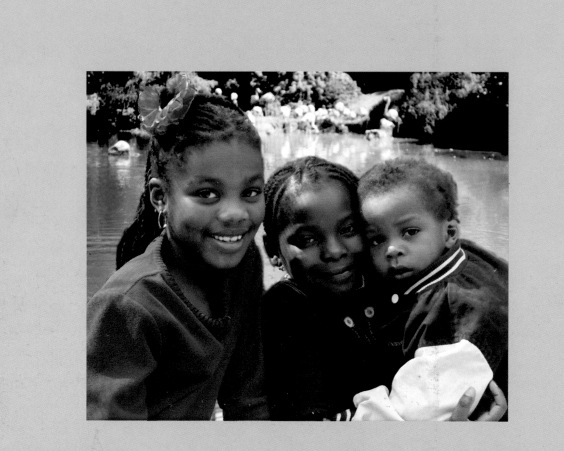

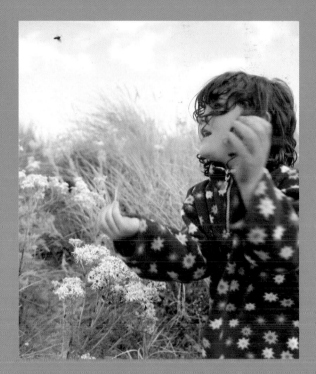

DIGITAL

family photography

A step-by-step guide to creating perfect photos

MICHAEL WRIGHT

MUSKA&LIPMAN
Publishing

First published in the United States by Muska & Lipman
Publishing, a division of Course Technology, in 2003.

Copyright © 2003 The Ilex Press Limited

For Muska & Lipman Publishing:
Publisher: Stacy L. Hiquet
Senior Marketing Manager: Sarah O'Donnell
Marketing Manager: Heather Hurley
Associate Marketing Manager: Kristin Eisenzopf
Senior Aquisitions Editor: Kevin Harreld
Manager of Editorial Services: Heather Talbot
Senior Editor: Mark Garvey
Retail Market Coordinator: Sarah Dubois

ISBN 1-59200-108-4

5 4 3 2 1

Library of Congress Catalog Card number: 2003108390

Educational facilities, companies, and organizations
interested in multiple copies or licensing of this book
should contact the publisher for quantity discount
information. Training manuals, CD-ROMs, and portions
of this book are also available individually or can be
tailored for specific needs.

MUSKA & LIPMAN PUBLISHING,
a Division of Course Technology
(www.course.com)
25 Thomson Place
Boston, MA 02210

www.muskalipman.com
publisher@muskalipman.com

This book was conceived, designed, and produced by
ILEX
The Barn, College Farm
1 West End, Whittlesford
Cambridge CB2 4LX
England

Sales Office:
The Old Candlemakers
West Street
Lewes
East Sussex BN7 2NZ
England

Publisher: Alastair Campbell
Executive Publisher: Sophie Collins
Creative Director: Peter Bridgewater
Editorial Director: Steve Luck
Series Editor: Stuart Andrews
Editor: Stephanie Driver
Design Manager: Tony Seddon
Designer: Jane Lanaway
Development Art Director: Graham Davis
Technical Art Editor: Nicholas Rowland

Printed in China

For more information on this title please visit:
www.sspous.web-linked.com

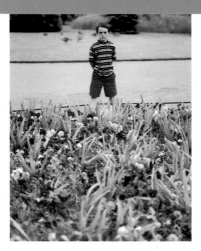

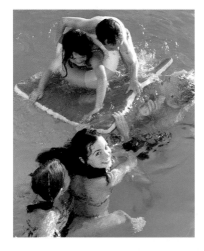

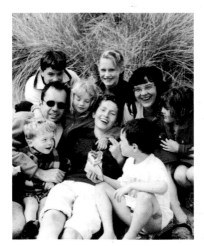

Contents

 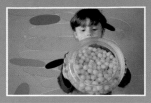

Introduction

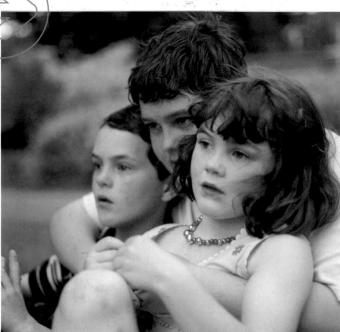

Using a zoom lens enables you to capture intimate moments without risk of intruding on your subjects or interfering in the relationships between them.

People photography is at its most expressive when you are able to capture a sense of an emotional connection in the image. Get in close and catch the moment of recognition when the subject's eyes turn to meet the gaze of the camera.

This book's aim is straightforward: to give you simple, powerful, and effective skills to take great portraits, and to introduce you to some of the amazing possibilities of digital photography. In particular, it focusses on the kind of portrait that most of us take most often—portraits of our friends and family. By the end of this book, you should be able to make the best of all the many photogenic moments that family life presents.

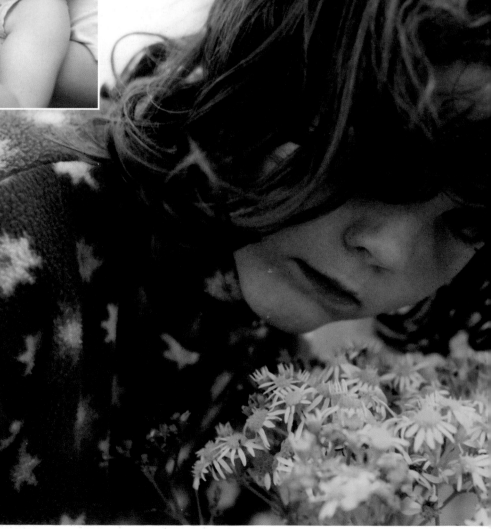

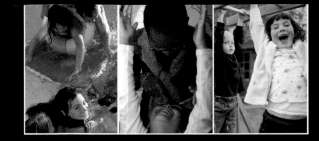

Family life creates a world of photogenic moments for you to visually explore, from exciting angular action shots of play to gentle gestures of affection. Take time to explore the possibilities of your environment and all its possibilities.

In film-based photography this has never been easy. When we compare our results with a professional photographer's compositions, we are often disappointed. We might even feel that good-quality photography is outside our capabilities. Now digital photography has radically changed the possibilities for all of us. We can take as many images as we like, experiment with composition and edit images

in ways that only the professional photographer could do in the past with specialized equipment and years of training. A good professional photographer takes many photographs in order to cover all the possibilities present in his or her subject, moving around and seeing it at different distances and from different angles. Now you can do the same. By shooting more, you have a better chance of catching a magical moment of expression or a great compositional arrangement. Digital photography enables you to experiment without the prohibitive expense of processing.

COMPOSITION AND CONFIDENCE

There is a host of ways in which you can improve the composition of a photograph, both in the process of taking it and in post-production. You won't improve everything at once, but by concentrating on the different technical and compositional themes outlined in this book you will absorb and use new skills, which will seriously improve your ability to create beautiful photographs. As you become more attuned to the different qualities of photography that appeal to you, you will become more selective and more adept at composing the photograph to your taste. As you practice each new skill, you will find that it becomes part of your repertoire of responses, and that you intuitively make compositional decisions where before you would only see the one possibility.

You will also learn more about light. When you take a photograph, don't just look at the action and expressions of your subject. Take a second to squint through half-closed eyes, so that you will become much more aware of the effect of the light on the scene. You will see that one light enhances the subject and another produces an uninspiring composition. Studying the light before you take a shot will cause you to wait, move your angle, or even move your subject.

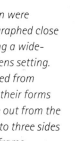 *Creative photography develops when you begin to play with compositional possibilities, and explore different angles and points of view. Here a group of* *children were photographed close up using a wide-angle lens setting. Captured from above, their forms radiate out from the center to three sides of the frame.*

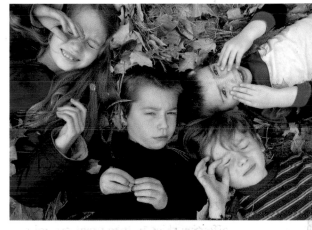

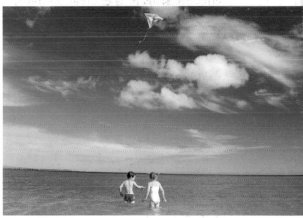

Explore the different seasons, settings, and environments that you inhabit throughout the year. This beach image uses a wide-angle *lens setting and a Polaroid filter to eliminate the glare of the sun and intensify the colors, particularly in the sky and the kite above the children.*

Introduction

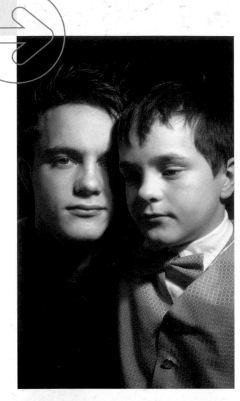

Learn to use light in your photography. Here careful positioning and control of studio lighting transforms a formal studio pose into a character study of two brothers.

INTIMACY AND DETAIL

It is interesting to consider what motivates us to take so many photographs. I am sure that in family photography it is not just the desire to capture a likeness or make a memento of a special moment. An even simpler and more powerful motive is at work; we take photographs as an expression of our attachment to each other. In this sense, photographing someone is a visual expression of affection. It is the very quality of intimacy that makes photographs of people so compelling, because it visually expresses our attentiveness to the posture and expression of the subject. In family photography your intimate knowledge of your subject will clearly influence the way you take a photograph. For example, your interest in the features of your subject will cause you to zoom in and be aware of the way the light falls across the face, or the way the body posture expresses an attitude. This attentiveness to detail is really to be valued, as it forms the most basic foundation of the skills you will need to take a good photograph.

In short, family photography is about seeing, responding to, and controlling the details of an image, the details of how you arrange the subject in the camera viewer, the precise action you catch in the moment of taking the photograph, the detail of the way the light falls, and the way the colors are arranged—all these affect the result.

Groups and compositions can work together if you can gently organize the family into patterns that fit your chosen format: landscape, portrait, oval, circular, or, as here, pyramid.

VISION

Above all else, photography is a celebration of vision. This is not just the optical vision of seeing and mechanically capturing the visible world in a likeness, but much more than this, our individual way of seeing the world. Each of us has a way of seeing which reflects our attachments, experience, and sensibilities. Our individual way of framing and composing an image will imbue the photograph with subtle differences of expressive qualities.

It is really important to value your own way of seeing. While you will improve your photography by studying the techniques in this book, or by studying the photographs of master photographers, it is equally important not to feel that you have to copy someone else's style to achieve a valid image or beautiful expression. "Ah," you might say, "I don't have a particular vision," but once you have taken a number of photographs and compared them with someone else's you will be surprised to recognize that they feel quite different. This won't just be because of the camera or the subject, but because of the way you take a photograph. This is the creative challenge of photography: to experiment with the wonderful possibilities and discover your own way of seeing.

For some of us it is the attitude and arrangement of the form which really holds our attention, for others color and pattern. These tendencies are what form the basis of a personal style. I trained as a figurative sculptor and, later, as a landscape painter, so it's only natural that, in my photography, I have a preoccupation with form and figure in the atmospheric light of landscape. This is reflected in the examples in this book.

Take time to explore your visual interests and give yourself the freedom to play. With digital it is easy to go for a shot wherever and whenever something catches your attention. Don't be afraid of making mistakes. We learn as much from what goes wrong as what goes right, and there is always the chance of a happy accident that makes a great picture.

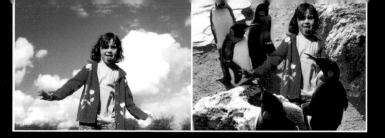

Digital software encourages creative play with composition. Through inventive image-editing, the girl has been lifted and moved into a group of penguins at the zoo. If you can imagine it, there is usually some way of doing it.

CREATIVITY AND DIGITAL-EDITING SOFTWARE

When you look through your family photo album, you will see that many of your photographs could really have been very good with just a few alterations. Now photo-editing software lets us make all those detailed adjustments that transform a casual snap into a beautifully composed image. Previously you could have managed this only by buying into a serious photographic course and getting access to high-end equipment in a specialist darkroom. Now you can have your very own darkroom facility on your desktop, this time minus the inconvenience of damp, darkness, hazardous chemicals, and the major expense of putting it all together. Having spent many hours in the old-fashioned color darkroom myself, I find it little short of miraculous to see how easy it is to make the most complex and time-consuming processes happen with a few simple commands on the computer. Needless to say, it's also much faster.

With your digital darkroom on hand, you can make strong yet precise alterations to color, tone, and composition. You can erase blemishes or unwanted objects, retouch a shot, or sharpen and blur at will. But you can also do much more than this. For example, you can have a great deal of creative fun with images by montaging them in quite imaginative and inventive ways. You can place a child on the moon or in the jungle, or next to their favorite TV character. You can shrink them to the size of Thumbelina or enlarge them to the size of King Kong by changing their scale or the scale of the background. You can use filters and color controls to emulate painted effects or antique tinted images.

And with an inexpensive inkjet printer you can print and enlarge these pin-sharp images in brilliant color and do a great deal more. You can make albums and books, create photo essays, amazing video picture shows, merge text and images, make cards, and e-mail images via the internet!

USING THIS BOOK

This book is divided into four chapters. The first covers the equipment, telling you what you need to know about your digital camera, with some advice on how to use it. The second chapter goes into detail on the hows and whys of taking formal and informal family portraits in nearly any situation. The third chapter leads you into the world of image-editing software, with practical projects laid out in steps, which make the processes simple to follow. The final chapter shows you how you can take your finished images, and discover new ways of sharing them with family, friends, and the world at large.

Taking family photographs is centered on capturing the affection and interaction that characterize these relationships. This means not just capturing the details of facial expression but also being attentive to posture and gesture—which are just as expressive of attitude and attachment.

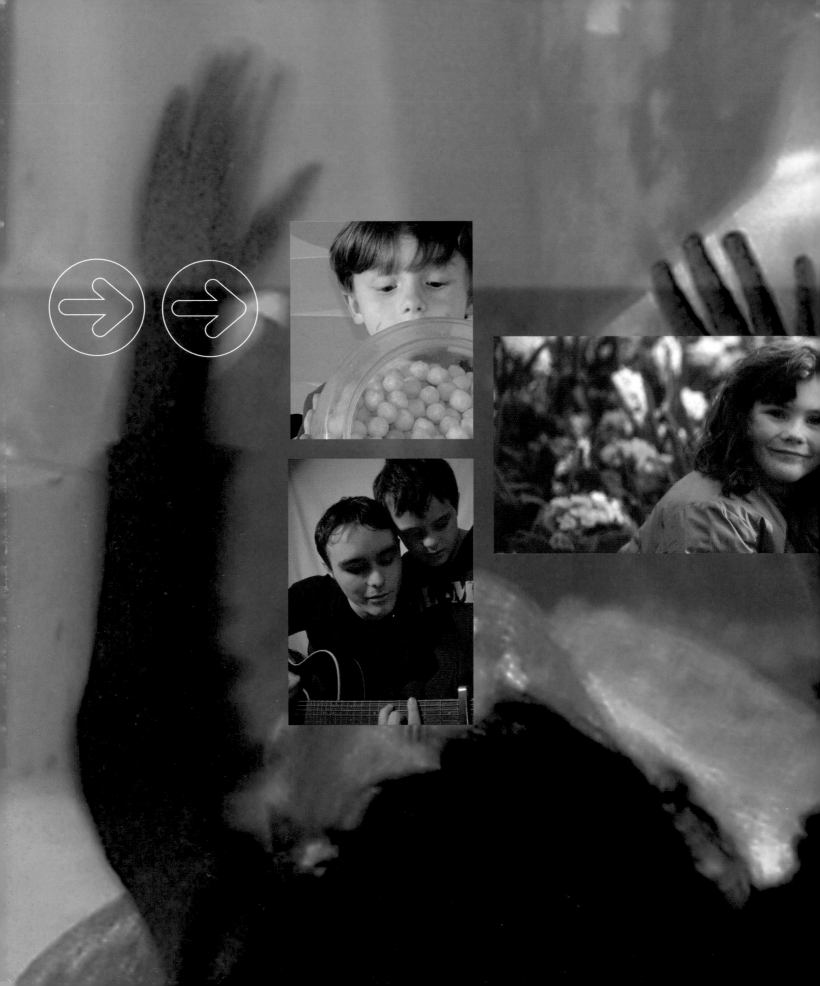

1 Your digital camera

The modern replacement for silver halide film is the silicon chip and photo-sensitive CCD. When it first appeared several years ago, the digital camera was a poor-quality relative to the film camera, producing vastly inferior results. Now we are reaching a point where the image quality of a good digital camera can match that of film in many situations, and even surpass it in some. This chapter takes you through the technology and how to make it work for you.

Choosing a camera

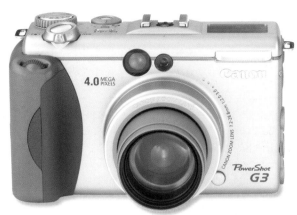

Less expensive digital cameras are still capable enough for great family photography. 4 megapixels should be your minimum resolution, and aim for some level of manual control.

There is a bewildering array of digital cameras on the market, with new models appearing daily. It's a good idea, therefore, to have a clear idea of what you're looking for, and to spend time researching what's available, before parting with your cash. Here we look at a midprice camera with an image size of 5 megapixels.

THE BACK OF THE CAMERA

The camera has an electronic viewfinder (in effect, a small, very sharp TV screen) and also a monitor, which is a larger version of the viewfinder. You will probably use the monitor rather than the viewfinder to set up and frame each shot, and to check each picture as you take it. The monitor also lets you play back pictures to review them as you work. On some cameras, you can flip or rotate the monitor to use it when you are shooting from ground level or holding the camera above your head.

The viewfinder is necessary only when you are working under very bright ambient light conditions that can "wash out" the image in the monitor. The viewfinder should have a diopter adjustment control so that you can set it to match your eyesight.

The zoom buttons enable you to zoom the lens in and out, as well as zooming in and out on pictures when you're playing back. The multiselector is used to navigate through the camera's menus, and also to pan across pictures when you're playing back.

On the back of the camera, you are also likely to find buttons to activate the camera's control menus and to delete images that you have decided you don't want to keep. The slot that holds the memory card is also on the back.

The front of the Nikon Coolpix 5700, showing the zoom lens, flash, and shutter release.

The top of the same camera, showing the accessory shoe, LCD information panel, and mode dial.

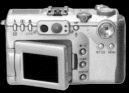

There is a bewildering array of digital cameras available on the market. Before selecting a camera, read equipment reviews in magazines and on websites. Even if you are on a tight budget, you can still find a capable model.

Choosing a camera

THE TOP OF THE CAMERA

On the top of the camera there may be an accessory shoe to which you can connect a flash unit or an adaptor to let you use studio flash heads. The shutter release button and power switch are also on top, as is the control panel in which information about the camera's setup is displayed. When the lens is in autofocus mode, applying half pressure to the shutter release will bring the lens into focus. Close to the shutter release you will find the command dial. This is used to adjust the camera's setup and also to control shutter speed and aperture when the camera is not in a fully automatic mode.

The control panel displays a wealth of information about the camera. Typically, this would include some indication of battery status, recording mode, image size, flash mode, an estimate of frames remaining on the current memory card, and information on the exposure mode.

THE FRONT OF THE CAMERA

On the front of the camera you find the zoom lens, the built-in flash, and a redeye reduction lamp. Some digital cameras in this price range have lenses that can be focussed manually by rotating a ring on the lens itself, but most use "focus by wire" systems, where you focus manually by rotating the command dial.

On the underside of the camera, as well as the tripod socket, you'll find the battery compartment.

INFORMATION ABOUT CAMERAS

There are several magazines and websites devoted to digital photography. Magazines include *PC Photo* and *Digital Camera*, while *Popular Photography* has plenty of relevant digital content. All of these have their own websites, containing helpful tips and equipment reviews.. A useful online resource for information about all aspects of digital photography is *www.dpreview.com*. This contains extremely thorough reviews of cameras and a buying guide that identifies for you all the available cameras that have the features you are looking for. The site also includes a valuable glossary to explain digital jargon.

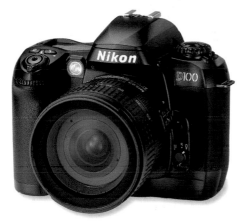

The Nikon D100, a 6-megapixel camera, is one of the first affordable digital SLRs—and it helps if you have a number of Nikkor lenses from an old conventional SLR. The results are outstanding.

TIP Always carry spare batteries on a shoot, and, if they're the rechargeable ones, make sure you do recharge them!

The back of the Coolpix 5700. The LCD screen flips out underneath the viewfinder, and the Zoom controls are also visible.

FACT FILE

Extra storage

Digital cameras store their images on electronic cards. When you buy a camera, it will usually be supplied with a low-capacity card—32 or sometimes only 16MB (megabytes)—that will hold about 20 or 10 images respectively. It makes good sense to buy a bigger card—at least 128MB, or 256MB if a card that big is available for your camera—at the same time as you buy the camera. You will find the extra storage invaluable, and storage cards are usually cheaper when you buy them with the camera.

The lens

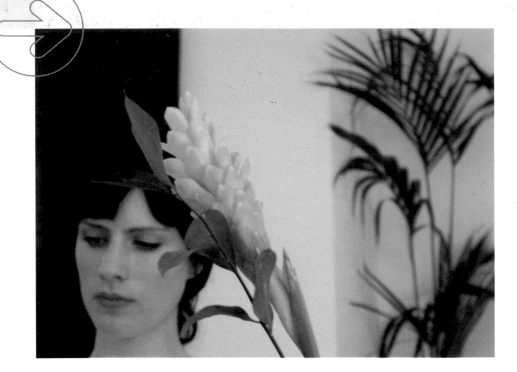

The lens is the very foundation of photography, and the most important component in any camera, digital or not. It is hard to overstate the impact that a good or bad lens will have on level of definition in your images. As is the case with film-based photography, the more you pay for the camera, the better the quality of the lens should be. That said, the quality of lenses in the midrange, as well as many of the introductory-range cameras, is generally good, so you may not need to buy an expensive camera to get an acceptable lens.

Apart from quality, the most important aspects of the lens will be the way the lens system operates, and also its zoom and wide-angle capabilities. The most basic digital cameras have a fixed lens, usually set to a wide angle. This offers no scope for zooming into a subject and really limits your ability to work with people in close-up. At the opposite end of the scale, with the top professional-level cameras, you just buy a camera body and use interchangeable lenses. This has advantages for the serious photographer, who may have invested in good-quality lenses prior to making the move to digital.

For most of us, the aim is to invest in a camera with the maximum level of flexibility. The most common arrangement is a zoom lens system that lets you zoom in on a subject and also zoom out to a wide angle. In addition, many cameras have an extra macro function, which effectively enables you to zoom onto very small areas with remarkable levels of detail. You can control exactly how the camera frames an image by moving in or pulling away from the subject without having to move physically closer or farther away.

The image of the young woman behind a flower in a restaurant is an example of zoom spatially flattening an image.

The image of the girl on the beach illustrates the way in which telephoto zoom has flattened the scene.

ZOOM-IN OR ZOOM-OUT?

The effect of zooming in or out has a significant impact on the look of an image. As you zoom in, the camera functions as a telephoto lens, which means that things behind or in front of your subject will blur and appear to be spatially flattened. That is, they appear closer to each other than they actually are. This effect can be very useful and is frequently used by portrait photographers to isolate the subject from distracting background detail. Zoom is also said to flatter a subject. For instance, it will flatten a protruding nose in a frontal shot.

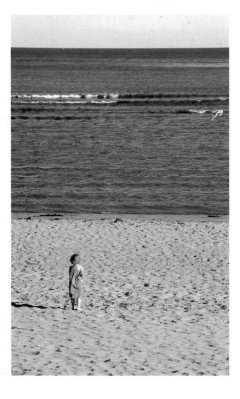

Far left, a close-up frames a face in exquisite detail, revealing character, while a longer view creates drama by contrast with the landscape. Left, a wide-angle setting creates distortion when used in close-up. Similar distortion is evident in the strong verticals in a long shot.

Setting the lens to wide angle has distinct advantages when you are in a space where you can't move back to include more of the subject—a feature that makes wide-angle particularly useful in group photography and landscapes. However, wide angle is usually regarded as unflattering, particularly if you are working with a subject in extreme close-up. First, there is a pronounced distortion of scale between near and far. For example, hands positioned closer to the camera will appear to be twice as big as the face. There is also a distracting "fish eye" effect, which bends lines and expands forms outward. This rarely improves a portrait—as you can see from the less than flattering example, right.

The image of a teenage girl illustrates the unflattering way in which wide-angle settings distort features in close-up.

The image of the girl standing in a Venetian square illustrates the way in which wide-angle settings also bend verticals out of parallel.

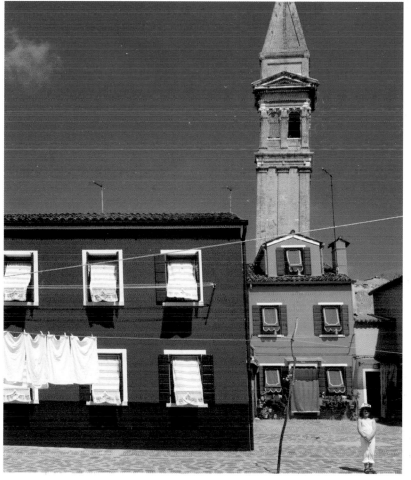

FACT FILE

Focal length
You will often hear lenses described in terms of focal length—the distance from the focal point at the center of the lens to the plane behind the lens at which the image becomes focussed (the light-sensitive CCD chip in a digital camera). A focal length of between 35 and 50mm is standard, and corresponds to the scale at which the naked eye sees things. A telephoto lens will have a longer focal length of 70mm and upward, which, as with a telescope, accounts for its length. The wide-angle lens will have a shorter focal length of 28mm, 35mm, or 45mm and a more convex form, which accounts for the bending and slight distortion of the image. The majority of digital lens arrangements have a variable focal length, stretching from 30mm to 70-80mm as a minimum. This roughly equates to an optical zoom ratio of 3x (three times) magnification. Some cameras go farther, to 6x or beyond.

Focussing

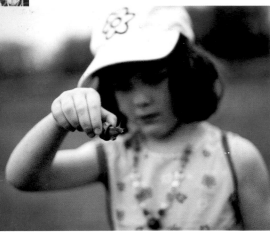

◀ Here, the way in which center spot autofocussing has been used has caused the subject of the girl to be out of focus and the hedge to be in focus. The center spot falls to the right of the girl.

▼ An example of extreme depth of field, using a wide-angle lens and an aperture of f2.8. You can achieve the opposite effect by increasing the depth of field, say by stopping down toward a very small aperture of f22.

There's no doubt that a good autofocus mechanism is a vital feature of a decent digital camera—having to manually focus every shot would soon put a stop to spontaneous, point-and-shoot photography. With the camera in autofocus mode, you can concentrate on framing the scene. There are, however, circumstances when the autofocus needs help, and most cameras are equipped with optional settings that can save the day.

FOCUS LOCK

At times, the autofocus system may focus on the wrong part of a composition. This happens when, for example, a figure is standing to the side of a view, or when you photograph two people with a space between them in the center of the composition. In most cases, the autofocus mechanism will concentrate on a small area in the middle of the lens. If the main subject of the composition is away from the center, the lens can autofocus on the background, meaning that your subject falls out of focus.

With some cameras you can get past this using another setting called "Focus lock."

To use Focus Lock: autofocus on your main subject; holding the focus lock button down, reframe the shot so that the figure is to the side of the composition; press the shutter release button to take the photograph. (On some cameras, the Focus Lock is controlled by the same button as the shutter release.)

DEPTH OF FIELD

In most digital cameras there are controls that enable you to adjust the depth of field—the distance between the foreground point at which a scene comes into focus and the farthest point at which the subject goes out of focus. As with conventional, film cameras, you control the depth of field by adjusting the size of the lens aperture upward and downward in f-stops. You shorten the depth of field by opening the lens aperture upward to the maximum of f2.8, which limits how much of the camera view remains in focus. With a short depth of field, the background becomes blurred, which creates a visually soft foil for the sharp definition of the foreground, removing visual distractions and focussing all the attention on the subject.

Far left, center autofocus spoils the first image, while this girl with a snail is a prime example of good focus technique. Left, changing the depth of field creates contrasting studies of this boy, first at one with the scene, then dominating it.

An interesting feature of digital photography is that depth of field blurring occurs to a far lesser degree than in conventional cameras. This is because of the focal length, lens configuration, and the small size of the CCD chip which records the light from the lens.

Depth of field is only truly controllable on cameras with an aperture priority setting. When you set the camera to aperture priority and move the aperture up or down, as you semi-depress the shutter release button, the camera will take a light reading and determine the correct shutter speed. What you must bear in mind is that as you select either a wide or a narrow aperture, the camera will select a slow speed to correspond to the small aperture and a high speed to correspond to the large aperture.

Nevertheless, as you stop up or stop down the aperture settings, you can still create some stunning images that rival the striking effects achievable with film-based photography, but without the graininess of film itself. For example, the two contrasting images of this young lad out in the countryside create drama, while retaining that unique digital clarity.

MANUAL FOCUS

However, autofocus also has trouble when the subject is in very low light or viewed through fog, smoke, or mist. Reflective surfaces such as water, shiny metal, polythene, and, of course, glass also confuse the autofocus. In these cases, you might need to switch to manual focus.

Midrange and advanced cameras will give you the option of manual focussing. This enables you to focus on a precise point in the field of vision that the autofocus setting would not select, even with a focus lock. The best cameras will have a zoom facility that shows as a magnified center square in the viewer, which allows precise manual focussing. If your camera does not have this feature, you can check the accuracy of the manual focussing by zooming in to see an area of the composition in detail, then zooming out to frame the composition. If that doesn't leave you confident, check the viewfinder for a distance measurement that decreases as you focus back or forward in space.

These two images of a boy in front of trees illustrate depth of field using a wide-angle lens. At f2.8, the background is out of focus. With an aperture of f 11, both the boy and the tree are in equal focus.

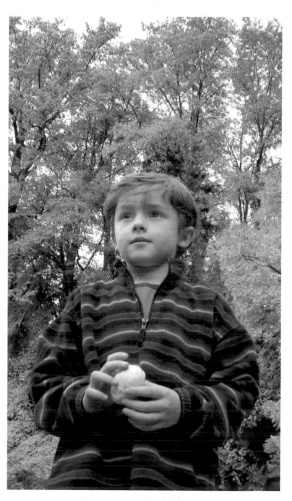

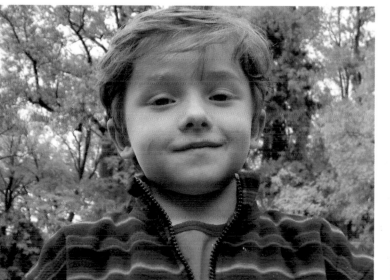

Focussing

TIP Tall, narrow, "portrait" shots, as above, stress the dynamic verticals in an image. But wider "landscape" oriented images, as left, tend to draw the viewer into the image.

Getting the right exposure

The first example is exposed correctly for the room using a *multi*-reading.

The second image exposes correctly for the window using a *spot* reading on the hedge outside the window. This makes the room seem dark.

Correct exposure is crucial in all photography. Let too much light into a camera—even a digital camera— and the image is bleached out, losing all definition and highlight detail. Conversely, too little exposure means the image will be underexposed, and the image will be far too dark. Luckily, all digital cameras have auto-exposure built in. This takes a reading of the light reflected back from a scene and automatically sets the ratio between aperture and speed to give a correct exposure. However, it is indiscriminate, and you will need to think carefully in scenes where there is a complex interplay of light and shadow.

On Auto, you can happily shoot away in most circumstances and auto-exposure will do the job of fixing your aperture and shutter speed. You may also choose between a standard setting and a low-light setting, but in more advanced cameras, you will set the camera's sensitivity in terms of ASA or ISO settings, which correspond to the old settings used for photographic film.

The camera will display a range of these when the camera is in Camera Shot rather than Review mode. You can usually scroll through the ISO settings from 25 upward to perhaps 800 or more. The higher the setting, the faster the CCD sensor responds to the light. A high ISO setting enables you to use a faster speed in low light, so reducing the blurring caused by long exposure, or to catch a fast-moving form in motion.

In film-based photography, high ISO films use larger particles of light-sensitive chemicals, which increase the graininess of the image. A similar coarsening occurs in digital photography. At higher ISO settings, noise appears, while overall definition also suffers. But digital wins in modestly low light.

Exposure is a matter of taste and of deciding what you are trying to achieve. From left to right, a multi-reading creates a striking balance; an exposure on the light accentuates shadows, while an average reading creates a flat image.

F-STOPS AND LENS SPEED

When you use auto-exposure, the camera takes a light reading that determines the amount of light in the scene and the exact amount needed to make a correctly exposed image. In some cases, you may need to intervene by using a fast shutter speed and a wide aperture, or a slow shutter speed with a small aperture. If you experiment, you should be able to see what difference this makes on your own digital camera. You can change either the shutter speed by setting the camera on Shutter Priority, or the aperture by selecting the Aperture Priority mode. Once the auto-exposure meter has determined the light, there is a fixed ratio between aperture and shutter speed. As you alter either aperture or shutter speed, the other will alter automatically to compensate and maintain the correct exposure.

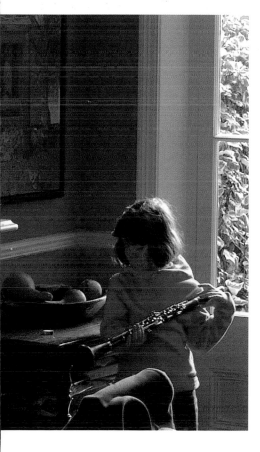

In the third image, the exposure is an average reading to balance exposure between window and room.

LIGHT METER SETTINGS

Move up to a midrange camera, and you should be able to apply different settings to the light metering (usually under the heading of Photometry). Most cameras list three modes: Average, Spot, and Multi.

Average: This meter reading takes an average of all the variations in the view and is useful for subjects that have contrasting areas, such as a subject in black-and-white clothing.

Spot: This meter reading takes a reading at a precise spot in the middle of the viewer, which makes it particularly useful for getting an exact reading for an area of a composition that is in extreme contrast with another, such as an open doorway from a dark room into a light space.

Multi: is the default setting for most cameras. Automatic scene recognition provides the optimum exposure in a diversity of light conditions.

BRACKETING EXPOSURE

There are situations when you are unsure what will be the best way to expose a photograph. Take, for instance, a shot of a figure in silhouette against a window. If you expose the shot so that the figure's features are correctly exposed, the view through the window would bleach out. Conversely, if you expose for window light, the figure darkens and loses detail. In these situations you can use an auto-bracketing mode that automatically takes three pictures, one at a slight degree of under-exposure, one in the middle, and one slightly overexposed. This gives you the choice of which tonal range shows the subject to the best advantage, or you can use your image-editing software to blend the best parts of each image together.

For this image of a boy holding a toy boat in an alley the multi-exposure reading averages between the light on the boy in the alley and the daylight at the end of the alleyway.

Point exposure

Some advanced cameras have an additional feature that lets you set where the auto-exposure is to function in any one of nine points across the lens. On this setting a grid will show on the screen and you can use the shift button to move the auto exposure up, down, or across the view.

Low light

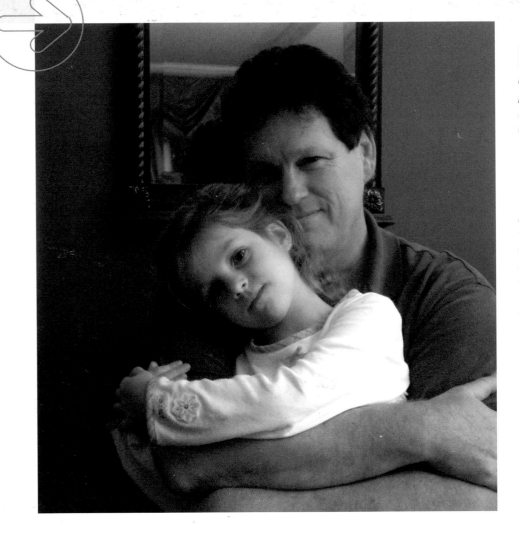

This is taken on a 400 ISO-equivalent setting, picking up a warm natural glow. The added noise benefits this "softer" image.

Another "flash-less" image, this time in the evening sun. Here a lower ISO setting and a longer exposure create a harder light.

As we covered on pages 18–19, Auto settings will do an adequate job of matching aperture and shutter speed to most common lighting conditions. In good natural light, or with a flash, you can leave the setting on 100 or 200, but in low light conditions it can help to set your ISO equivalent to 400 or higher, corresponding to a middling fast film in traditional, film-based photography. You will lose some detail and get a little added noise, but you're more likely to get an image with a level of exposure you can work with.

ISO settings of 800, 1600, or even 3200 are available, but such ultrafast settings produce extreme graininess in film-based photography, and an equivalent level of pixel noise in digital photography. With digital photography in particular, even professional photographers should take care with this level

There are many occasions when you might want to photograph a subject in low light, but it would be inappropriate to use the flash, either because the flash would ruin the natural beauty of the low light, or because the subject is too far away for the flash to make any impact. In these circumstances, you need to adjust the settings on your camera to ensure that you get a good photograph.

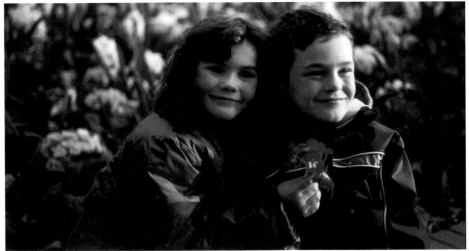

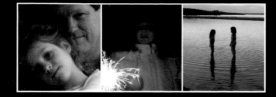

Three very different examples of low light, each complex in its own way. From left, a warmly lit, flash-free portrait; the marked contrast of a brilliant firework and its soft reflections; and a tranquil shoreline at dusk, perfectly balanced.

Scenes like this are tricky. The tank is a diffused, shifting light source, containing brilliantly colored fishes and splashes of directional light.

There is little ambient lighting, there are no reflective surfaces, and the boy's face needs careful exposure. This image was taken at f3.5 and ISO 400.

The cool grays, blues, and greens of a shoreline at dusk risk under- and overexposure. Here we've achieved harmony at f2.8 and ISO 200.

of noise belying the clarity of digital photography in modestly low light, or in scenes that have complex or challenging lighting conditions.

The alternative is to use a lower ISO rating—say, 200 ISO—and take a longer exposure. To avoid camera shake, use a tripod to keep the camera stable. Even a small, mini-tripod will give you the stability you need to take a decent shot. Tripods are usually inexpensive, but take care that your camera is properly fixed onto it, or you will lose the advantage of the extra stability.

All of the examples on this page illustrate some of the occasions when flash photography would disturb the delicate lighting balance of a scene. They show what you can achieve with practiced use of aperture and shutter speed to capture natural light and complex subjects.

TIP To achieve a balanced exposure at low color temperatures, bracket the exposures at +1, +-, and -1, then select the best from the three.

A real challenge: the brilliance and movement of a firework, and the reflected glow on the face. This took f3.5 at ISO 400.

FACT FILE

At high ISO settings the image as a whole and dark areas in particular will be subject to loss of definition and "noise." Noise is when the pixels in the image lose their smoothness of transition and appear markedly speckled. You can rectify this to a degree in the digital editing software using a *Despeckle* filter, but this will not rectify extreme noise.

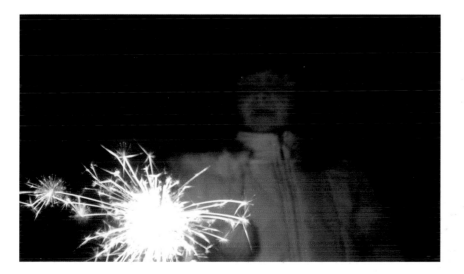

Artificial lighting

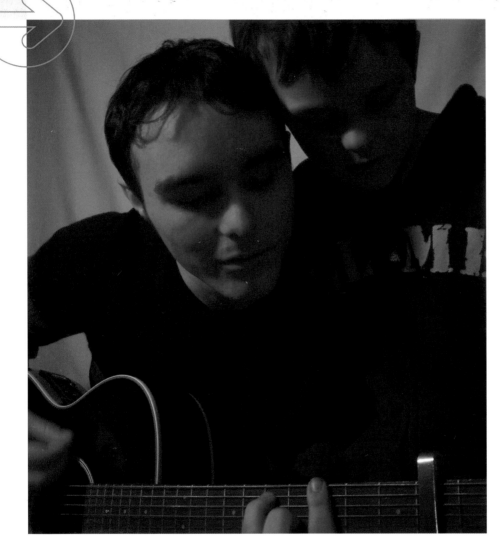

◁ *Two brothers and a guitar: an example of false color created by setting white balance against a green card to create a red color cast in the photograph.*

▷ *In this shot, of children pretending to float in an aquarium, the children are illuminated in warm tungsten light, which works well in contrast with the neon lighting of the aquarium.*

halogen, or neon lighting, daylight bulbs, or even by using colored lightbulbs.

The most common of the artificial light sources you will work in is the tungsten light bulb, which has a characteristic yellow bias. Fluorescent light varies between a yellow and a blue bias, depending on the make. You can buy daylight bulbs that have more of a cold, blue bias. Halogen lights are becoming more popular, both as spotlights and lamps. They produce a whiter light that is a good imitation of natural daylight.

WHITE BALANCE / COLOR CAST COMPENSATION

You will often want to improve your photograph by compensating for the color temperature of artificial light. Tungsten light, for example, creates a depressingly gloomy, yellow color cast that dulls all the local colors. There are simple techniques for eliminating the color cast and these will give the photograph the appearance of natural daylight. In film photography you would need to use a blue filter on the lens to compensate the yellow bias of the light. In digital photography, however, you can compensate more effectively by using the camera's white balance setting.

To adjust the white balance, select the custom white balance setting. Hold a sheet of white paper in front of the lens so that it fills the viewer, and press the white balance button

A rtificial light offers a different range of moods and colors. The advantage is that you are in control: you can add light to a scene, adjusting its direction and intensity. You can position the subject against a fixed light source, or use artificial light to supplement low-level daylight—dull daylight interiors can be improved by the careful use of artificial light.

COLOR TEMPERATURE

You do need to be aware of one thing with artificial light. Each type has a distinct color temperature, which will translate into your photograph as a color cast affecting every element in the photograph. You can control this for creative effect by making use of the different lighting qualities of tungsten,

TIP Use white balance to fool your camera in creative ways by setting it against colored cards or via color filters. In this way, you can add different color casts to your image.

Artificial lighting can be a useful contrast with the existing light source in a scene, left, but it can also be an end in itself. Far left, the warm glow that silhouettes the subjects is vital to the success of this composition.

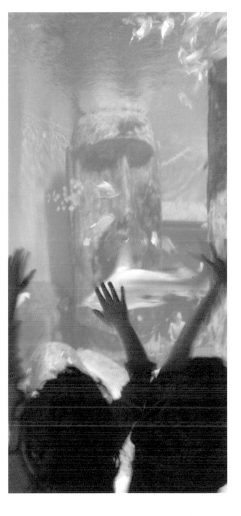

Mother and daughter in backlit tungsten light. The light is sympathetic with the tender embrace of the mother and daughter.

Here the yellow color cast of the tungsten lighting acts as a gentle contrast to the violet coloring of the tutu, and the shadow aids the composition.

Artificial lighting

on the camera. The camera reads the color cast of the yellow light on the paper and compensates for the color bias to achieve a pure white.

When you view the images in review mode or downloaded on the computer, you will see that what would otherwise be a very yellow biased image has been corrected toward daylight color.

If you forget to use the white balance control, don't worry—you can always fix the color cast using your image-editing software (see page 96).

FACT FILE

False color for special effect

A neat little by-product of the white balance feature is that you can hold colored sheets in front of the lens and the white balance setting will compensate by creating the complementary color. For example, if you held a green card in front of the lens, the white balance will create a red cast in the image. Alternatively, you can use colored lights or sheets of colored acetate to cover and color an artificial light, radically coloring the scene.

Using flash

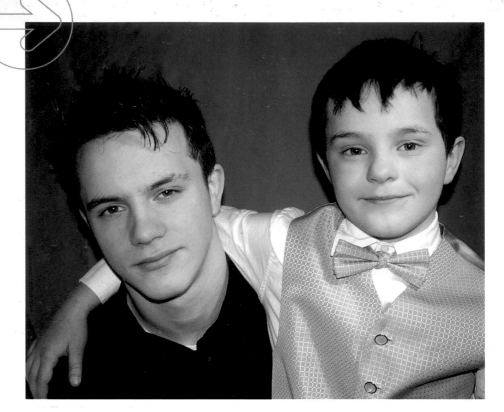

Flash and artificial light combine in this spontaneous portrait, which uses a frontal built-in flash in combination with a tungsten lamp at the side.

This shot shows you the way in which the built-in flash can create an offset shadow around a subject—which is more likely to ruin an image than enhance it.

While digital cameras are comfortable at low light levels, that does not in any way reduce the importance of using flash. As well as getting enough light onto the subject, flash can also be a creative way to change the atmosphere of a scene. The flash emits a powerful burst of white light and, used carefully, it can create either dramatic directional lighting or subtly expressive lighting effects. You can also make use of flash to record movement or reduce extreme shadows in a daylight scene.

YOUR DIGITAL CAMERA

BUILT-IN FLASH SETTINGS.
The inbuilt flash is now very simple to use. Many cameras automatically switch to flash mode when the exposure meter detects that the ambient light is too low for good results. In some cameras, you will have to press a button to make the flash unit pop up. The distance a flash will cover is fairly limited, with few built-in flash units covering a distance of more than 10-13 feet (3-4 meters). The light produced rapidly diminishes over distance, which is called the rate of falloff.

Using flash settings, you can adjust the level of light to suit your circumstances. For example, on a standard flash setting, when you are close to a subject, the light from the flash can be far too bright and will bleach out areas of the photograph. Conversely if the subject is farther away, the flash can be too weak to illuminate the subject fully. In these situations you can either lower the flash intensity to get a more gentle light that does not overexpose the subject, or you can raise it to illuminate a

distant subject. One of the great and unique advantages of digital photography is that you can take a shot, review it, and then modify the flash if you don't get the desired result at the first attempt.

Lowering the flash setting can also solve some potential problems. Many flash photographs look unattractive because flash kills ambient light, and a lower setting will compensate for this. It will also lessen the shocked, "rabbit in the headlights" appearance that is created when an inbuilt flash is (inevitably) aimed directly at the subject. Since the inbuilt flash is also offset to the camera lens, when it fires it will create a dark shadow that outlines the contour of the subject, especially if the subject is close to another surface such as a wall. If the flash is set at a lower setting, it will illuminate the scene gently, rather than hitting the subject with a blast of light. This strategy softens the light on the subject but leaves the background relatively dark and underexposed.

Far left, flash gives this interior portrait a warm, natural feel, but overexposes the girl's sleeve. The image, left, attempts to balance near and far subjects outdoors, using a slow shutter speed and firing the flash toward the end of the exposure.

OTHER FLASH SETTINGS

Your camera may or many not have one or more of the following flash settings:

Fill (in) flash: Flash is not just for night-based photography, but is also an important way to improve your daylight photography. In low light, if a figure is in shadow, or if the shadows are too strong across the features of your subject, you can use the flash to add a degree of additional light. This is called Fill (or Fill-in) flash and—particularly when a subject is in shade—it strengthens color saturation and adds sharp detail. Fill flash lightens the shadows without obliterating the atmospheric quality of the ambient lighting.

TIP With a digital camera, you can see the impact of flash straight away. Try the shot, then adjust the flash strength to get the right exposure.

Redeye: Redeye occurs when the flash illuminates the retina of your subject's eyes, giving them a spooky red glow. On the redeye setting, the flash fires twice in rapid succession. On the first flash the subject's irises contract, so that on the second flash for the photograph, the surface area of the retina is covered by the closed iris, eliminating the incidence of redeye.

Action: Flash is a useful way to freeze action in both daylight and at night time. Because the flash fires in as little as one thousandth of a second, the camera records that instant in high definition.

Slow flash: Combined with a long exposure, this setting is ideal for moving subjects in low light conditions, such as dancers in a dance hall or a night procession. On the longer exposure the image records the ambient atmosphere, and at the end of the exposure the flash fires to give higher definition to the subject. This two-pronged approach avoids over- or underexposing picture elements.

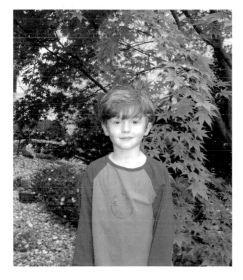

Here the fill-in flash works to add detail to the boy, separating him from the bright colors of the tree in the background

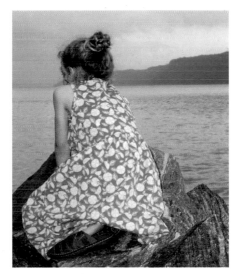

Fill-in flash can help outside, working here to get a correct exposure of this girl against the dark, stormy sky.

A classic example of how using a slow flash can give enough light to expose a nighttime scene, and freeze the action.

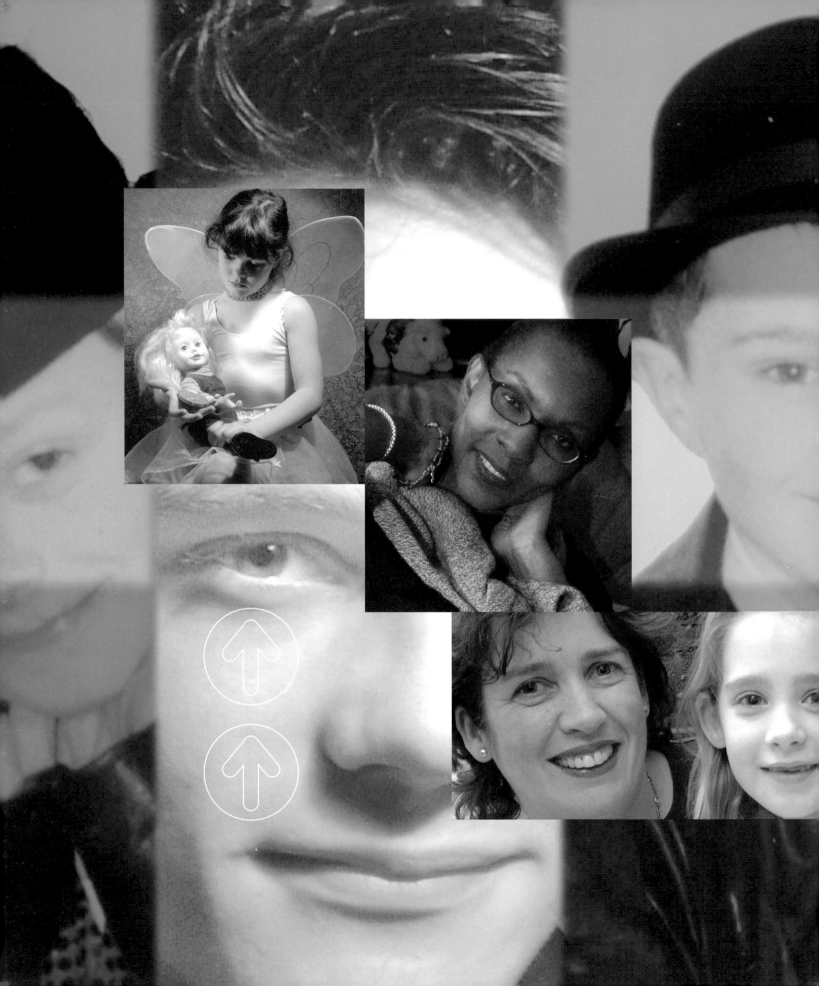

2 Taking great people shots

Good people photography combines a degree of technical ability with a personal way of seeing. Increasing your technical ability will improve your photography, but developing these skills will bring results only if you develop your understanding of composition. In other words, you can take great photographs only once you can see what makes a good photograph. Practice and experience are the best ways to develop your photographic vision, but this chapter should help put you on the right path.

The natural look

In the case of photographing children, giving them something to distract them will divert their attention and create vitality in the image. This pose frames the image perfectly.

This portrait is a good example of the "captured moment," with the low angle and deep focus adding the impression of a glimpse into a secret, summer world.

TIP In close-up portraits, look for a natural "frame" to the image, like the girl's hood, opposite, or an arm. This creates visual interest and life.

A portrait in which the subject holds an unselfconscious pose within a strong composition has great natural charm. To achieve these qualities in a photograph requires a combination of skills on the part of the photographer. You need to frame a composition carefully, while encouraging the sitter to reveal his or her personality through posture and animation. As you do so, you need to be sensitive to the way the presence of the camera affects the sitter—you don't want the pose to appear stilted or artificial. In effect, you need to be able to capture the subject behaving as if they were unaware of your presence, or were perfectly at ease with it.

While we often use the camera in quite a casual way, taking a photograph can be an emotionally charged activity. If a subject becomes self-conscious or tries too hard to pose, then the image is rarely successful. At its best, the compelling power of a photograph is when the relationship between the photographer and the sitter is calm and informal, letting us capture an expression of our relationships toward each other. A gesture or a glance toward the photographer can capture a complexity of unspoken communication, and we can interpret something of the subject's character from the nuances of posture and facial expression. This candid communication happens most naturally when the subject has become unaware of the presence of the camera, has been distracted, or drawn into a relaxed working relationship with the photographer.

This scene shows the advantages of photographing the interactions between two people. It reveals not only their relationship to each other, but also to the photographer, with the final shot adding a clever visual joke.

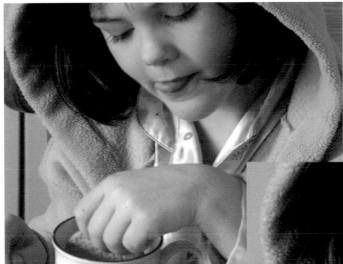

Giving your subject something to occupy them is usually successful. But having a good eye is vital too—the curves of the hood and arm make this picture.

Taking a number of shots in rapid succession will also give you a range of options and poses to choose from. With practice, you will develop a more sophisticated eye.

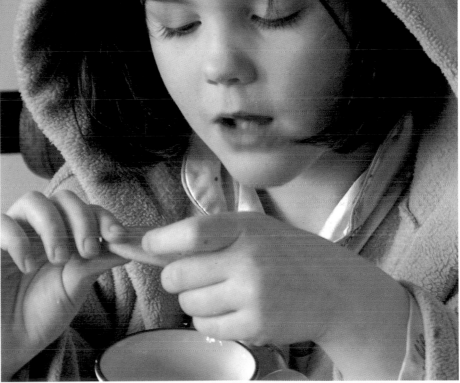

BECOMING "INVISIBLE"—THE SECRETS OF BEING UNOBTRUSIVE

The easiest solution, and often the most effective approach, is to be unobtrusive in your approach. First of all, it is most important that your subjects are engaged in some relaxed activity that won't take them out of the camera frame, so you need to choose an appropriate setting and time. Then by standing a little way back and using the zoom on the lens to get back in close to the action, you can observe and compose without having to engage their attention. This approach is especially effective when photographing a couple or small group, particularly if they are engaged in conversation. Also, it is often the most effective way of taking pictures of children, who are usually disinclined (to say the least) to sit still for a shot. It is important to move around without calling attention to what you are doing and to take a good number of photographs. If your subjects are sitting and relaxed in conversation, or playing quietly, they will be animated enough to create a variety of expressions and poses without your intervening. The camera always picks up any attitude, from you or your subject, so stay calm and focus on catching their expression.

PUTTING YOUR SUBJECT AT EASE

The art of taking a candid photograph is to devise ways to let the subject be themselves. You need to defuse any tension by encouraging your subjects to move (but not too much) and talk. One solution is to photograph them while they are engaged in a gentle activity. If they are occupied, the photograph will be a more accurate image of their personality: a portrait. If your subjects are not physically occupied, you need to engage them in other ways, such as listening to music or conversation. In either case, you need to be focussed on your subject's expressions and not jump at shots. Start by trying to frame the subject in a good light and get the exposure and focus fixed, so that you can then concentrate on composition. Finally, work on catching their expressions. You can vary the composition by gently zooming in or out.

Capture the moment

G reat photographic compositions arrive and disappear very quickly. It is this spontaneity that causes both the pleasure and the frustration of photographing the movement and interaction of people. Since subjects are so unpredictable, photography can feel like chasing an elusive butterfly—just as you're about to land the net, it flits on just out of reach.

With film-based photography, the expense of film and processing sometimes inhibited spontaneity. When every shot costs, you are less likely to try taking multiple photos to capture the moment. Once you go digital, however, you can run off a whole series of shots, giving yourself an even greater chance of capturing that elusive moment. That makes digital a seriously effective butterfly net!

So, use your digital camera to its full advantage: shoot and shoot again. Sometimes casual images can reveal some wonderfully surprising compositions that even the most imaginative preplanning could not have devised.

PLANNING AND ANTICIPATING THE MOMENT

While capturing the moment doesn't require a military campaign, it does take some strategic thinking to ensure that you are in the right place at the right time. The challenge is twofold: to be prepared technically for the moment; and to anticipate the photogenic opportunities. The great thing about photographing the family is that you have insider knowledge—you can set up scenarios in which you can predict the likelihood of certain events and gestures, enabling you to plan your photography. You can't control the action, but you need to anticipate it. Think ahead, positioning yourself where you are most likely to catch the action and frame the subject against a good background.

Think of the professional press photographer, who prepares by familiarizing himself with the terrain, ensuring that he has the right exposure readings and prefocussing in readiness to fire off a rapid set of shots, all to guarantee that he has caught the moment. While you should not adopt every tabloid tactic for your family photography, it is still worth applying those same skills, ready for those fleeting moments that we all say, with hindsight, would have made a great shot.

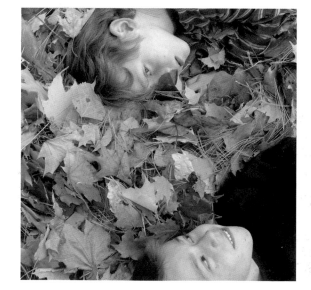

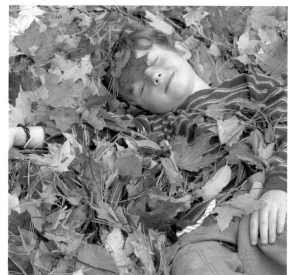

The situation might be a little contrived, but the relaxed interaction of the children at play makes these images work. Also, their bright clothes against the scattering autumn leaves create a series of striking and lively color combinations.

In this set of photographs, I encouraged the children to play in the leaves and, as you would expect, they were soon throwing drifts of leaves in the air and collapsing into the soft piles. For some of the shots I wanted to catch the moment of the action, while for others I waited until the action paused so that I could catch the children's eyes as they relaxed. I varied the shots from close-ups of individuals to group shots, and framed the children in a variety of arrangements to create maximum compositional interest. As the children were all in one plane, lying on the ground, I was able to set one exposure and switch the camera to manual focus. I also set the camera on manual focus and shutter speed priority to catch the children throwing the leaves in the air, so that I could catch the precise point in the action where the leaves were suspended in mid-drop above the children's heads.

PREFOCUSSING AND PRE-EXPOSURE

Catching the moment is not as technically challenging as you might think. It really involves two quite simple procedures: prefocussing on your subject and presetting your exposure. Using the automatic settings will guarantee that the camera is correctly focussed and set to the right exposure settings, but it also adds a delay called "shutter lag" as the camera takes its readings and makes its settings. This isn't merely annoying – it will get in the way of a truly productive shoot, and you could even miss out on some of the best potential photos.

To avoid shutter lag, you need to use the auto exposure to take a reading and then either prefocus on the subject or switch to manual focus, which fixes the settings. This lets the camera respond more rapidly, and enables you to concentrate on the precise framing and timing of the shot. Remember, if you subsequently reposition the angle of the camera into a different light, or if the subject moves too far toward or away from the camera, you will need to reset either or both settings by switching between manual and automatic settings.

FACT FILE

Setting a stage
A series such as this shows some of the advantages of introducing an element of contrivance into a shoot. Essentially, you are creating a stage and a situation, then introducing your set of characters onto it, and encouraging them to improvise—in this case, simply to be themselves. The advantage is that you can set up your camera to capture the "stage" by presetting the exposure and planning your angle of attack. Once you have preset the camera to capture the type of image you want, it's best to switch to manual focus. This will give you the most dynamic relationship possible with your camera to make fine adjustments and capture the moment.

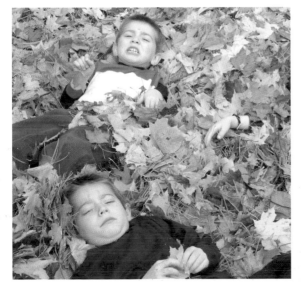
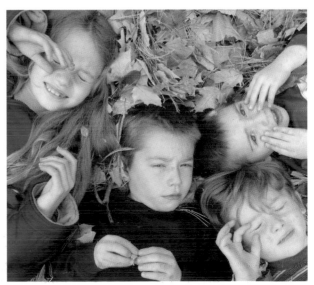

Backgrounds and surroundings

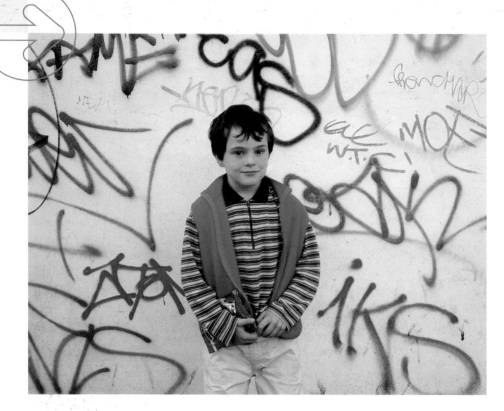

Even if you think graffiti is a menace, it suggests a spirit that says "this is me" to the world. Here, it creates visual bursts of energy, color, and movement, putting the subject into a revealing context, or perhaps creating an effective contrast.

This striking composition sets up a series of visual themes that make for a dynamic image. Look at the strong horizontals in the top half of the image, the bold color contrasts, and the strong pose of the subject in a vertical composition.

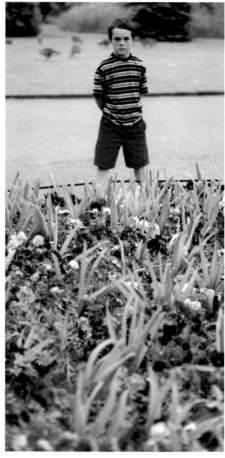

The choice of setting can make or break a photograph. As you look through your family album, you may notice that a great shot of a person has been compromised by an uninspiring or distracting setting. All too frequently, the setting will not have been a matter of choice. This is understandable, because the pleasure of family photography is in the spontaneity with which we respond to the moment. Our focus is so often on the subject that we ignore what is going on in the background. But by taking setting into consideration, your portraits will be enhanced.

The setting you choose will completely determine the mood of the photograph. It is striking to see how shifting a subject from one background to another will completely transform the atmosphere and visual theme of the composition, revealing new aspects of a person's personality. You can observe this clearly when you look through a selection of photographs you have taken of an individual in different contexts.

INFORMAL SETTINGS

You do not need to lose your spontaneity when you start to take setting into consideration. Rather, it is a matter of extending your spontaneity by improvising different backgrounds from the possibilities on offer. There is a world of backgrounds to explore creatively, from simple, uniformly colored backgrounds to complex patterns of textures on natural or manmade surfaces. Just by following your subject around the house or garden, or watching them at work, you will notice a variety of options.

Six very different backgrounds and textures from both the natural and manmade worlds. Placing any person in any or all of these contexts would create a very different dialog between subject and camera, and a new theme.

This image is a complex interplay of moods, shapes, and color, the bright stripes mitigating against a potentially gloomy or ghostly image.

Lucy in the sky... this image recalls the late 1960s and early 1970s, but in an obviously contemporary style. Playing with context is part of the fun.

One simple and effective way to explore settings is by going for a walk together, framing your subject against the differing colors and textures of the backgrounds you pass, and selecting backgrounds that harmonize or contrast with your subject's complexion and clothing.

Try different settings, both natural and manmade, and don't be afraid to explore the less obviously photogenic environments, such as a simple bank of grass or the texture and pattern of leaves or a stone wall. Urban environments also offer very exciting backgrounds, where, for example, a worn or graffiti-covered surface makes a striking contrast to skin tones and clothing.

FORMAL SETTINGS

When you want to create a more formal composition, you need to choose a setting that complements the dominant color values of your subject's features and clothing. Alternatively, you can also compose from the other direction, by selecting a setting and asking your subject to dress in a way that is sympathetic to the background you have in mind. But take care not to inhibit spontaneity.

With portrait photography, it is a basic rule to simplify the background, going for a more uniform and neutral setting, in order to concentrate attention on the form of the subject. Architectural features, such as doors, windows, archways, or pillars, are natural frames for formal compositions. You can always find a wall or some drapery against which to position the subject. Think in terms of color and texture. A neutral color and a distinctive texture can make a striking contrast to the softness of skin and clothing. A single, dark-colored surface will make a powerful foil for the lighter tones of your subject.

Backgrounds and surroundings

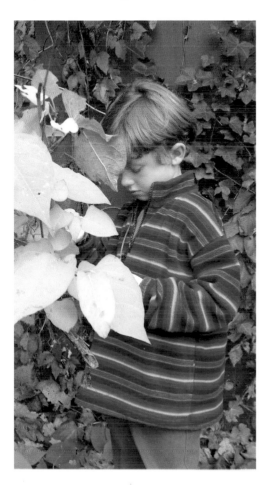

Composition

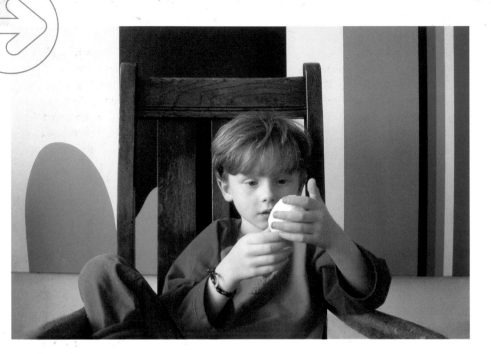

An awareness of color, shapes, angles, and strong horizontal and vertical lines is no great mystery, it's simply a matter of training yourself to look, and to frame.

This image is both a charming child picture, and a bold composition in terms of its perspective and use of framing devices from everyday household objects and textures.

TIP Walk around your house with your camera, looking for shapes, textures, framing devices, and potential visual themes. Test them through the camera from every angle.

Composition is at the heart of successful photography. Often the process is an intuitive one, as we make unconscious decisions about the balance of light and shadow, and the arrangement of shapes and colors in the frame. Equally intuitively, we all make judgements about why one image works and another one does not. It does not require training in visual arts to develop this critical faculty—be confident in your own ability. With a little careful analysis of your pictures, you can easily improve your awareness of composition.

COMPOSITION AND BALANCE

Good composition simply means creating an active relationship to the subject. As you explore different distances and angles of view, the subject will create different shape arrangements in the viewer frame, varying from the balanced and stable to the dynamic and angular. Given that the normal photographic format is a rectangle in either a vertical (portrait) or horizontal (landscape) position, all the shapes in the composition should either harmonize or contrast with this basic shape. Horizontal lines are calm and, in conjunction with vertical lines, create a sense of order and proportion. Curved and diagonal lines create movement. Most good compositions are made up of a balance of the two. Too much stability creates boredom, but too much movement creates chaos.

GEOMETRY

There are some very simple time-tested guidelines for improving composition in photography, which are based on proportions and geometry. Obeying these, or playing with conventions, can create dynamism and interest where before there was none.

FACT FILE

Practice
Compositional instincts develop through practice, and digital photography is the ideal means, since you can take endless permutations of shots without needing to worry about the expense of film processing.

The most important step you can take to improve your skills is to take more shots to create compositional variation, and to move around your subject to find the most expressive angle of view. This simple strategy will radically improve the chances of getting good results. When shooting, slow down and take time to look and see the expressive qualities of your subject. It is often only with hindsight that we learn that just waiting a bit longer or moving the camera would have made a photo that much better.

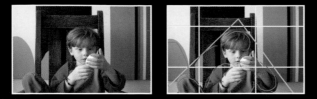

We know instinctively from looking at the image, far left, that it is well composed, but in spite of that it does not appear contrived, thanks to the relaxed, and preoccupied subject. But the strong formality of the image is revealed, left.

PYRAMIDS

An individual or portrait group positioned in a pyramid arrangement creates a sense of compositional stability. If the apex of the pyramid is displaced to the left or right this adds some pleasing variation to the basic symmetry of the picture.

RULE OF THIRDS

All basic photography manuals refer to a compositional convention called the "rule of thirds" and some cameras will offer a display setting that divides the LCD screen or the viewer into equal thirds both across and down the image. Positioning your subject square in the middle of a composition usually creates a dull and static picture. By applying the rule of thirds, you can divide the composition in proportions of thirds to two-thirds and position the subject in a way that creates a far more pleasing balance of shapes.

VISUAL THEMES

There are many possible ways to organize a composition, and it helps to think of it occurring on several levels rather than just as an overall balance. As well as geometry, look for visual themes that recur throughout the photograph. We'll explore some later in this book. Each subject you choose will naturally have a different unifying visual theme, and it's really the aim of composition to see, acknowledge, and accentuate the importance of that theme. The theme might be in the atmosphere created by the color and direction of the light, or a dominant color harmony, or a rhythm of the forms or arrangement of textures. By being aware of and selecting a theme, you can arrange the frame to include or exclude parts of the scene that either enhance or diminish it. Also, setting a subject against a highly contrasting theme can create real drama in the frame.

IN CHAIR AGAINST A PAINTING

This image demonstrates the three compositional principles that I have introduced. The yellow grid divides the composition into thirds across and down. In this composition you will see that the major horizontal lines of the top of the chair and the bottom of the canvas on the wall roughly coincide with the division of thirds, as do the vertical lines.

The orange lines demonstrate the stable pyramidic structure of the pose as it comes to an apex at the focus of attention: the child's head. The green lines highlight curved rhythms, which create movement and counterbalance the structure of vertical and horizontal lines.

Additional themes are created by the simplicity of the color scheme, which is based on the contrast between orange and blue. There are other subsidiary themes in qualities of shape, form, color, and light that are repeated in the composition. One obvious visual echo is in the form of the child's raised knee, which is repeated in the curved blue shape in the painting backdrop. Lastly, but most importantly, there is the unifying light, which falls evenly across the right side of the forms.

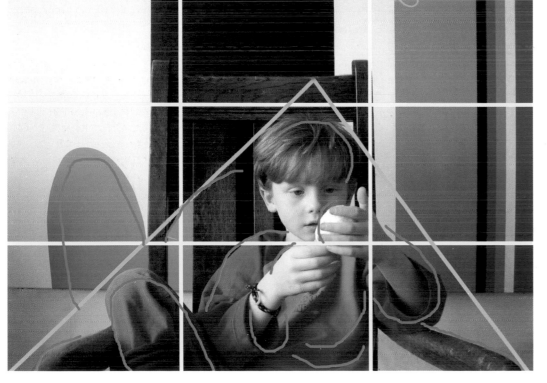

This image combines the rule of thirds with a strong pyramid structure that also suggests perspective and draws the viewer in. Also, notice the dialog between strong verticals and gentle curves, and between equally bold color combinations.

Color

In a portrait, the colors of the subject's skin, eyes, hair, or clothing will suggest a theme that prompts you to place him or her against a background that harmonizes or contrasts. Sometimes a simple prop that the subject is holding, such as flowers, will suggest a visual color theme. If you want to develop color as a theme, it is well worth the effort of selecting a few different lengths of colored cloth from a fabric store, or buying some large colored sheets of paper from an art supply store, from which you can improvise a background for your subject.

Look at the image of mother and child. There is no color contrast; the image is desaturated. Look at the color wheel, left, and you can see that each color has an opposite. These are referred to as complementary colors. Placing pairs of complementary colors together creates both a sense of harmony and a vibrant contrast.

Color saturation is explored to the maximum in the composition of the boy holding a container of orange cheese puffs. There is a strong contrast between the cool hues of the blues and greens against the warm hues of the reds, oranges, and pinks. There is also harmony at work in the use of related colors.

Color is a key compositional element in both film-based and digital photography. But with digital photography, the quality of color is particularly exciting. A vivid depth and saturation of color is on offer to the digital photographer who takes advantage of the computer-based darkroom. Today we have complete control over how color works. We are able to make adjustments and create effects that would be impossible in a darkroom, even in the hands of experts. Although you can make adjustments during processing, color considerations still have to play a part in your planning.

TIP The use of contrast and color saturation can have an impact on the way we see the subject. The image below is muted, which perhaps mutes our view of the mother and child.

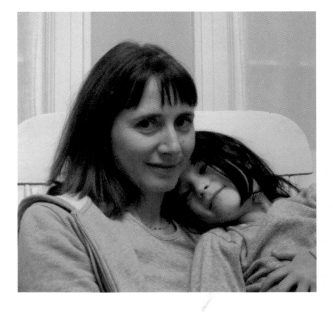

These are both artificial patterns and shapes, and artificial color juxtapositions. But deploying such color contrasts within a picture of a human being often emphasizes their natural character and humanity.

▶ *You can see this in the contrast of the boy's orange T-shirt against the blue of his jumper. The same theme is also repeated in the background colors. By positioning the boy against the blue area of the background, the blue enhances the warm hues in the child's face. This typifies the way that tone and hue contrast can emphasize faces.*

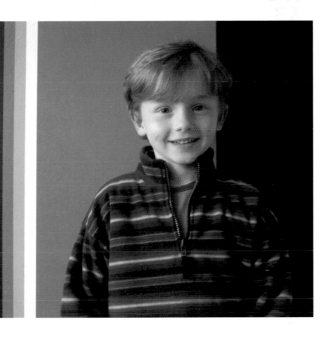

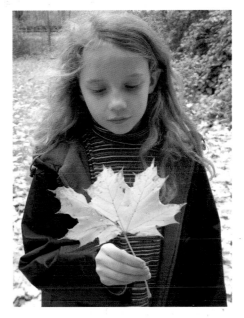

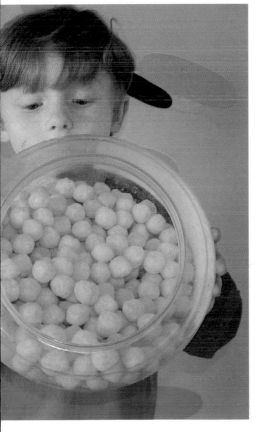

There are some basic guidelines to using color, which will help you in your photography. First, it helps to understand the relationship between color hue, tone, and saturation. **Hue** refers to the fundamental color (i.e. red, green, yellow, etc.). **Saturation** refers to how intense that hue is, and the **tone** describes how dark or light a color is. With these three attributes of color, you can explore and create endless permutations of harmony and contrast by making one attribute of color harmonize, and another contrast.

For example, in the image of the mother and child the color is desaturated with very little color contrast. The color is made of subtle transitions of warm and cool grays that harmonize well with the delicate pinks of the faces and hands. The contrast in the image is in the tonal range, which runs through all the grays in the scene, culminating in the contrast of the child's black hair set against the white of the chair back. This image can be summed up as having a close color harmony and a strong tonal contrast.

▲ *In the image of the girl holding a leaf, a combination of mute color harmonies and strong color contrasts is brought together in a single composition. Another theme is developed through the use of violet and yellow. These complementary colors create a dramatic contrast, look at how the saturated color and bright tone of the maple leaf react against the dark tone and violet hue of the girl's jacket. This creates the dominant visual focus, but the emotional focus is still the girl's face. The natural light of day has created a gentle atmosphere of reverie. The harmonies of violets and yellows in the background echo the yellows and violets set up in the initial contrast of leaf against jacket.*

Light

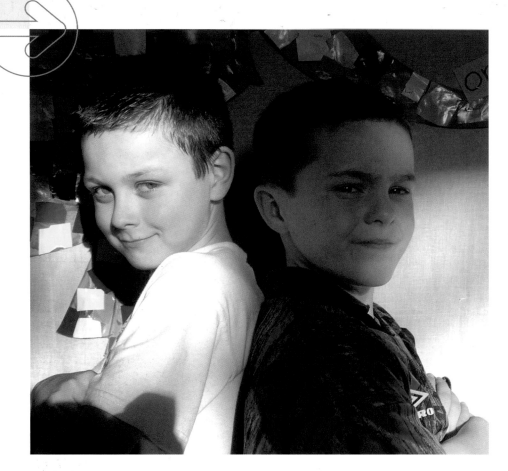

TAKING GREAT PEOPLE SHOTS

Directional light can be especially effective in a double portrait, here suggesting two very different characters indeed!

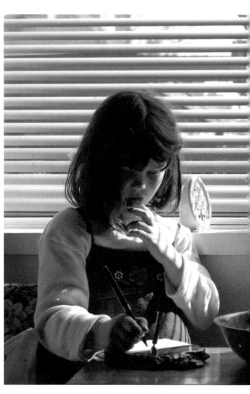

The pleasure of observing and capturing the beauty of light is at the heart of good photography. The quality of the light will both describe the form of your subject in a distinctive way and poetically define the expressive mood of the image. This is why an awareness of the impact of the light on a scene, and the ability to control lighting, form the basis of a successful photograph, both in a technical and a compositional sense.

Creatively managing light is about selecting sympathetic lighting for your subject. You can radically change the feeling of an image by photographing your subject in different lighting, moving, for example, from the gentle atmosphere of soft reflective lighting to the high contrast of strong directional light.

There are many creative techniques with which you can control the way light falls on the subject: the simplest is by repositioning the subject in the light source. But you do not need to use artificial lighting in order to do this. You can control the way natural light falls on your subject by choosing different settings. A good way to explore the expressive properties of natural light is by setting your photograph by a window. This lets you work with natural light in a directional way, controlling the light by repositioning the sitter or filtering the light through drapes.

There are infinite nuances of natural light to explore, in terms of atmosphere and mood throughout the season and the day. Natural light is generally softer than artificial light because daylight is diffused through particles in the atmosphere. The light is also bounced around, reflecting off both natural surfaces, such as clouds and water, as well as the multitude of manmade surfaces. Even if the light of the day is consistent, which is rare, you can radically alter the appearance of your subject by repositioning either the camera or the subject in the available light.

Depending on direction and strength, ambient lighting can both reveal or obscure the form in a portrait. Dramatic side lighting, for example, emphasizes form and contour but places facial features in shadow.

The potentially harsh sunlight through this large window is diffused and given added warmth in this placid indoor scene. Blinds and drapes are designed to shield or deflect light, but the clean, modern lines of this blind also create a striking compositional element that adds drama to the frame.

COLOR, TEMPERATURE, AND MOOD

You can tell what time of the day and what season a photograph was taken in by the ambient light in the photograph, and you can take advantage of the normal variations in natural light by being attentive to the changes of the day and the season.

The time of day and the season will cause light to have a "color temperature" that creates an overall color mood in an image. The white light of midday is the baseline measurement for color temperature. Through the day, as the sun moves across the sky toward the horizon, light becomes warmer as the morning's ultraviolet light gives way to the infrared light of the afternoon, culminating in the orange light of sunset. The light in winter is cold and will be biased toward blue, while in summer it is warm and biased toward yellow. The position of the sun in the sky also has a bearing on the quality of light: while the sun is lower in the sky throughout the winter, on bright days it creates dramatic shadows.

DIRECTIONAL LIGHTING AND SHADOWS

The direction and the strength of the lighting will affect the amount of detail appearing in the photography, and for this reason it is very important to be aware of the way the shadows are being formed in a scene. Sometimes a strong directional light will create distinctly dramatic shapes, adding to the drama of an image, but this has to be balanced against the loss of details in the shadows.

Sunny days are not always the best on which to photograph people because the light can be so strong as to create overly dark shadows in which detail is lost. On a cloudy day the light will be weakened, reducing the shadows to a minimum, and this surprisingly creates a good light for portrait work. Rainy days are not to be missed either, since the air after the rain is often beautifully clear and the colors of surrounding plants and foliage are deepened, making a delightful backdrop.

The secret is to keep your eyes open and to regard light as another character in the scene.

Right, the prevailing temperature of this scene is cooled off, appropriate for an image of a swim on a blazing afternoon. But there are areas of warmth in the group.

Far right, the afternoon sun just past its apex both lights the scene brilliantly, and also creates a stunning shadow that adds strong diagonals to the composition.

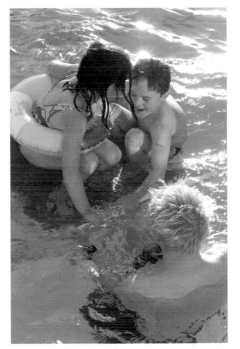

Difficult lighting situations

Dramatic light creates very exciting compositional possibilities but can also create difficulties in fixing the right exposure. Candlelight illuminating a dark space, or a striking sunset behind a figure—these are the photogenic lighting situations that instantly affect our sensibility and draw us into an imaginative reverie. The technical difficulties they present can be easily overcome, allowing for some exciting compositions.

BACKLIGHTING

When the sun is low in the sky in the late afternoon, that natural lighting takes on a dramatic, atmospheric character, and the photographer in all of us wants to point the camera into the light and photograph figures against the backdrop of the sky.

This lighting situation is called backlighting. It also occurs when you are photographing a subject set against an artificial light source, such as a lamp, or when a figure is positioned against a fully lit window. Backlighting throws your subject into shadow, creating silhouettes. These lighting conditions create memorable images by combining areas of sharp contrast with areas of ambiguity in the composition.

The technical challenge of backlighting is to capture the silhouetting of the subject, but without the silhouetted area becoming too dark and losing all detail. You must make a careful exposure reading of the shadow areas. If you underexpose, the shadow areas will fill in and you will lose all definition in the dark tones. If you overexpose for the shadows, you will get the detail in the darker tones but the surrounding light areas will bleach out toward white. In order to control exposure in a backlit situation, spot metering capabilities and the exposure lock feature become indispensable.

1 Select the spot meter option under photometry settings.

2 Position the head in the middle of the viewer and semi-depress the shutter release button to take an auto-exposure reading. You will see the exposure being adjusted and the face becoming brighter in the viewer as the camera adjusts the exposure for the shadow in the face.

3 *You can then either take the picture with the head in the middle of the frame or alternatively lock the exposure by pressing the AE-L Auto Exposure Lock button and reframe your subject against the surroundings. Bear in mind that if you reposition without using AE-L, the spot meter will automatically adjust for whatever is in the middle of the lens.*

Backlighting is found in nature, as in this sunset, far left, which throws both the land and the lone figure into striking shadow. But it can also be created artificially, as with the warm glow behind these two secretive figures.

SPOT METERING AND AE-LOCK

The spot meter takes a reading at a precise point in the middle of the lens and is used to set a reading for one area of a composition that is in extreme contrast to the rest of the scene. In the case of a face that is in deep silhouette against bright light, you can set an exposure to capture the detail in the face.

The deep atmospheric effect of artificial light on a woman in candlelight in Notre Dame, Paris. This image was exposed using the default setting in the light metering. The challenge for both camera and user is to not overexpose the flame, or under-expose the woman's glowing face.

FACT FILE

Lens flare

Another feature of photographing into the light is lens flare. This is a phenomenon in which circles of light appear in the image where the sun has caught the lens. In small amounts, this adds to the drama of the photograph, but more often than not it will spoil the reading of the photograph. The best solution is to use a lens hood; in the absence of a hood, you can cup your hand over the top of the lens to mask the sun from hitting the lens surface.

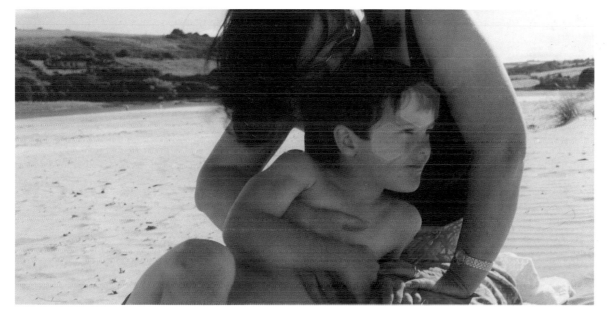

This backlit shot of mother and son on beach is an example of when to use spot metering and also shows the effects of lens flare.

Getting in close

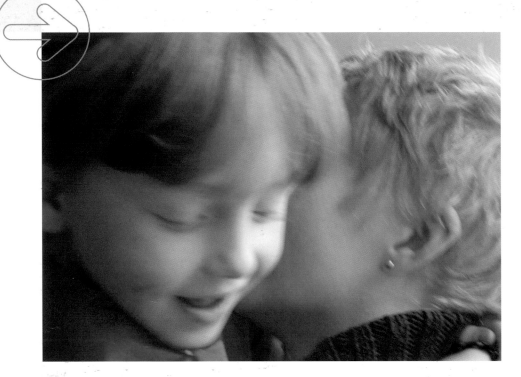

The pictures on these pages come from a session in which I was photographing a woman painter and her young son. The shoot took place in her studio, which was open and bright, so I was able to use available natural light. I was keen to capture mother and child in spontaneous, informal poses that caught the closeness of their relationship.

USING YOUR ZOOM TO GET IN CLOSE

There will be times when you'll want a close-up group shot but you won't want your subjects to react to you and your camera. Instead, you want them to react to their surroundings or to each other. Instead of crowding them, stand back and use the zoom on your lens to move in closer to the subject. Beware, though, of standing too far back; the more you increase the zoom, the more you increase the likelihood of camera shake.

When we remember a person or an event, it is often a particular detail that we recall. Our memory edits images in the mind's eye to the essential and poignant details—the way someone smiled, the turn of their head, or a characteristic gesture. This is also true for the best photographs we take of the people we love. They hold some intimate moment, a characteristic look or gesture.

The best family photographs work because they feel intimate and relaxed. Sometimes you can catch a spontaneous moment in a couple of shots, but it is more usually the case that you need to take a succession of photographs of your subject over a period of time. It can take several shots before you begin to see the possibilities, and before your subject relaxes. In the past, only a professional photographer could afford to use several rolls of film to catch those intimate moments. Now, with digital photography, you can afford to shoot and shoot until you capture the perfect expression.

Good family photographs are all about unspoken communication, and subtle but expressive detail. A common problem is that the pictures are taken in haste. Give yourself enough time to see these moments, to settle into composing the subject within the frame, and to stay with the subject for long enough to record the moment.

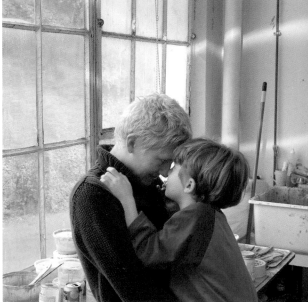

1 **Wide-angle shot**
It's not a disaster, but we're simply too far away from the couple. The eye is distracted from the subjects and drawn to the clutter that fills the artist's studio.

Once you have your subjects framed at their most natural and relaxed, firing off a number of shots can capture a highly successful series of images, as here. Each shot stands on its own merits, but together they offer tremendous insight.

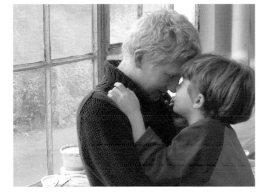

② Medium shot
Zooming in closer cuts out a lot of the distracting detail and uninteresting background, but the image still lacks power. Even the non-expert photographer can sense that the image is incorrectly balanced and needs reframing. The window is far too dominant in the frame.

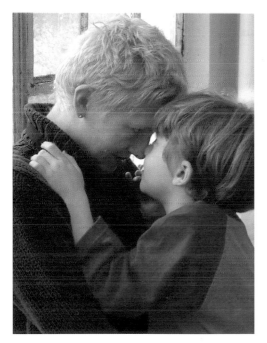

③ Close-up shot
At this focal length, attention is firmly on the intimate moment between mother and son. It's a successful image—though one might want to remove the turquoise paint pot from the window ledge at a later image-editing stage.

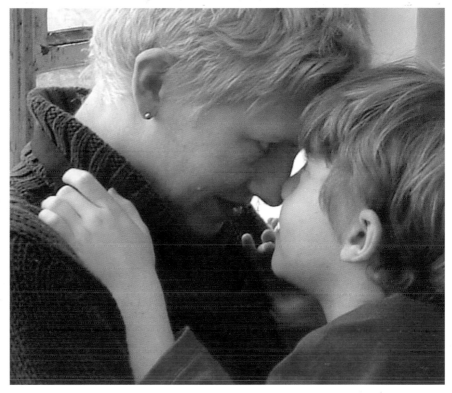

④ Tight-cropped close-up
In this very close shot, the image is reduced to its essentials, focussing attention on the details of expression. The art of framing is to zoom in as close as possible to heighten the intimacy of the photograph but without making the crop so severe as to awkwardly chop the image. There is real dynamism here.

MOVING IN CLOSE TO YOUR SUBJECTS
If you shoot from too far away, your subjects will be too small in the frame and the viewer feels distant. There isn't enough detail visible to draw our gaze into reading the subtleties and details of expression. Move in closer if you want to achieve a feeling of intimacy in your photograph. You come into a more intimate relation with your subject, and the photograph conveys a feeling of being both physically and psychologically close.

FACT FILE

Sometimes, in an intimate photograph of a spontaneous gesture, motion blur occurs. While you normally want to avoid this, there are times when motion blur adds to the photograph. In the picture on the opposite page, top left, the motion blur helps to capture the spontaneity of the child's response. How much blur is acceptable is, to some extent, a matter of taste, but you should judge it by whether it detracts from the image or adds emotional impact.

Action shots

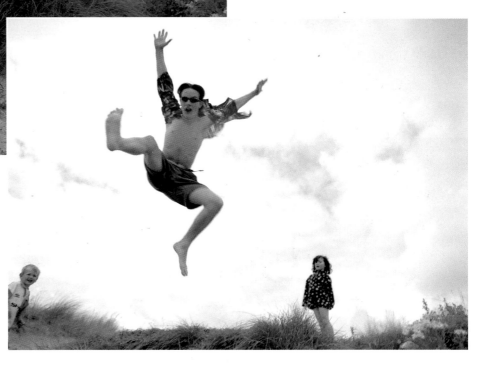

up to a 1000th of a second, but it is exceptional to use this speed, since a shutter speed of 250–500th of a second will be high enough under most circumstances to avoid motion blur in the image.

As you raise the shutter speed, you need to consider how much light is available. As a general rule, you need strong light and a wide aperture to compensate for the faster shutter speed. This is fine when you're shooting in bright sunlight, but if you find that the scene is too dull, even with the aperture wide open, you can either raise the sensitivity of the camera to light by choosing a higher ISO or add your own light by using the flash.

Through the use of the camera, we can freeze and observe a movement in detail that the naked eye would see as no more than a blur. In this sense, action shots truly are a revelation—they display what the eye *can't* see. A few simple techniques will enable you to capture the drama and detail of movement, so that you can add some dynamic images to your family album. Frozen motion can catch the essence of a person.

The most basic strategy for taking motion shots is to increase the shutter speed. In the intro-level cameras, and in the Special program setting on some of the midrange cameras, you can set the camera to function automatically for action shots by selecting the little running figure icon in the category called Special. In the midrange cameras you need to set shutter speed priority and select a higher shutter speed. Most of the midrange cameras will have

The children running and jumping from the sand dunes toward the camera required prefocussing on the grass before the children passed that point in space.

The image of children on a trampoline was a simple problem to solve because the action was mainly up and down, and required no panning. These images were selected from a set of five rapid motion shots.

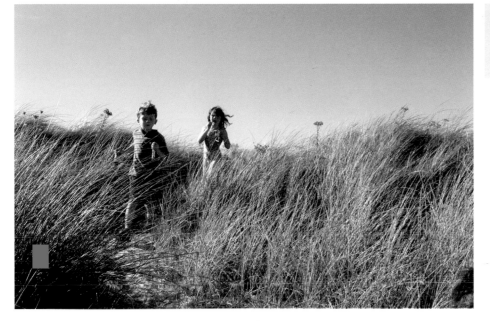

Shutter lag

Shutter lag is the delay between pressing the shutter release button and the point at which the camera actually takes the shot. When you use the autofocus setting, the camera pauses as it takes a reading and adjusts the lens to focus on the subject. At the same time, during auto-exposure, the built-in light meter will take time to make a light reading and adjust the aperture and speed settings. The length of time between pressing the shutter release button and the actual camera action of capturing the image depends on the camera model, but the delay can be up to a second or more when the scene is tricky. And this is a significant time lag—that half a second, or worse a whole second, can mean the difference between catching and missing the moment when you are dealing with fast movement, such as sporting activity.

Some situations create longer than average shutter lag: action shots are difficult for the autofocus function; reflective surfaces and low-light situations also increase shutter lag as the auto-exposure function struggles. Shutter lag is one of the most vexing attributes of some models of digital cameras. As such, it is one of the technical issues you need to evaluate when buying one.

That said, there is a simple strategy for eliminating shutter lag: switch the camera to shutter priority to raise the shutter speed. Take an automatic reading to set the exposure, and then use manual focussing. This way, the camera will respond by taking the photograph at the instant you press the shutter release button, and you will also derive the additional benefit of having hands-on control of the shot.

USING FLASH TO CATCH MOTION

Many photographers will use flash even when the scene is bright enough, because the flash speed, at about a 1000th of a second, guarantees that the action is frozen in sharp light for maximum detail. Another alternative is to use Slow flash, which incorporates some motion blur, recording the trace of the motion, then finishes the exposure with a burst of flash to create a sharply focussed image on the end of the blurred action.

PANNING AND CONTINUOUS MOTION SHOOTING

One of the great advantages of many automatic cameras is Continuous Shooting Mode. This records up to five images of a subject in movement, often with less than a second between each shot. To do this well, you need to practice panning the action—that is, following the action as it occurs. If the action is moving toward you, you will get blurring caused by the subject having run past the point of focus. In this case, you will need to prefocus on a point in space where the action is going to pass and shoot at that point.

To freeze this magical summer moment in time required pre-focussing on the bend in the path that created the strongest composition.

This photo was easy, despite the subject's tumble. A third person threw the ball to the girl, on whom I had already focussed to set up the action shot.

Simple "studio" setups

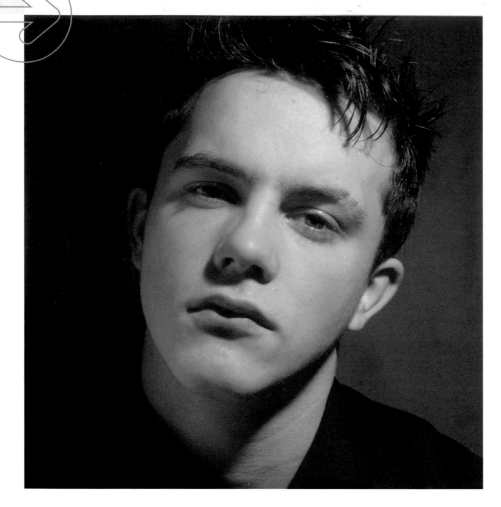

This is a well-lit full-face shot. The directional light has created shadows which a second light source—a reflector— has softened, revealing skin tones. The effect is warm, with highlights.

Any studio shot is a trade-off of lighting, shutter speed, aperture, composition, and that elusive "moment." Here the model is seen holding the reflector used in the final shot.

There is tremendous pleasure in composing a photograph when you can really control the lighting. Often your photography will be compromised by unsuitable lighting, or the quixotic nature of the weather. By shooting in a studio setting, you can control your image and take as long as you like. Using easily available equipment and materials, there are many possibilities for taking refined, impressive portraits.

A studio sounds rather a grand affair, but it does not have to mean a space set aside solely for the purpose of professional photography. Rather, think of a studio arrangement as an easily constructed and temporary gathering of some additional equipment in an existing space. You can set up a studio anywhere you can access lighting and a power source; you can even use extension leads to work outside.

SETTING UP STUDIO LIGHTING

The simplest lighting setup involves positioning your subject near a window, which creates a strong sense of directional lighting across the subject. You can use the drapes or blinds to control how much light falls across your subject, and how scattered the source is.

The next step up is to position a lamp so that it casts a deliberate light. The best lamps to use are free-standing with an angled light that you can position, and which are fitted with a daylight bulb. Within this simple arrangement, there are many different lighting effects. The way you position the lamp on the subject will cast or eliminate shadows, which in turn will affect the amount of detail. By adding another lamp at a different angle, you can project light to reveal more of the detail in the shadows. This softens or neutralizes the shadows caused by the primary light source of the first lamp and enables you to create subtle controlled lighting and a predictable atmosphere. Again, the digital advantage means you will not waste film experimenting.

The digital advantage lets you fire a range of shots, and experiment with exposures, shutter speeds, and lighting schemes. Dramatic shadows appeal to some, but can lose detail in the eyes. A tilt of the head and... a perfect shot.

A directional lamp knocks out shadows behind the sitter—you can see the amount of shadow where the light has not fallen. When your subject is sat at an angle, directional lighting casts shadows on cheekbones and highlights details on the hair, face, clothing—and here, the guitar. In one shot, I've used the lighting source as a prop in the final composition.

The top one of the two images below makes use of a soft, directional light using a daylight bulb, and a reflector to knock back some of the dark shadows and bring out healthy skin tones.

The image beneath makes stark use of a halogen light, which emphasizes the details it picks out, leaving the remainder of the shot in the shadows. This would also work in black-and-white.

By positioning your subject against a bare wall or placing a large sheet of cloth or paper as a backdrop, you can create a neutral surface for the light and shadows to create shape and contrasting areas of tone, in order to throw your subject into uncluttered focus. By moving the light around, you can create backlighting or rim lighting, which highlights the edge of the form of your subject.

BOUNCING LIGHT

You can reduce the harshness of lighting by directing the light away from the subject and bouncing the light off a reflective surface near to the subject. This is done either by using the ceiling or the wall if it is close enough to the subject, or mounting a sheet of reflective paper card or cloth or even crumpled aluminum foil. If you want to set up a more professional arrangement, you can buy studio lights to which you fit attachments that further control the lighting: softboxes diffuse the light; umbrellas bounce the light back in a more diffuse way onto the subject. Alternatively you can construct a very simple frame over which you can stretch a sheet of tracing paper, in order to diffuse and soften the light from an ordinary lamp.

Simple "studio" setups

FACT FILE

Colored light
By using colored light bulbs, you can create different background colors and ambient lighting effects in contrast to a daylight bulb. Natural lighting on a face, with moodier, colored lighting around the model, can create a striking combination of tones that draws the viewer into the frame.

Simple "studio" setups

BACKGROUNDS

By using sheets of different colors and textures, you can create all sorts of imaginative environments behind your subject, varying from the simplicity of neutral backgrounds to rich colors that complement or contrast with the sitter. All it takes is a set of sheets, ranging through the spectrum from blue to green to yellow through to oranges and reds, which are pinned to a board placed behind your subject. The various colors provide a host of associative possibilities, evoking the lighting conditions of day or night, heat or sunlight. By using patterned cloths, you can recall the atmosphere of a particular era or culture, or create a harmony in a color or tonal range to match the skin complexion of the sitter. Abstract color themes offer even more possibilities.

PROPS

Props create interesting shapes and shadows, arranged for their shape or their color, either to echo or to complement the sitter. They also occupy the sitter, lengthening the time they will happily sit while you engage in your creative play with composition.

Using props can be great fun. It is surprising how few you need to evoke a time and a place. A single flower in the hands of the sitter, for example, will create a poignant focus. Alternatively, groupings of flowers and plants

Props and backgrounds are an essential part of your home studio setup, and they create an interesting interplay with your lighting choice. You can vary the color and texture of backdrop to suit the atmosphere. Props can also communicate something about your sitter's character, or put them at their ease.

This enchanting image is a blend of old and new; an outfit and backdrop that suggests, perhaps, the turn of the last century, mixed with modern props and accessories and a warm but unsentimental lighting sheme.

Getting the sitter to play with a range of props not only changes the compositional possibilities, it also alters the sitter's relationship with the prop and the camera, offering a range of options from which to choose the final shot, above.

A range of lighting schemes, temperatures, and color casts illuminates your subject—in every sense of the word. Each brings out different aspects of his character, and shifts the relationship between him and his environment.

can be attractively arranged around the sitter. Some inanimate props, such as a bust, statue, or a screen, make a wonderful contrast with the vitality of the sitter.

In this setup, I asked my youngest child to dress up as a character she would like to play and to choose her favorite dolls to join in the game. To my amusement she returned dressed, as she informed me, as the tooth fairy, complete with wings, and proceeded to explain to her dolls how to brush their teeth and what kinds of useful things the fairies made with all the teeth they collected. For this subject I wanted soft lighting and a subtle textured background of green embroidered pattern, both to complement the pink of her costume and also to evoke the visual association of a garden. Her choice of character reminded me of early Victorian photography, when photographers created ingenious montages that convinced the gullible of the existence of fairies.

In the images of my eldest son I wanted to use a prop and the obvious choice was his acoustic guitar. As he played, the bright lighting seemed inappropriate so I used the strong yellow bias of a tungsten lamp to create a more evocative lighting redolent of a café. Whereas in the images of my daughter I used white balance, in these shots I turned the white balance off so as to retain the yellow color cast of the lighting.

TIP Lighting the area behind a sitter, and using reflectors to bounce sufficient light onto the subject's face can create attractive lighting schemes.

This moody shot complements the intensity of the concentration of the sitter. This is not about the subject's face, but about what he does. We can read his character.

Using a directional source means the sitter can move into or out of the light. In both of these images, I turned the white balance off to retain a yellow color cast.

Poses and expressions

This seated, torso-length shot is a formal composition, yet also warm and tranquil, showing the subject relaxing at home. The rule of thirds is visible in the off-center composition. Strong diagonals draw you into the scene and create visual interest.

Professional portrait photographers will spend a deal of time studying their subjects to gain an understanding of their posture and expression. In family photography you have one very special advantage—you know your subjects. You know their habits and idiosyncrasies, you can read their posture and expressions. Also, when you photograph your own family, they are more likely to be relaxed in your presence than they would be in a professional photographer's studio.

Posing your sitter is an interesting problem. Very rarely can you just stand someone in front of you and find that it makes a good shot. They usually look like they are waiting to have a photograph taken! You need to intervene, getting them to move around and try different positions, until they settle into a comfortable and expressive pose. This will also help you to choose the best position for them in relation to the light.

FULL-LENGTH POSES

There are more possibilities to a full-length pose than you might initially think. Full-length poses work best when they are asymmetrical—that is, not just straight up and down and square onto the camera and in the middle of the frame. You can ask your subject to lean against the wall or turn side on and look back to the camera. If you ask him or her to rest

their weight on one leg, they will relax into a more informal pose. Leaning on a window sill, chair, or a mantelpiece or bookshelf creates an expressive arrangement and lets your sitter rest their arms in more interesting ways than simply leaving them to dangle.

In fact, what your sitter should do with his or her hands is one of the key considerations for any full-length composition. Body language is vital. Holding hands in front and folding arms are defensive gestures and a sure sign of nervousness. Try asking your sitter to unfold his or her arms and rest one hand on the hip. If this doesn't work, you might give them something to hold, which also creates a focus of attention. If your subject is wearing trousers, they can put their hands in their pockets, creating a very informal pose.

TORSO AND THREE-QUARTER LENGTH POSES

A compositional arrangement, like the one on this page, creates a wealth of possibilities because you can sit your subject down and she can physically relax into different postures by folding her legs or resting her arms. By turning the chair or bench at a tangent to the camera, you will create interesting angles in the composition. Also the sitter can place her hands in different positions on the arms of the chair or in her lap, or even rest her head on her hand. This will place her head at an expressive angle. You need to make sure that if she rests her hand under her chin, it is on the opposite side to the camera and not in a fist shape, as this tends to distract from the subject's features.

Telling the sitter what to do with their hands is a challenge for most photographers. Overly formal poses make the subject look either defensive or standoffish, suggesting you need to distract them before taking the shot.

▽ This full-length pose plays with the confines of the frame as though it were a doorway. The subject is poised between light and shade. She looks self-conscious, but with this shot of her in a party or bridesmaid's dress, that works to its advantage. The pose, although static, suggests movement.

▽ This more formal, three-quarter-length pose draws the eye upward to the subject's face, while she directs her own attention at the small bouquet she's holding. This misdirection of the eye is a feature of good people pictures —and the flowers give her something to distract her.

▽ This seated, full-length study tells us a lot about the subject's character. Making a show of being bored with the process of picture-taking, this boy still manages to project a great deal of emotion toward the camera, suggesting he enjoys the attention after all. A posed, yet still insightful image.

Poses and expressions

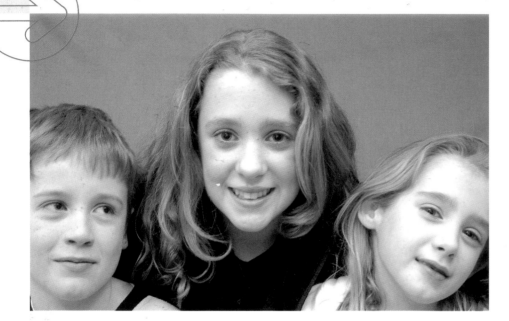

The face is the most expressively complex of all subjects for a photographer. From our earliest infancy it is the focus of our emotional attention, and throughout our lives, we never tire of examining others' features. This makes us all experts at reading facial expression. The face communicates nuances of feeling and thought that are often quite independent of our intentions, and in close-up work you will be able to catch and communicate a wealth of subtle and sometimes surprising changes of expression.

Close-up photography needs careful consideration. You need to establish even lighting. Avoid using wide-angle since this severely distorts features in close-up. It is better to move a little way back and to use a degree of zoom with the light source behind you. Because you will be photographing so close to your subject, you also need to be attentive to all the details, from the way the light is catching the features, to the way hair is arranged around the face.

Find ways to make your subject relax, because when you are focussed this close every nuance of expression and any tension in the sitter will be captured in the shot. Many people have a tendency to stare at the camera and adopt a fixed smile. If you engage your sitter in conversation, this will encourage them to use a range of expressions as they articulate their thoughts; in turn you will have the opportunity to get a series of shots of their various moods and expressions. It is important to wait until they are relaxed in the presence of the camera. If they don't want to talk, give them something to look at or listen to; or try positioning them so that they can view a window behind you or play music that the sitter has chosen.

This three-shot directs your eye around the composition in an arc, creating a great deal more visual interest than a simple symmetrical composition.

With their eyes at different levels, and the adults looking away from the camera, these simple double portraits have visual flair and reveal their human relationships.

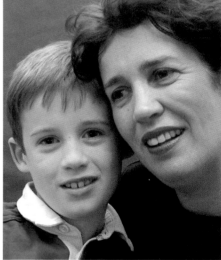

While you are trying different lighting and exposure settings, talk to your subject and fire off a series of test shots. Try telling them that you need to take some test images that you will not use... maybe one will be the best shot!

▼ *Hiding one face partially behind another adds an extra element of visual charm to this torso-length shot, which also captures the emotions of the sitters in the moment.*

▷ *When using a zoom to get in close to the subject without intimidating them, it is vital to focus on the eyes. This creates a strong relationship between subject and viewer.*

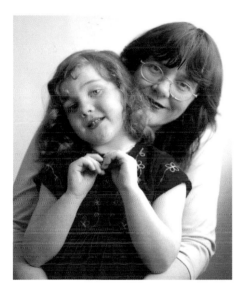

Until your subject is relaxed, don't move the camera in too close. One trick is to focus the camera and take an exposure reading, then lower the camera so that the sitter can see your face and talk to you. You can glance down to frame the subject using the LCD viewer. As they talk, you can discreetly fire off a succession of shots. Another solution is to set the camera up on a tripod, compose the sitter in the frame with enough surround, and engage the sitter in conversation so that they are not looking directly at the camera but at you. These shots can later be cropped down to a more precise composition. Try making them laugh, or surprise them. Ask them to pose, but fire off a shot before they can do it.

EYES

The eyes are poetically regarded as the "windows of the soul," and they truly do express a complexity of thought; we can so easily read a thought in a glance of the eyes. It is important to focus the lens carefully on the eyes because they will form the natural focal point of the photograph—just as human beings focus on each other's eyes during a conversation to strengthen the relationship. But it is not psychologically comfortable for us to stare into each others' eyes for long, so photographing at close quarters causes a degree of embarrassment to the sitter. However, people will more readily stare at the lens, and so the final image can have a degree of intimacy and directness of expression which would be difficult to achieve with face-to-face contact. However, do not make the sitter stare at the lens for too long, because this can develop into an unnatural fixed stare. A good solution is to ask the sitter to look away and then look back to the lens. This guarantees a more relaxed and natural look to the eyes.

FACT FILE

Soft-focus effect or sharpness
You need to consider whether you want a soft-focus effect or sharpness. Sharpness is best suited to photographing the very young, whose complexion is smooth and unlined, unless you want to take stark portraits of older subjects. With older sitters, a glancing light will be unflattering because it will exaggerate lines and blemishes. Don't use strong directional lighting unless you want to amplify the way aging has imprinted in the features. It is more flattering to soften the lines by using frontal lighting, and by selecting a soft definition in the camera options. You can use a reflector to diminish shadows and the appearance of lines.

Couples

When one thinks of a couple in the context of family relationships, the first thing that springs to mind is the idea of a married couple, whether newly wed, or together for decades. But, actually, there are many kinds of couples in the extended family—brother and sister, twins, mother and daughter, father and son, and so on. The challenge of photographing a couple is to create a good photograph that celebrates the unique relationship between two individuals who live together and may know each other from birth.

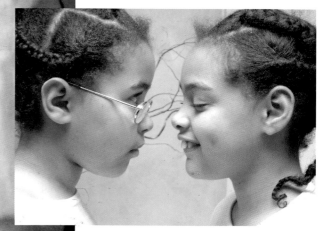

This beautiful, joyous pose is something that you may find only among close family relations or intimate friends. Get your subjects to celebrate their relationship, and you are onto a winner.

Sisters or brothers have a rivalry and a shared history that is unique to them. The secret to capturing this relationship on camera is to spend time with them just being themselves.

TAKING GREAT PEOPLE SHOTS

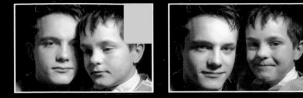

Sometimes the simplest ideas are the best. This two-shot of big brother and little brother isolates them with light, and speaks volumes about their relationship. Putting them on a similar eyeline encourages direct comparison.

Couples

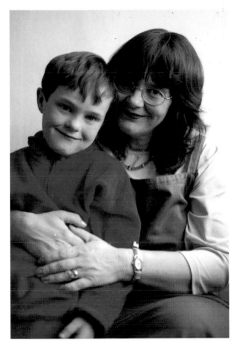

The strength of this photo lies in the similarity of form and expression between mother and son. Getting boys to relax for a photo like this can be tricky, so take advantage when they are off-guard.

You could guess that this is a mother/daughter relationship, sharing a moment that crosses a generational divide. Creating this type of contrast takes just a little thought; nothing more.

The most expressive images of couples are often captured when their attention is focussed on each other, so, at least for the initial shots, encourage the couple to relate to each other without paying attention to the camera. It is important to choose or create a setting in which the couple can feel comfortable and relaxed, and encourage them to take a pose that feels natural to them.

Setting a couple on two chairs, or one sitting and one standing, will create a more formal composition. If you encourage them to arrange themselves comfortably, a couple may surprise you with the positions they take, often choosing poses that give expression to the depth of their relationship. The poses they settle into will often hold more character than the poses that you contrive, so be flexible in your approach—it is easy to make people freeze into strained poses.

Choose a setting with a suitable background and lighting. Look at the possibilities of both interior and outdoor settings, so as to frame the composition attractively. Remember to think about different colored backgrounds, experimenting with different wall colors or a selection of colored sheets hung behind the subjects.

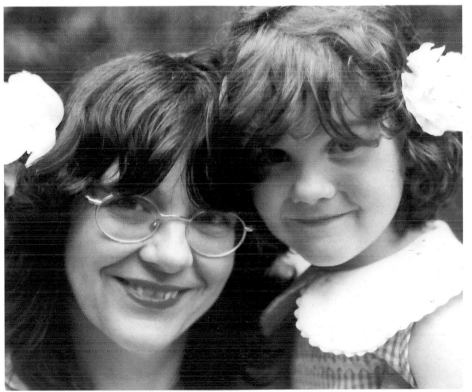

Selective autofocus

Many digital cameras, even relatively inexpensive ones, have an autofocus function built into the same button as the shutter release. For posed shots, especially one using a telephoto zoom function, use this to center the focus on the eye of your subject. Once you have done this (the camera may beep), you can reframe the composition and shoot. The camera will hold the focus on the eye of your subject. Although a little slow and clumsy, this approach does encourage a good relatioship between you, your subject, and your camera.

Group shots

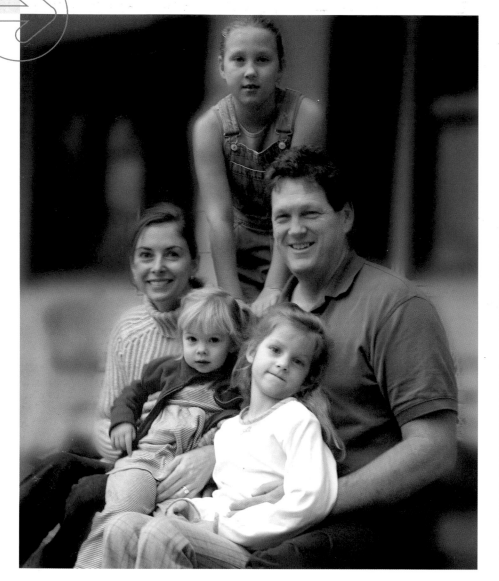

Here, deep focus with masking and blur concentrate the eye on an important subject: the family group. Isolating them with deep focus creates a strong relationship with the camera.

This stunning, complex group composition works by dividing friends into two distinct groups, then concentrating on the relationship between the two, visually and emotionally.

TIP
If you're dealing with large, complex groups of people, try creating visual divisions to introduce drama into your composition.

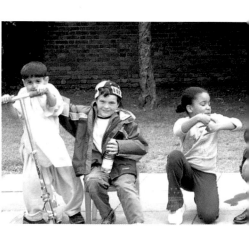

Group shots—pictures of anything from three people to a crowd at a wedding—are always a challenge. At the same time as you focus on technical matters of style and composition, you have to organize groups of people into a pleasing arrangement—and get their attention!

POSING A GROUP SHOT

It can be very tempting just to line the group up against a wall, but this is a fairly unimaginative and dull solution to group photography. You need to think of ways in which you can break up the line. You can have some standing, some sitting or kneeling, with the younger members of the family sitting on the floor or on someone's lap. Bring the group as close together as possible without blocking a view of the person behind, and arrange the group to fill the picture frame.

This process requires considerable negotiation skills on your part. You need to be assertive, yet affable and always diplomatic to gain everyone's attention when attempting group photography. If this does not suit your temperament, it is worth enlisting the support of a more extrovert member of the family to hold the group's attention while you focus on the composition and taking the shots. Never forget that, when taking group shots, creating as natural a dynamic as possible between the group members is essential.

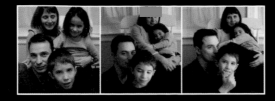

Any family group contains strong, dynamics and inter-relationships. When shooting a group such as this, encourage them to talk and to interact, then record these unique events as honestly as possible.

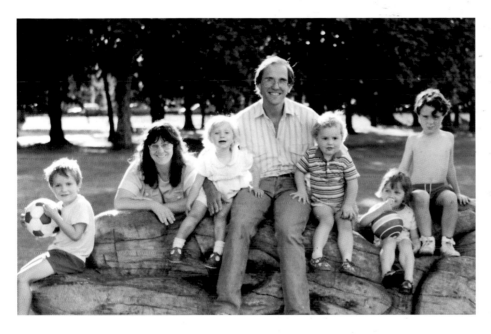

This large family was always going to make an interesting image. Finding a natural device, such as this rock, to support the group adds to the composition.

Making direct compositional comparisons within a group shot can throw the emphasis onto each of their faces, which reveals the dynamics between the group.

FRAMING A COMPOSITION

In most digital imaging software packages, you can use the *Crop* tool (see pages 84–85) to compose the figures within the frame and also to create oval or rounded compositions. The way you arrange the figures while shooting will later suggest a square, oval, or circular format for the overall image. But you need to decide first how best to show off the group as a whole, and the dynamics within it, to the best advantage. As these images show, changing the composition reveals different aspects of the group members' characters.

FACT FILE

When photographing a group against a visually busy background, you need to use focussing creatively to separate and lift the foreground figures away from it. The most effective way of achieving this—and one that has been used for years in portrait photography—is to use the zoom lens and the widest aperture setting. This creates a shallow depth of field, which limits sharp focus to the subject and blurs the background.

Children

This shot risked looking too posed or contrived, despite its playful, everyday aspect. The shot works as the children are distracted by a third person, rather than looking into camera.

Capturing children focussing intently on something away from the camera, perhaps a sporting activity, a friend, or a family pet, often tells us much about their personalities.

For the family photographer, children are a wonderful source of visual invention and pictorial surprise. If you want to expand your repertoire of compositions, simply take time to photograph children at play. They will create compositional arrangements that will surprise and delight, moving about to form countless patterns and shapes as they play. When you are creating your record of childhood, do not forget to include the places, people, and objects that play an important role in their lives, because in the future these will be important reminders of childhood past.

So many pictures of children are still, posed portraits. While a formal study can be a delightful memory, it is also important to capture the essence of all those special relationships that the child builds with family and friends, and this is best done informally. A good strategy for preserving evocative mementoes of childhood is to photograph children at play with friends, or involved in an activity with their favorite toys or in their favorite play spaces. Children will also appropriate whatever comes to hand as a toy and invent imaginative games to fill their surroundings, using objects and spaces in novel ways—the spoon becomes a wand, the box becomes a rocket—leading to many creative possibilities.

Another alternative, and a more imaginative way to approach photographing children, is to step back and recall one's own childhood relationship to the world. Imagine how you felt about spaces like the woods, a puddle, or under the stairs, the little things that seemed magical to you when you were a child. The world is seen in detail by a child, and their imagination inhabits all the little spaces that we no longer see as adults; to a child, a patch of moss can be a mini forest. An interesting challenge is to photograph the world, bearing in mind the detail seen by children. Ask them what they are thinking as they are playing, because their answers can often illuminate how differently they see the world. Their responses can suggest surprising and inspiring ways of photographing childhood.

One of the defining characteristics of children is their emotional attachment to, and relationship with, toys and other personal objects. So photographing them at play will tell you much about their emotional lives.

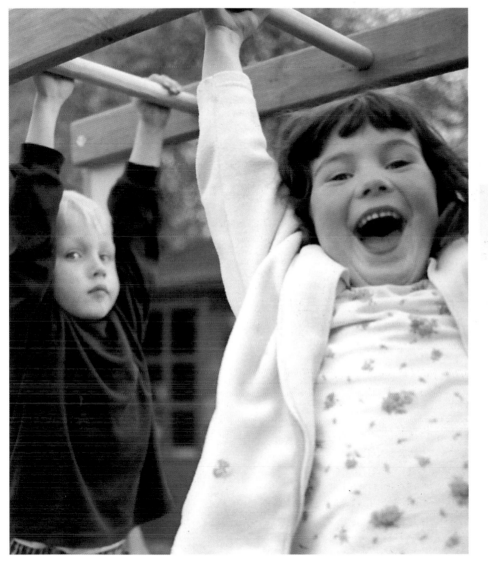

Even if you set up a shot such as this by actively encouraging children to play on a climbing frame, you will still get the results, as the activity of play will dominate their concentration.

Children either love sport, or see it as a chore they would love to get out of. Photographing children at moments of sporting pride—or otherwise—in their full regalia always has good value.

FACT FILE

Imaginative settings

When photographing children at play, use zoom for details and wide angle for group shots. Children are associated with color for good reason—they are surrounded by color in the clothes they wear, the toys they play with, the décor of their rooms at home, at school, and in the playground. Make use of colorful and imaginative settings to photograph the children.

ATTACHMENTS AND FRIENDSHIPS

Think of the relationships that are significant in the child's life, and take photographs as mementoes of their bonds and friendships. This includes their parents, siblings, grandparents, and friends, as well as their pets and favorite toys, which are often invested with personalities. Photograph the places of importance to them, such as their bedrooms and toys, their favorite play spaces in the park or the beach. When you include the children themselves in these shots, you catch them in a variety of different settings and moods, including great action shots, quiet scenes while they are engrossed in play or resting, and of course in angelic (or not!) slumber. If you capture children at such definitive moments, you will reveal much about their personalities and their relationships, and they are less likely to be self-conscious about your intrusion into their secret worlds with the camera.

Babies and toddlers

Toddlers and babies will stay put if they're given something to occupy them, enabling you to prepare a two-shot like this.

Watching a baby learning about the world is one of the pleasures of capturing them in their formative years on camera.

Babies and toddlers are notoriously difficult to photograph in a formal sitting. Unless you are gifted with that rare child who arrives in the world with the angelic photogenic knack of sitting still and smiling on cue, you will need to employ a few devious strategies. The most expressive shots occur when the infant is responding to stimuli. Make sure that, even if you are not calm, the child is relaxed and distracted by something. Wherever possible, enlist someone close to the child into the temporary roll of photographer's assistant so that you can concentrate on catching that enchanting, elusive smile.

PHOTOGRAPHING BABIES AND TODDLERS

Babies feel most secure in their carer's arms, and this is where you will be able to catch the very young baby's animated responses to the carer. Position them in a soft light and take close-ups using zoom. The form of a baby's head is beautifully smooth and sculpturally compact. A stronger light source from a lamp or window can catch the beauty of their rounded contours and the details of their features. Get in as close as possible.

TODDLER'S PROPS

Professional photographers have devised all sorts of ways to achieve animated and expressive photographs of toddlers and young children by using props or a third party to distract their attention. If a parent or carer is standing out of camera shot, talking to them or showing them something to distract their attention, you can concentrate on catching the expression. An alternative is to photograph a small toddler in a playpen, surrounded by all the toys that will occupy their attention. It is often best to distract them deliberately.

ANTICS AT MEAL TIME

Baby in the high chair at meal time is a source of great shots, as the baby will be seriously occupied with experimenting with food. These mealtime antics offer you the chance to take some great sequences for their album, as the baby gets a faceful of food, plays with it, or becomes frustrated by the experience of trying to eat. A further advantage is that you will have time to frame and expose the shot well.

Catching the emerging emotional bond between a young child and a newborn sibling or close relative reveals much about the older child's ability to make new ties. The compositional possibilities are good for relaxed, angled two-shots.

> Soft focus and a color cast add to the success of this charming shot of a baby at dusk. Choose strong angles for intimate shots.

> (Below, right) The very different lighting here suggests that it's wake-up time for this one. A shot to treasure in future.

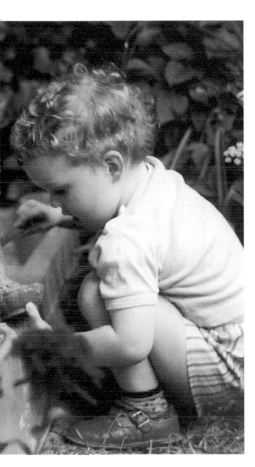

NEWBORNS AND SLEEPING BABIES

The easiest shots are when the baby is sleeping, and they are some of the most precious. Every parent cherishes memories of studying their child asleep. As a photographer, you can take the time to compose the image with care, almost approaching the child in the manner of a still-life subject. Take some time to arrange the lighting. By placing a lamp near to the scene, you can pick out all the contours of the child's form. Do close-ups of the face and hands, and don't forget the delightful row of toes arranged like new peas in a pod. But if arranging the lighting artificially is not really an option—you might disturb the child, after all—you can always use blinds or drapes to create shadows and diffuse the light. Also, early morning or late afternoon light has a strong, identifiable character. Use it.

EXPLORING THE WORLD

To toddlers the world is a place of fascination, and everything must be explored, touched, tapped, and sucked. Take time to follow them on their exploration of their environment and get down to their level. The continuous shooting mode can help you make a small but fascinating action sequence. A low angle and deep focus will really convey the impression of a glimpse into their world as they see it.

TIP If you can, grab shots of sleeping babies at key times of day—early morning, late afternoon, —as the light will have a strong character.

Parties and special occasions

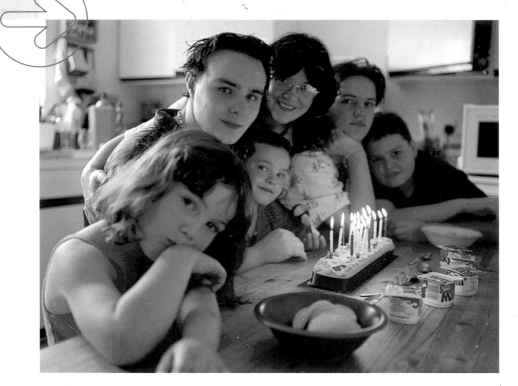

Taking the table at an angle is an excellent way of gathering a group, but also of framing an interesting composition with deep focus and strong angles. Take time to set it up.

Decorating the tree is, for most of us, a treasured childhood memory from when Christmas was a thrilling experience. Take time to capture the eyes and the reflected lights.

TIP Don't spend too long trying to set up the perfect shot of a big group of toddlers, as the moment will pass very quickly!

Parties and special occasions, punctuating the year, form an important part of the family album. During festive holidays or celebrations of birthdays or anniversaries, a photographer has a chance to capture special moments and family relationships. If the event is in celebration of an individual or a couple, you will spend a large part of your time focussed on them, following them as they enjoy the occasion. You will also want to take group images, employing different strategies and techniques to arrange the best images.

It is good idea to vary your approach throughout the event. You can gather everyone together for a formal group shot at an appropriate moment, such as a toast or presentation of a gift, the cutting of a cake, or the blowing out of candles. At other moments, it is important to move around unnoticed, in order to observe the different relationships and friendships at play in the group.

LIGHTING

Outdoor daytime parties and occasions are little problem, but evening events, parties, and special occasions indoors are likely to present lighting challenges. There may be a time during the event when all the lights are turned on, such as during a toast or the presentation of a gift, and this is a time you might be able to work without flash. If the lighting is tungsten, you will need to adjust your camera settings, using white balance *(see page 22)* and checking that the ISO setting *(see page 20)* is high enough to record the ambient lighting without the shutter speed dropping so low as to create image blurring.

So many party photographs concentrate on key moments—it pays to keep an eye on what's going on in the background too. Shoot the children playing quietly in the corner, or the reactions that emerge when the presents are opened.

Shots like this of Gran with the kids will almost certainly be some of your most treasured images in future, as they go right to the heart of family life. They will rarely be perfectly composed, but catch moments in time forever.

USING FLASH

If the occasion is a dance or a cocktail party when the lighting is low, you will need to use flash. Use the redeye setting if your camera has this option. This produces a double flash that stops the pupils of your subject glowing red. If it is a big occasion in a large venue, an external flash can provide extra power to illuminate a larger area. Bear in mind that using flash rapidly depletes battery power, so be prepared with spare batteries because it is deeply frustrating to run out of power midway through an occasion. If you haven't used your camera for a while, and you have left your batteries in the camera, they will likely have drained down, so check them in advance, leaving yourself enough time to recharge.

FACT FILE

Enlisting a junior assistant

One strategy that can result in some charming shots is to give the camera to a child and supervise him as he takes photographs. If you put the camera on auto settings and make sure the camera is on a strap so he can't drop it, you will surely end up with some delightful shots, as people respond joyously to the young photographer. With a digital camera, he can fire away without fear of wasting film. He may take shots at odd angles that add to the charm—you can always crop and straighten the images later *(see pages 84–85)*. Even a small child will quickly master the use of the camera, using the LCD, and he will be immensely proud of his achievement when you show him the photographs in Review mode.

Weddings

◄ *You can plan shots like this with a reasonable degree of certainty, but once the action is happening, there's no going back!*

▼ *Don't expect the bride and groom to pose just for you—there will be lots of competition. But it still makes for a memorable image.*

THROUGHOUT THE DAY

The early-morning preparations present good photo opportunities, but usually the last thing anyone appreciates at the time is the presence of a photographer. This is a case for applying the fly-on-the-wall technique, quietly catching a few shots as people go about their business.

ARRIVING AT THE CEREMONY

Assess the best vantage points in advance for taking discreet shots at predictable moments. On the day, make some prefocussing and pre-exposure settings so that you can do some rapid shots of the bride and groom arriving. Such moments are unrepeatable.

The informal family photographer at a wedding has a special function—to catch all those memorable moments that the professional wedding photographer will not be commissioned for, or have time to photograph. A beautiful gift to a newly married couple is an album of all the events of the day, throughout the preparation, ceremony, speeches, gift giving, dancing, and family exchanges. Many of these special moments occur before or long after the professional photographer has left the scene.

PREPARATION

You need to be well prepared, with enough battery power and memory cards to last the day. You might want to consider using an additional flash gun; particularly when dealing with large groups over a distance, the built-in flash will sometimes be inadequate to illuminate the scene fully. Also, the built-in flash can quickly deplete your battery power.

PLANNING YOUR PHOTOGRAPHY

It is a good idea to ask the couple for a list of who and what they would like photographed. Using this list as a guideline, remain alert, because sometimes, in all the excitement, some really special people may slip through without a photograph. As much as possible, plan a sequence of venues and events that you want to photograph, so that you have a framework for your shoot. But do not let this constrain your creative instincts.

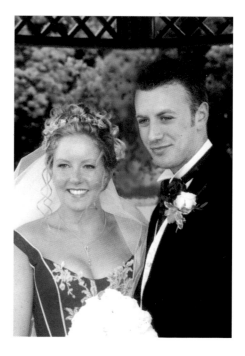

All too often, wedding photographers can ruin people's memories of the big day by constantly interrupting the action to pose formal shots. A better strategy is to take constant, informal shots throughout the day to capture what really happened.

LEAVING THE CEREMONY

The archetypal image of a wedding is the moment when the bride and groom exit the ceremony amid showers of confetti, smiles, and commotion, before the professional photographer organizes the group shots. These are key moments, so use the continuous shooting mode to catch the action.

WORKING IN TANDEM WITH THE PROFESSIONAL PHOTOGRAPHER

The professional photographer has a difficult task organizing everyone into a shot. While everyone is waiting for the formal shots, you have a great opportunity to catch those

Weddings are unique in that most are designed to have formal photo opportunities alongside all the ceremonial aspects

and the many informal moments. Agree with an organizer where these might be, and take time to set up the camera first.

informal moments when the couple or group relax between the professional photographer's takes. Also, this is the time to catch some of the people who are not in the formal shots. No one will leave for the reception before the bride and groom, and the professional photographer will require a half hour to take their shots, giving you a captive audience.

DURING THE RECEPTION

Children will get bored and vacate the table, especially during speeches. This is a good time to catch them playing: informal shots of children in their best, formal party clothes are always charming

Grab shots like this when you can, and do not be too precious about composing the shot. If you are lucky, you will get a truly magical composition,

such as this one. It is a matter of taste whether to set up the camera with a fast shutter speed to freeze the moment, or go for a slower exposure, as here.

Following the formal meal, there is often a lull when guests move around and chat. This is an ideal time to take relaxed shots of relations, and also to shoot the gifts table.

During large weddings, old acquaintances are often renewed, and there are many joyous reunions among old friends or family members. As an informal photographer, and one with insider knowledge, you can be on the lookout for these priceless moments.

THE SEND-OFF

It is usually evening when the bride and groom finally depart the reception, so you will need to be prepared with a flash setup. Take a couple of test shots before the couple arrives so you can get the right level of flash. You can work this out as you take shots of the more mischief-minded friends and family as they redecorate the bride and groom's car.

Even once the bride and groom leave, it is a good idea to keep shooting, so that you can keep a record to show them how the evening ended in their absence.

Holidays

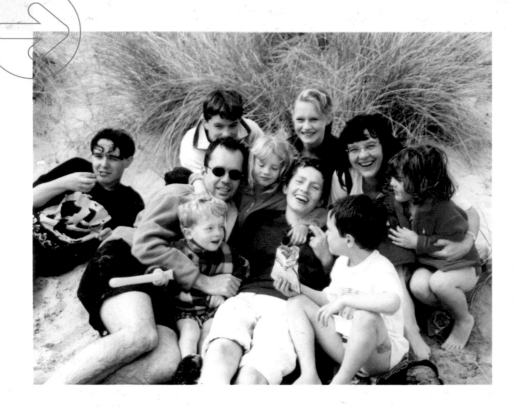

People are more likely to stay in photographable groups on holiday, so you will have the time to set up a shot such as this one.

Beach holidays offer unique opportunities for compositions that place people in dramatic perspective against sea and sky.

For the photographer, a holiday offers an opportunity to relax and explore the creative use of the camera. Some people choose this time to buy a new camera, because they will have time to familiarize themselves with it. Whatever you choose, this is a chance to have fun with your photography. Make sure you take your camera manual with you for reference so that you are not constrained by unfamiliar technology. (While we are on the subject of what to remember, don't forget your battery charger—and a mains adapter if you are going abroad.)

The images of happy family memories in the holiday album are always treasured. The holiday album has a special role in charting the life of the family, recording so many of the highpoints of family life, and measuring the passing of time as members of the family grow up. During holidays, the family is really together, playing, relaxing, and communicating. There is the excitement of going somewhere different and the pleasure of recording new sites and experiences, all of which can be relived when you review the images.

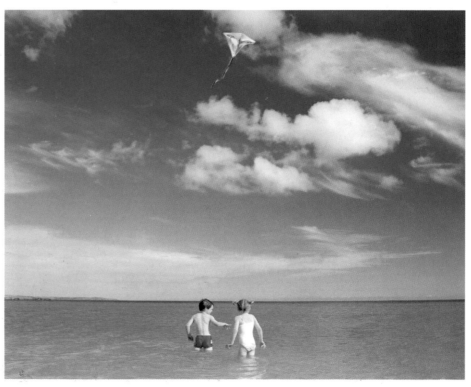

Fire off a sequence of shots at the pool. People move slowly in water, so you will not have to refocus too much. The complex play of light, form, and color in water is always good to capture, as are all those unselfconscious antics.

There are so many ways in which you can vary your holiday photographs, from action shots of fun activities, to group portraits and individual studies of the characters of the family. Because many of us spend more time than usual in the great outdoors when we are on holiday, this is a good time to explore the possibilities of different lighting and atmosphere in the landscape, and to seek to create a family photograph set against an outstanding scene. This is also when you can try out new techniques and master some of the more complicated procedures of taking motion shots or refining your skills in controlling exposure as for backlighting.

MEMORY

Having enough memory to store all the photographs you will be taking over a week or two is a crucial issue with digital photography. While digital offers you in-camera editing to remove unwanted images, your memory card will soon fill up, especially if you are taking images at normal or fine (for prints) rather than at basic resolution (for the web or onscreen viewing). Taking a laptop onto which you can download images is one solution, but it isn't necessarily a good idea. The easiest solution is to find a cheap source of memory cards. It is well worth searching the internet, as there are many excellent low-price sources.

CAMERA CARE

Digital cameras are sensitive to harsh treatment, so keep the camera around your neck to avoid dropping it onto hard surfaces. With most digital cameras, one severe knock is enough to cause camera failure. Don't leave your camera exposed to rain, salt water, or excessive heat. Worst of all is exposure to fine sand that blows unseen into the zoom mechanism. It is worth investing in a good-quality camera bag to protect your gear from the elements. Particularly useful is one with a detachable bottom, which you can use to hold external flash unit, battery charger, and leads.

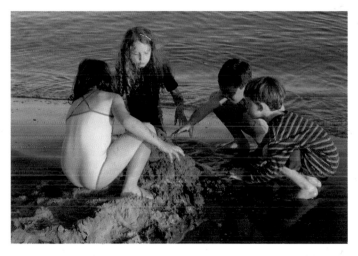

City trips are a golden opportunity for grabbing truly memorable shots—beaches have a tendency to look similar the world over. Children will pose for a one-off moment like this.

If you are having a day trip to the beach, or a resort holiday, use the beach and the sea to frame moments between the children in close-up. These are shots to treasure.

But don't forget the adults in your rush to capture the children. Intimate moments like this between parent and child are perhaps the ones you will look at many times—and so will your child.

Sports events

ACTION SHOTS AND BLURRING

Speed, motion, and adrenaline are subjects to explore using the skills of panning and composing action shots. Use Continuous Shooting mode and flash photography to catch the action (*see page 45*). To avoid blurred images, you will need to use shutter speed priority and set the camera on a higher shutter speed of 250–500th second.

Sometimes, however, blurring will add to the drama of the image. If you use a slower shutter speed of 60th of a second and move the camera to follow a rapid action, you will catch some of the subject in sharp definition, while some of it will blur.

Standing on the touchline of a sports field as you watch someone you love competing is a mixed pleasure. However, during the gaps, in between cheering encouragement, it is a good time to explore the use of the camera. Sporting events offer great photographic possibilities and a host of visually varied and exciting compositional arrangements. The fast action of racing and competitive sports events is animated by strident colors and shapes, and these qualities create great patterns and visual drama in a composition. In contrast, other sports events, such as gymnastics, can produce beautiful sculptural compositions on a par with the elegance and poetry of ballet.

Photographing sports events doesn't always have to result in dramatic action shots, since just as many sports are motivated less by competitive striving than by the desire to attain a skill or to work in partnership. Many popular activities are really about balance and control, such as horseriding, skiing, skateboarding, wind surfing, sailing, golfing, cycling, and so on. Some outdoor sporting events also present great opportunities to explore scenic venues, from the sea, lakes, and rivers of water sports, to the snow and mountains of skiing, or the simple beauty of parks, woods, and fields when riding, jogging, mountain-biking, and walking.

Remember that not all sports have to be daytime events. A floodlit game of soccer at dusk provides good opportunities to capture not just the action, but also the drama, saturated colors, and stark shadows of the setting. It's also a predictable light.

Getting behind the goal creates the impression that you're in among the action, and you'll capture images of great tension, motion, and dynamism. If there are nets, focus through them for effect.

TIP When photographing group sports, add impact by lining up shots with the zoom lens to fill the frame with action.

Skateboarding is one of those sports that cries out for some blurred action—it adds to the excitement of

watching an expert really showing off his skills. Also, rundown urban scenes and subways all add to the trendy image.

USING THE ZOOM FOR ACTION SHOTS

Professional photographers will have a telephoto lens the size of a howitzer positioned on a tripod. This gives a clue to one of the key techniques of successful sports photography—you will need to use a zoom lens to catch the action, because half of the time the action will be down the other end of the field. Even standing on the touchline will not get you close enough to the players without the aid of a zoom. Because most of the real drama will happen near the goal or nets, this is the best place to position yourself to get some bold close-ups of the action.

USING FLASH

The flash can be used for dramatic effect. When the action is in range, either inside or outside, you can use flash to freeze the action, because the flash illuminates the scene in 1000th of a second.

If it is not a sunny day, or if the action is inside, you will need to set the camera on a higher setting of 200–400 ISO. With indoor events, such as gymnastics, ice skating, hockey, or basketball, you definitely need to set a higher ISO because you will be using a fast shutter speed to catch the action.

At some sporting events, you will not be allowed to use your flash because it could distract the competitors. At other times, because of distance, the flash can't reach the action. In these circumstances you will need to work within the ambient artificial light, which will usually be biased toward yellow. This is a good example of a time to adjust the white balance to compensate for the color cast of artificial lighting *(see pages 22–23)*.

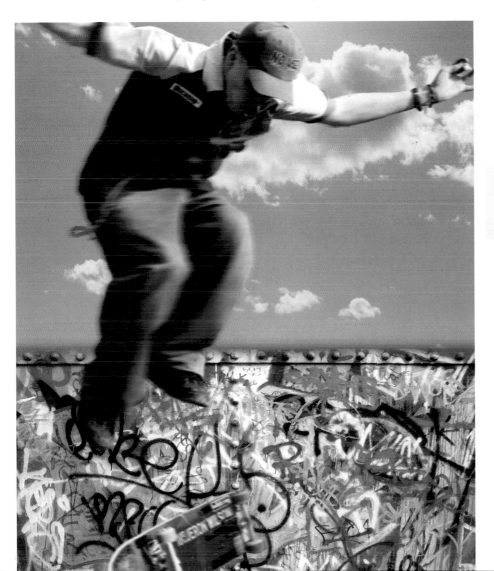

FACT FILE

Photo essays and group shots
Sport is also about cooperation and building community spirit, a time when strong bonds and friendships are formed. This makes sporting events a good opportunity for a character study or a photo essay. Try catching a few images of the friends and family members of the competitors as they watch the action—their faces will display the full range of emotion as the game seems to be going one way or the other.

A day in the life: a single subject

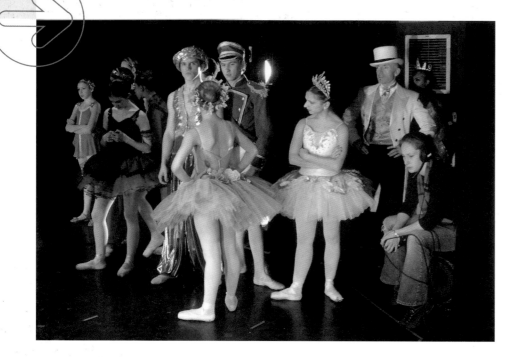

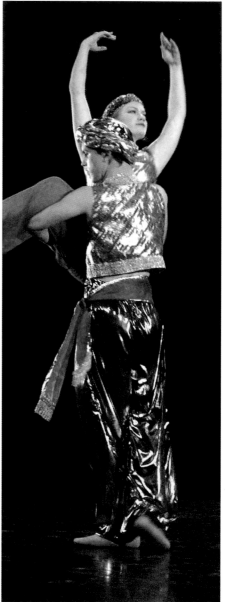

Backstage is the perfect environment to show a group of people "in their own space," waiting to perform. The real drama behind the drama.

Using a fast shutter speed, and a wide aperture to capture the light without flash, this shot really grabs a fleeting pose for posterity.

There are special events in family life that highlight one person in the moment. So, why not record a day in the life? We often miss good opportunities to photograph the people and places that have filled an individual's life, either through work or their passions—areas of their lives which they participate in away from the family. But because they are actively engaged in it, they don't have the opportunity to photograph the activity themselves. These important memories are often lost, or not shared with the family. They need you to photograph them in action. It may take a little negotiation, but the effort will be well rewarded with unique shots.

I wanted to photograph my second son as he was performing in Tchaikovsky's *Nutcracker* ballet. I wanted most of all to create a personalized memento of the performance which would be more focussed on him than the professional photographs which the company was selling. As with most professional and semiprofessional productions, there was no photography allowed during the performance, so I negotiated to attend the dress rehearsals. If you offer a free copy of your photographs to the organizers of an event, they will often be more than pleased for you to make a record as they themselves will often be too busy to take photographs. Also, they know that everyone else will be looking for photographs of their members of the family. You can download the photographs onto a CD, which they can then use to create their own prints and maybe use some of the images for future publicity.

The dress rehearsal was an opportunity to take photographs of the performance at close quarters and also to photograph my son between scenes with the other performers and friends. From a creative point of view, the theatrical lighting, costumes, and props formed a wonderful opportunity to explore different

The silence of digital cameras, compared to the noisy shutters of traditional cameras, means that theater performances are not disrupted. Digital works well in modestly low light, without flash.

Classical dance is all about exposing the beauty of angles, curves, and points, the highest mark of physical excellence. A fast shutter grabs these moments.

The mix of color, movement, and poised forms that is ballet. This is the perfect opportunity to explore the drama of physical motion with blur.

photogenic compositional arrangements, from the striking shapes created by the bright spotlights through to the subdued lighting of waiting in the wings. This is where the digital camera excelled, in that I was able to take dozens of shots of each of the scenes. I didn't use flash because I did not want to distract the performers. In particular, catching the action was made easier because of the camera's ability to work so well in the relatively low light. Using the zoom to move in and out on the different scenes, I was able to get both close-ups and wide-angle shots of the performance.

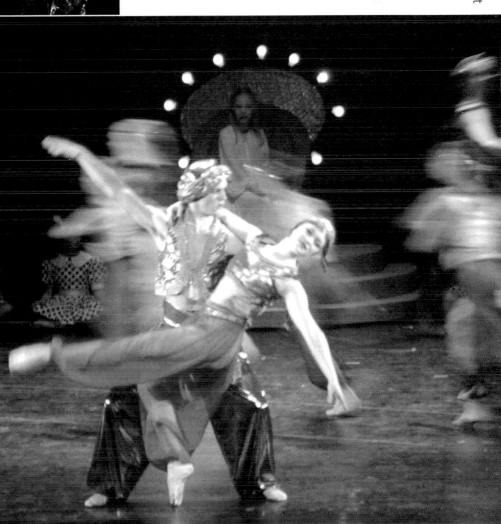

A day in the life: a family

An informal moment is a more potent memory than a posed shot. The advantage of boats is that your immediate environment is fixed and predictable—it's the landscape that moves!

Lying in the back of a boat gives you all the time in the world to set up the camera perfectly for the duration of the trip. Your choice is whether to pull the landscape into focus, or your fellow travelers...

Some of the most memorable days are those when the family goes on an outing, and these are times when you really want to create a photographic memory for the album. Sometimes the events that stay with us fail to be captured in photographs. This is because the photographer has not kept up with the action, but has stopped the flow at intervals for posed photographs in which everyone's attention is called to the camera. The key to creating photographs of future memories is to try to capture people when they are absorbed in the scene.

In order to make a major improvement to your compositions, let go of the attitude that if you haven't got someone's face fully in the frame, it isn't a proper record of them. The frontal photograph is not the only form of portrait. As a parent you spend a lot of time behind your children, both physically and metaphorically, keeping up with them, watching over them. So for this set I wanted to include a series of views that caught this parental view of childhood, from the back. What is surprising is how much expression is held in body posture.

You don't need to see an individual's face to read attitude—posture will tell the story.

In this set of photographs, fathers and uncles are taking sons and cousins on their first fishing trip on a lake. It was a day guaranteed to become a vivid childhood memory. Because there are lots of other photographs of the children's features in the albums, what I wanted to do was to combine images of the children with what they were seeing—that is, to combine a visual image of their view of the scene with my view of them.

These two images show that a traditional "family snapshot" with the subject centered in the frame is no match for these bold compositions that are achieved through playing with shapes and making striking visual contrasts.

◀ *Both these images show that your pictures need not be full face. The strong shapes of the outfits against the shifting scene are striking enough.*

▼ *These waterlilies pick up and contrast with the life jacket's shape and color, while this angle on the boat really makes the picture. Don't be afraid to fill the frame with a strong theme, then play with it.*

The children loved the drama of being in a boat, and as the high expectation of catching a fish subsided, they became absorbed by the mesmerizing movement of the water, by the passing birds and insects, and by the beauty of the scene. The water lilies held a particular fascination. Their unspoken reverie and companionship was conveyed in their postures, interrupted only by the excitement of finally landing a fish.

On days like these, you can be tempted to interrupt the action and force everyone to pose. This spoils it for everyone, including you. You will find much greater pleasure in sitting back and observing through the lens, taking the time to explore forms, thinking about juxtapositions, and coming up with new ways to frame the scene.

> **TIP** → Abandon all thoughts of taking dull, centered shots when you are presented with a shifting vista of a boat trip. Be more creative.

A day in the life: a family

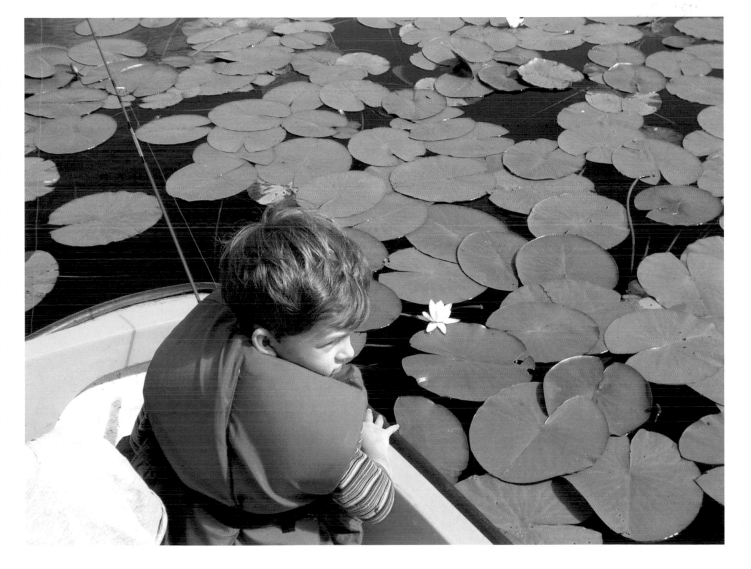

A picture essay

When you review a batch of photographs that you have shot over a day, you will often have enough material to edit into a story sequence, making a photo essay. With the freedom that digital photography gives you to take so many photographs, you can set out with the deliberate aim of narrating an event without being concerned about wasting film. The great advantage of digital is that it lets you relax into taking runs of shots, knowing you can later edit down into expressive sequences.

Using the Continuous shooting mode on your camera, you can create narratives that unfold over seconds. Alternatively you can stretch out a narrative over hours, days, or even weeks. In this way you can create a

1 In the first frame, I have caught the child in reflective pose, in close-up, examining the ragwort for caterpillars.

Taking a photograph is just another way to tell a story, using a visual language. Every photograph catches a moment and in that moment is held a world of visual details that eloquently expresses our feelings and relationship to a subject. While a single photograph will express your relationship toward a particular subject, a sequence of photographs is also a story that narrates the way you see your world. Put two or more photographs together and you have begun to construct a mini-narrative with a "before" and "after." Put a sequence together and you have constructed a photo essay.

2 In the second frame, she is animated by the surprise of a moth alighting from the flowers, and she gestures to catch the moth in flight.

Running the four frames together like this really tells the story. But you can see that here I've chosen to crop into the pictures to focus on the narrative elements, and concentrate less on the landscape.

photographic story that can either stretch or compress a story over time.

Because pictures tell stories, they also suggest stories. While you can arrange your photos into a kind of photojournalism, which truthfully documents an event, you can also let your imagination play with the images to create new story lines. You will find that as you move your photographs into different sequences, you can create story lines that both amuse and stimulate the imagination. It is interesting to note that film-makers create similar photo essays in the form of story boards made from still photography and drawings as they plan out and play with potential visual narratives.

We are used to viewing stories in different formats, whether in a book with pages to turn in sequence, in a time sequence in film, or in a linear or collaged grouping of images. A grouped arrangement is a simple but powerful format that lets you see all the elements of the story at the same time, even though the natural tendency is still to read the images from the top left to the bottom right as you would a page of text.

The process of editing a photo sequence is not dissimilar to making a short film, as you arrange photographs into a story line in an album on your desktop. You can tell a story about your subject, or you can focus your attention on trying to express their point of view. That is, by catching them in a certain pose or attitude, you can capture something of the way they—your characters—see the world. This was my intention in the sequence of photographs of the young girl chasing a burnet moth over the dunes.

Every story will have a beginning, a middle, and an end, even a very short story, such as this photographic sequence, which was edited down to four frames.

This is a good example of the mantra "less is more," and an example of the need for a strong editing vision. If you try to capture every nuance of every part of the story, you risk losing the story. Boiling it down to a few significant frames can say much more than ten times the number of frames. Think of the way picture stories or comics work.

TIP Picture essays can work on different time scales. Capturing an expression over a few seconds is as valid as following your subject for a day.

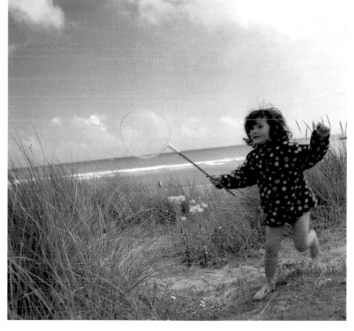

3 In the third frame, she has found an abandoned net and runs to catch the moth. I have deliberately left this composition askew as the diagonal line of the horizon adds to the immediacy and spontaneity of the shot.

4 In the final frame, the child proudly presents her catch to the camera—an impressive feat, given the holes in the butterfly net.

Shooting for post-production

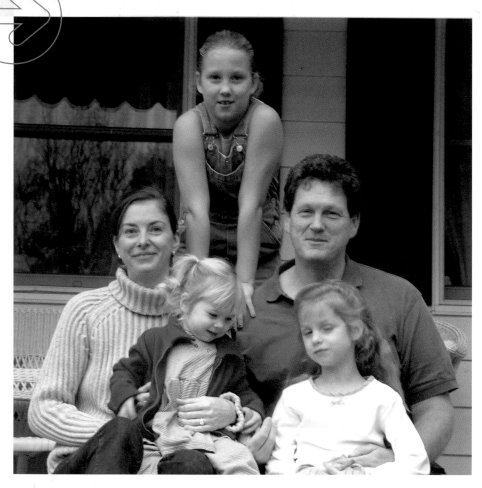

1 In each of these two shots of the group, one or other member was either distracted, not caught in a favorable expression, or they blinked.

Shooting for post-production is all about planning for the digital editing stage. Shoot more rather than less, as you will optimize your chance of getting a good image. A tremendous advantage of digital is the ability to edit images using layers. This means that you can add and remove elements from your compositions, or build a composite image from the best parts of several images. You can add effects and compensate for lighting errors.

THE BENEFITS OF MONTAGING

It is extremely difficult to get everything right in a group shot. You are trying to take a good shot of all the individuals in the scene, and just as one looks good, the chances are another individual in the group is looking away or spoils the shot by a sudden movement. All too often one of the group blinks. As well as the problem of managing all the group to look at their best, you have to get a correct light reading against an attractive background setting and then compose the whole in a pleasing composition! You can see why it is a tall order. With these difficulties in mind, it really pays to take a variety of shots of the different component parts of your intended image, so that you can edit and montage the best images into a perfect whole.

TIPS ON THINGS YOU NEED FOR MONTAGES OF A GROUP

It is important to take shots at different light readings so that you can choose the images with the best definition. Vary your angle and take shots from different positions. Also, take shots of the group and of individuals.

You need to take as many shots as possible of the group, with a view to combining the best of each into a single image. Another useful tip is to take a shot of the scene without people, so that you have a spare background in case you later decide to delete people or move them about. As you remove anything from a scene, you create a hole in the image. If you have a spare background shot set in a layer behind the image, this will show through any hole you make.

Digital image editing lets you have the best of all possible worlds, by selecting either the best elements from a scene and montaging them together, or editing out and replacing distracting parts of a good image.

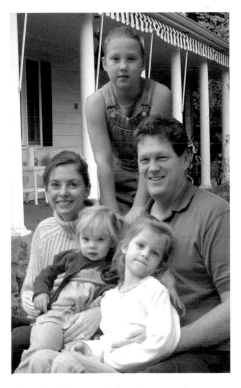

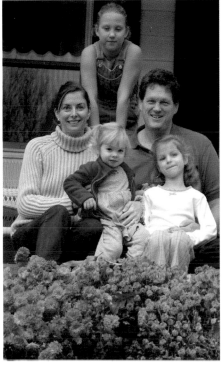

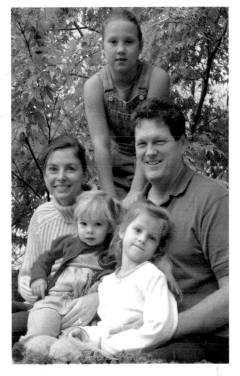

2 In this example, I really wanted to present them with a decent group photograph, so this was clearly a case for montaging the best shots of the family members and then placing them against different background images from their house, and grounds. I had photographed the group in front of the house but this presented problems in that the porch area where they had positioned themselves appears dark and unattractive as a setting.

3 I took other photographs of the front of the house and grounds and initially tried montaging the group onto the image of the house in the background, but this too looked unattractive because the pillars on the porch created too strong a visual structure, which detracted from the group.

4 It was fall and the surrounding trees were dressed in outstanding colors, so I decided to montage the best images of the group against a separate shot of foliage and to take the foreground flowers from another shot and montage this into the final image, which I also cropped into an oval arrangement.

TIP Shoot "coverage" images, which you can use to fix holes or correct errors if you fail to get the perfect shot on camera first time around.

RECAP

Ⓐ Once you have posed your group, take as many shots as possible of them.

Ⓑ Don't discard images from the camera at this stage—review them later on your computer. Review them and look for the best overall shot, and also strong individual details.

Ⓒ Consider whether the background shows the group off to its best advantage. Is there a background from another shot —or a specially shot background— that you could drop in later?

Ⓓ Consider making a composite image of the best elements, or removing distracting elements from the shot.

3 Digital darkroom techniques

The capabilities of the digital camera are only part of the digital photography revolution. Further possibilities have been opened up by the advent of inexpensive image-editing applications that enable you to correct, retouch, and totally rework your digital photographs. While this will require you to learn new skills, these won't take long to acquire. What's more important is that you can still apply your vision and imagination in this new realm of creative opportunity.

Image-editing software

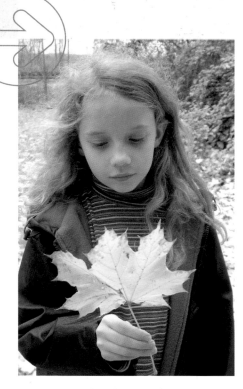

This shot is perfectly acceptable as an image, if a little bit posed. But one of the joys of image-editing software is painting with the elements...

For example, you could cut out the girl with the leaf, and position her on a layer. Then on a layer beneath, use a shot of similar leaves whose colors you

have inverted or changed and drop it in the background. Or clone the leaf itself and paint it in the background. There are infinite possibilities.

This version is sightly easier on the eye... a shot of fallen leaves on the ground, with new colors delicately picked out, adds context to her pose.

A digital camera lets you take a digital photo, but it's only with a computer and image-editing software that you gain complete creative control. Every digital camera comes with some software to download the images from the camera onto your hard drive. If it's more advanced, the software will also help you to organize and save your images, enable you to make basic crops, alter brightness, or make other alterations such as removing redeye. Both the Microsoft Windows and Apple Macintosh operating systems also contain their own downloading, slide show, and cataloging functions.

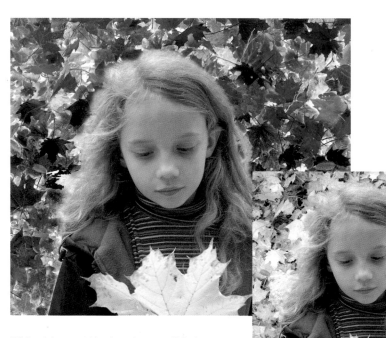

While this sort of basic software will help you get photos onto your computer, stored and printed, real creative control takes something more powerful. Professional picture-editors and designers use something like Adobe Photoshop, which enables you to alter nearly any aspect of an image or create seamless composites from several different images. Such packages are undeniably powerful, but they are also take years to learn and several hundred pounds to buy. Unless your ambitions and budget are running high, you would do better to take a look at something less expensive, and more novice-friendly.

The best such package at the moment is Adobe Photoshop Elements, a cut-down version of Photoshop. While it has many of

that package's powerful features, Elements swaps its professional publishing options for a more approachable look and feel with plenty of help for beginners. Windows users might also consider JASC Paintshop Pro, which offers similar image-editing power, or other entry-level budget packages such as ULead PhotoImpact or Roxio PhotoSuite. Many cameras, computers, printers, or cameras will include older or stripped-back versions of image-editing programs, and these can give you a starting point before you step up to something with more power.

With image-editing software you can go to whatever extremes you like and remake the world as you would wish to see it, or simply use it to correct color casts, blemishes, poor lighting, or redeye problems caused by flash at night.

This playful shot of a group of boys in an outfit that's half gangster, half "Two Tone" is a delightful, and characterful, study. But the background and that doorway detract and distract from what could be a truly classic image. Load up your image-editing suite, and you're on the way to a work of art.

Whichever software option you start with, you will soon discover the truly remarkable advantages of digital image-editing software, namely being able to create images with a depth of color well in excess of your normal processed photos, access your photographs within minutes, and create and store hundreds of images without expense. Once you have

TIP It's fun to experiment with image-editing software, and you can be as subtle or as inventive as you like. But remember to save a copy of the original image first!

Take the elements of the image that work— the fun picture of the three boys—and throw out everything else. Why not turn it into a pop image using this diagonal blend of color?

mastered the basics, you will then want to explore some of the more advanced features of image-editing software's astonishing capacity to alter and refine images. With relative ease you will be able to make alterations to potentially great images that didn't quite work because of some flaw in the original composition. Image-editing software enables you to make both subtle and creative alterations to achieve a professional level of photography.

This software effectively emulates a photographic darkroom. In fact, the tools in the software are organized and denoted with symbols which connect them to the physical operations that would take place in a professional photographic studio. You can crop and rotate, make basic color and tone adjustments, remove color casts, burn and dodge to darken and lighten areas of a composition, or mask areas to remove and add pictorial elements.

In the past, these operations took time, training, and access to specialized equipment and expensive materials. But nowadays, image-editing software lets you make alterations to color and tone with a level of ease and speed undreamed of by previous generations of photographers. Software such as this is, to put it simply, your own digital darkroom without taking up space, and without the need for expensive chemicals and messy processing.

Other levels of creative manipulation are unique to digital image-editing. You can organize images in layers, which act like transparent overlays stacked on top of each other. This enables you to digitally montage and collage different images. Then there are a range of filter effects, some of which mimic photographic lens filters and others which are borrowed from the world of fine art printmaking and graphics. Some are entirely unique to the digital world, and can sharpen, blur, or distort photographs in ways that you would never think possible.

Image-editing software

Rotating and straightening

DSCF0026_1.psd @ 19.2% (Background co|

19.21% Doc: 12.4M/24.7M

Image Enhance Lay
Duplicate Image...
Rotate ▶ 90° Left
Transform ▶ 90° Right
Crop 180°
Resize ▶ Custom...
Adjustments ▶ Flip Horizontal
 Flip Vertical
Histogram...
 Free Rotate Layer
Mode ▶ Layer 90° Left
 Layer 90° Right
 Layer 180°
 Flip Layer Horizontal
 Flip Layer Vertical

DSCF0026

 Straighten and Crop Image
 Straighten Image

19.21% Doc: 12.4M/24.7M

Since few of us get every image perfectly straight every time, tools for rotating and straightening images are crucial attributes of even the most basic image-editing program. Because most compositions are framed by a rectangular box format, any lines that deviate from the vertical will be very noticeable and will disturb the balance of the composition. While diagonal lines create movement and lead the eye into the composition, vertical and horizontal lines create stability and act as the foil to the lines of movement. For this reason it is important to take care with the alignment of the vertical planes and the horizon with the edges of your composition in your photographs.

1 The most basic rotation tools let you turn an image around so that you can view it the right way up on the desktop. When you are taking pictures, you will naturally turn the camera between a horizontal landscape format and a vertical portrait format. However, when you download your images onto the desktop, the images in portrait format will appear on your screen on their sides. These images need to be rotated by 90° clockwise or counterclockwise to view them the right way up. The software that comes bundled with digital cameras or printers provides basic rotate and crop facilities, as does Apple's free iPhoto software. Within Photoshop Elements, you can get a quick 90° rotation by selecting the *Quick Fix (Enhance > Quick Fix)* option. Select *Rotate* in the adjustment category and either the *90° Left* or *90° Right* option, according to your photo.

Keystoning occurs when you photograph a scene from an acute angle, where the vertical lines in the image appear to converge or skew. This is the Elements *Skew* correction tool at work. Go to *Image> Transform > Skew* to select it, then click in the appropriate corner of the bounding box and drag it out to correct the keystone effect.

STRAIGHTENING SKEWED HORIZONTALS AND VERTICALS

The *Quick Fix* is fine for turning portrait pictures the right way round, but not as useful in situations where you need to correct the skew caused by a shot taken at a slightly off-kilter angle. For this, you need the more advanced *Custom Rotate* option.

Rotate Canvas

Angle: 3 ⦿ °Right OK
⭘ °Left Cancel

2 The *Custom Rotate* tool enables you to make more precise adjustments by rotating clockwise or counterclockwise in increments of degrees, which you type into the *Angle* box. This is essential, because you will find that most of your images will be slightly askew and would benefit from being rotated by as little as one-half, one, two, or more degrees to re-align the image to a true vertical.

FACT FILE

Flipping to rework compositions
The *Quick Fix* rotate option has another trick up its sleeve: the *Flip* command. This literally flips the image over, either vertically or horizontally. The horizontal *Flip* command is particularly useful as a creative tool for exploring which way your composition works best. Most people unconsciously read an image from left to right. Because of this, images featuring strong diagonal movements are read as descending when they run from top left to bottom right and ascending when they run from bottom left to top right. Also, figures will be read as looking forward when they face to the right or backward when looking to the left. You can use this convention in your own compositions.

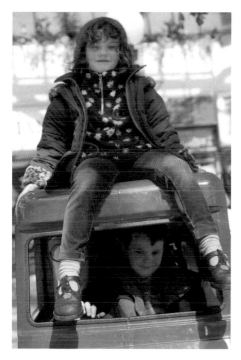

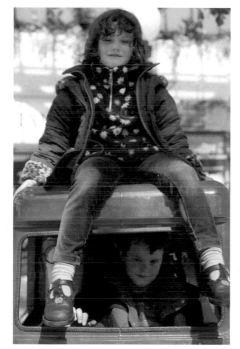

1 This quick snap captures a playful moment, but the composition would work better if the shot were level. The degree of skew isn't actually that high—it works out at approximately 3° from the horizontal. To straighten it back up, select *Rotate > Custom* from the *Image* menu.

3 It usually takes a little trial and error to get the image straight, so take your best shot and then, if necessary, select *Undo* from the *Edit* menu and have another go. In this case, 3° was the magic number. After you've rotated, you'll need to crop to get straight edges on your image. Turn the page to find out how.

Cropping

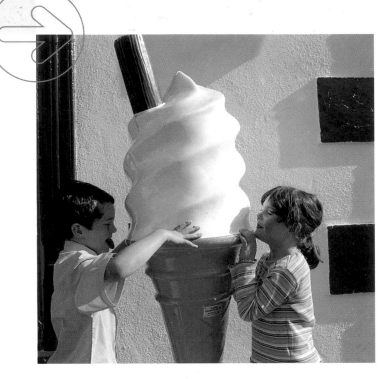

In the image of the two children pretending to eat a giant ice cream, I cropped the image to create a balance of positive and negative shapes. Successful cropping is a balance between framing and sympathetic proportions.

USING THE CROP TOOL

1 Open your image on and select the *Crop* tool from the *Toolbar*. Position the cursor at a point to the top left of the area of the image that you want to crop and then drag the marquee diagonally across and down to the right until you have framed the crop area. As you release the mouse button, the crop shape is defined in dotted lines with squares on the sides and corners. This is referred to as the crop marquee or bounding box.

Cropping refers to the process, or rather the art, of trimming a photograph so as to make precise adjustments to the proportions of an image. It enables you to compose or to reinvent the way the subject is framed in the photograph. When you frame an image in the viewfinder, the frame is a fixed proportion. By using the *Crop* tool in digital-imaging software, you have greater freedom to select and try a range of compositional formats and proportions for an image, adjusting the *Crop* tool from vertical to horizontal, from oblong to square, or you can use the *Marquee* tool to crop an image into oval and circular compositions.

While the general aim is to frame images successfully at the time of taking the photograph, the image will sometimes need subsequent adjustment to achieve a well-balanced composition. As with most of the basic editing in digital software, this is now a simple and efficient procedure. Because you can easily make copies of an image, the process is instantly reversible, letting you create and save variations of compositional crops from an image. The *Crop* tool enables you to locate the marquee anywhere in the image, and to rotate the marquee so as to take a crop at an angle to the original format. This effectively combines the *Rotate* and *Crop* facilities in one action.

A key skill is to judge the amount of space around your subject. Cropping effectively zooms in on the subject. The more you trim, the closer you will draw the viewer in. From a composition point of view, cropping adjusts the proportion of negative background shape to positive foreground shape (the subject). Successful cropping is a balance between framing the image and creating a sympathetic proportion for the subject in the composition.

TIP Many digital camera "viewer" programs provide a basic crop facility. The limitation with these systems is that you can make only a basic crop to the image, without the rotate option or options other than a rectangle.

DIGITAL DARKROOM TECHNIQUES

Cropping slightly farther in from the image, far left, produces this more dramatic composition, left. You can see also that the crop we are making in the first image is not entirely rectilinear. You can correct the camera angle too!

Shade the cropped area

2 In the *Options Bar* you can tick the *Shield* checkbox, which overlays the uncropped area with a semitransparent mask set to gray as a default. This mask lets you see the effect of the crop more clearly while still being able to see the remaining image outside of it.

3 You can reposition each edge of the selection by placing the pointer onto the little squares, called handles, which are located at each corner and at the midpoints of the bounding box. You can increase and decrease your selection by clicking on the handle and dragging the line of the bounding box inward or outward. You can also constrain the proportions and maintain the same aspect ratio by holding the Shift key down as you drag on one of the handles. To reposition the bounding box and change the area to crop, click and hold inside the marquee, then drag it to the new position

4 You can also rotate your image while you are cropping. This can be an effective way of dealing with images that are skewed to a small degree. To rotate the marquee, position the pointer outside the bounding box and the pointer will turn into curved arrows. You can now precisely rotate the image to complete your crop.

5 To crop the image, you can click the *OK* button, click the big tick in the *Options Bar*, or double-click inside the marquee. If you want to cancel the operation, click on the cancel symbol in the *Options Bar*.

TIP Some midrange digital cameras have a facility built into the camera image review software that enables you to crop the image in the camera. While this lets you make fairly crude crops on an image, it is generally better to wait until you have downloaded the images to your desktop software.

RECAP

Ⓐ The initial crop
Drag the marquee diagonally across and down to the right until you have the crop area correctly framed.

Ⓑ Refining it
Increase and decrease your selection by clicking and dragging the bounding box by one of the handles.

Ⓒ Adjustments
Rotate the Marquee by moving the pointer outside the box, then clicking and dragging when it turns into curved arrows.

Sharpening filters

In the image of a boy painting, the photograph was originally taken at a wide angle and on a fully open aperture to minimize the depth of field. This created an out-of-focus background that directed attention to the child and the toy soldier on the table. I applied the *Sharpen* filter to increase the definition in the features of the child and the toy in front of him, so as to increase the contrast between the high definition of the face of the child and the out-of-focus background. Later on I found this shot also worked very successfully as a study of intense concentration with a tight crop in on the boy's face and a more "widescreen" style of frame to the composition. Decisions like these are a pleasure of image editing.

Sometimes a photograph will appear out of focus for a variety of reasons, including using a shallow depth of field, low light and a slow exposure, camera shake, or poor focus due to subject movement. An image can also lose definition as it is edited, developing softer edges and blurred definition. In either case, the solution is to apply the *Sharpen* filter, which adds focus and clarity to the image.

1 You can apply the *Sharpen* filter simply by using the *Quick Fix* tool, selecting *Focus* as the *Adjustment Category*, and choosing *Auto Focus* in the *Select Adjustment* column. Click *Apply* and examine the effect in the *Before* and *After* preview windows, then click *OK* to apply the filter. You can apply the filter more than once to increase the sharpness, but bear in mind that applying the filter more than twice to an area of an image will begin to increase noise.

While the original shot had a lot going for it—the composition, the boy's expressive concentration—it was not quite sharp enough to really grab the attention. A tight crop helps.

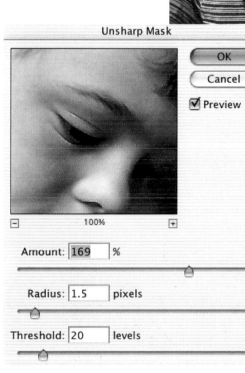

Unsharp Mask

OK

Cancel

☑ Preview

100%

Amount: 169 %

Radius: 1.5 pixels

Threshold: 20 levels

2 A more refined method for applying the *Sharpen* filter involves selecting *Sharpen* from the *Filter* menu in the *Menu Bar*. As you open *Sharpen*, a sub-menu will appear to the side of this window, listing four *Sharpen* filter options: *Sharpen*; *Sharpen More*; *Sharpen Edges*; and *Unsharp Mask*.

Sharpen automatically applies a set level of sharpening in the same manner as the *Quick Fix* option and is simply applied by highlighting and releasing the mouse button. The *Sharpen More* filter works in the same way but applies a slightly stronger sharpening effect. *Sharpen Edges* is applied the same way, but sharpens only the pixels at the edge of forms.

3 The last filter, *Unsharp Mask*, allows for very precise control of the degree of sharpening under the headings of *Amount*, *Radius,* and *Threshold*. Practice using it, and you'll never touch another sharpening tool. These categories have defaults that you can adjust by moving the pointer on the slider bar. Watch the preview to see how the changes affect the pixels, and for when noise begins to occur.

4 The *Amount* controls the level of sharpening. The *Radius* controls the distribution—try moving it up from the default if you're working on a large, high-resolution image, or down if you're working on a small one. *Threshold* limits how sharpening works on large areas of continuous color. Adjusting it upward can help if your sharpening is badly affecting areas of skin tone. This image needed a high *Amount*, a lower *Radius*, and a small *Threshold*, but every image is different. Experiment, then press *Apply* when the image looks sharp enough.

TIP
→ You need to apply this filter with moderation, because an excessive application will create visual noise. Noise is the term used to refer to the speckled appearance created by too much tone and color difference in pixels. Keep your eye on the preview window.

Fixing over- and underexposure

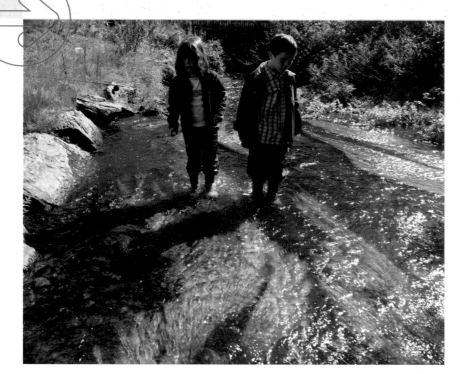

1 In the case of this image of children in a brook, the high contrast between the children in shadow and the brightness of the water caused the camera to expose for the brighter tones, and consequently the children, and particularly their features, are too dark. To fix this sort of image, click on the *Quick Fix* option in the *Menu Bar*.

2 In the *Select Adjustment Category* column, you need to select *Brightness*. Select the *Brightness/Contrast* adjustment from the second column. You can adjust either setting in the third column by moving the slider to increase or decrease the level, or by typing values into the appropriate box.

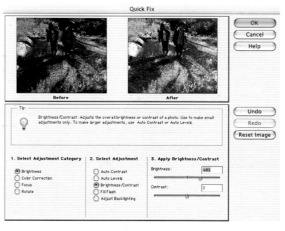

Fixing over- and underexposure is necessary when the camera has incorrectly exposed for a scene. This often occurs when shooting a scene that is divided by areas of high contrast—that is, between a bright area and an area of deep shadow. When the camera is set on auto-exposure, it will set the exposure for the overall image based on what the camera exposure meter reads through the center point of the lens. If the camera exposes for the shadow, the area of light will be overexposed, and conversely, if it exposes for the light, the shadows will be underexposed. Exposure problems also occur when using flash.

FIXING UNDEREXPOSURE

There are several ways of fixing exposure problems within Photoshop Elements, but the simplest and quickest way is to use the *Quick Fix* option. This will fix 90% of faults—for the other 10% you might need to work directly with *Levels*.

3 For this image the contrast levels are already quite good, so they did not need altering. Because the image was too dark, however, I needed to adjust *Brightness* upward by 43%.

There is a degree of under- or overexposure that cannot be rectified. If you have heavily underexposed an image, some shadow areas will fill in as black and only the midrange and lighter tones will contain detail. Similarly, if you have heavily overexposed images, the brightest areas will fill in as white and contain no detail.

FIXING OVEREXPOSURE

To fix overexposure you need to repeat the same procedure, moving the slider on the brightness to reduce brightness. In this image of mother and child, I had overexposed the image because of too strong a flash setting. This commonly occurs when photographing with flash at close quarters. I applied an additional 20% tonal contrast and reduced the brightness by 20%. Note that in this image, the lightest detail in some areas of the child's jumper has filled in as white and cannot be adjusted.

USING LEVELS

Brightness and contrast adjustments won't fix every exposure problem. When you adjust either or both, the effects take place across all the tones in an image. This can lose you warmth, color, or detail, usually in the highlights or the deeper shadows. A more refined way of fixing exposure is to use *Levels*.

Open Levels by pressing Command-L, or by picking *Enhance > Adjust Brightness/Contrast* and choosing *Levels* from the submenu. The *Levels* dialog opens with a histogram of the tonal range in a photograph, which visually shows you the balance of tones from the lightest tones through the midtones to the darkest tones. In a well-taken photograph the histogram will show a more even distribution throughout the tonal range, sloping up to peak in the middle. In a photograph that is under- or overexposed, the distribution will be bunched up more to one end of the histogram.

There are three arrows under the histogram: a black one for the darkest tones, a gray one in the middle for the midtones, and a white one for the lightest tones. The beauty of *Levels* is that you can precisely adjust any part of the tonal range by sliding each of the arrows independently. For example, you can lighten or darken the midtones without moving the lightest or the darkest tones. With the *Preview* box ticked, you can watch the effects update in real time.

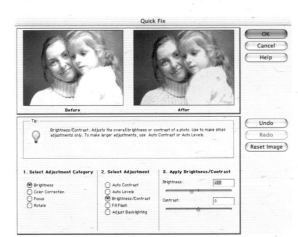
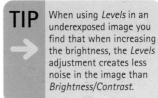

TIP When using *Levels* in an underexposed image you find that when increasing the brightness, the *Levels* adjustment creates less noise in the image than *Brightness/Contrast*.

This image was nearly there, but in places it was excessively bright where it should have been warm and natural. A Quick Fix was all it needed.

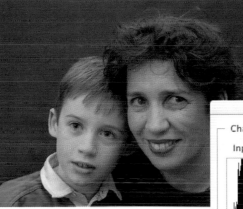

1 With its dull colors and lack of highlight detail, this shot shows all the signs of a slight underexposure.

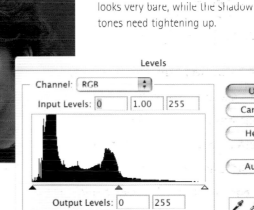

2 Open up the *Levels* dialog, and you can see that the highlight end of the histogram looks very bare, while the shadow tones need tightening up.

3 If you concentrate on the main peaks of the histogram, you can fix many *Levels* problems by moving the black slider to the right until it sits under the start of the first upward slope, and the white slider to the left until it hits the end of the last downward slope. In this case, pushing the black slider slightly to the right and the gray slider to the left adds some extra contrast to the final image.

Fixing over- and underexposure

Optimizing contrast

Optimizing contrast is a simple but essential procedure if you wish to improve the overall tone of your digital photographs. For most makes of camera, when you download your images into the digital–editing software, many of the images will appear to have a somewhat flat tonal range. Depending on the light levels in the original subject, some images will appear to have a faint, pale gray cast and lack depth of contrast. You can rectify this by applying two simple commands.

AUTO CONTRAST

Auto Contrast adjusts the overall contrast and mixture of colors in an image, making the darkest parts of your image deepen in tone toward black and the lighter parts lighten in tone toward white. *Auto Contrast* increases the tonal range, evenly distributing the intermediate tones, so as to increase the overall depth of contrast of the image. In most images, it will perform this feat without significantly altering the color values. It is wise to use this command after you have corrected the color in the photograph.

1 A combination of winter light and dominant white tones has given this image a slightly flat overall image without much depth or contrast.

2 The quickest way to the *Auto Contrast* adjustment is to go straight to the *Enhance* menu in the *Menu Bar* and select *Auto Contrast*. The adjustment happens immediately.

3 Alternatively, go to *Enhance* and select the *Quick Fix* tool. The advantage of using *Quick Fix* for your automatic adjustments is that you can preview the effect using the *Before* and *After* windows, and switch quickly between different adjustments to see which one works best.

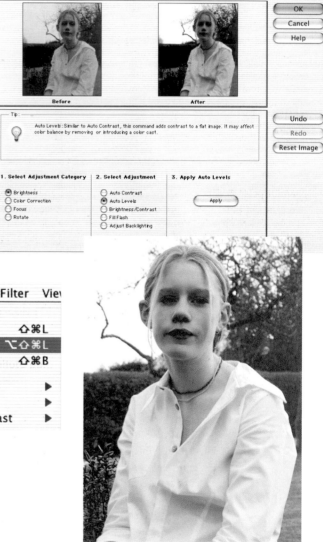

4 *Auto Contrast* has succeeded in adding some tone into the image, and this photo looks much warmer and more natural as a result of this relatively simple change.

Awkward color casts and dull areas can render many a good composition flat and lifeless. But there are several ways to turn a problem image into a vibrant, stand-out image that makes a strong statement about its subject matter.

AUTO LEVELS

Auto Levels is similar to *Auto Contrast* in that it adds contrast to a flat tonal range. However, while *Auto Contrast* alters and deepens the tonal range of the image, but leaves the colors alone, the *Auto Levels* command will also significantly alter the color balance. This command needs to be used with care, because it may introduce a color cast as it adjusts the color balance of the image. Using the *Quick Fix* tool means you can preview the impact of the adjustment in detail. Using *Auto Levels* will adjust the color balance of the image: for example, in an image taken in a yellow-biased light, where the highlights have a yellow color cast, it will correct the color bias back toward white.

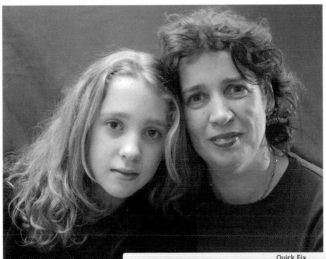

Optimizing contrast

3 Switch to the *Auto Levels* adjustment to deal with this one. If you use the *Quick Fix* tool, you can switch quickly between the two to see which is more effective. As you can see from the *Preview* window, *Auto Levels* dispenses with the red overtone.

2 Using *Auto Contrast* would improve the image by adding some depth and contrast back into the image, but it goes only so far and doesn't do anything about the prominent color cast...

1 In this fairly informal portrait, the problems include a slight orange/red color cast and a lack of both highlight and shadow detail. We can solve both of these problems using *Auto Levels*.

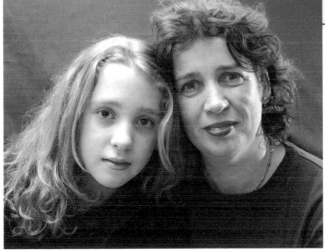

4 Here's the result. The highlights stand out more, there is slightly more detail in areas of shadow, and the color cast has gone for good. As a bonus, the two subjects now stand out more clearly from the background.

Fill flash and backlight adjustment

The *Fill Flash* tool literally acts like a low-level flash on the scene—it will illuminate and reveal all the details that were lost in the shadows. This is a handy remedy for an image that has lost detail in the shadow through being underexposed. It is quick and easy to apply.

1 To fix this underexposed image, I tried to cure the fault using *Auto Contrast, Auto Levels,* and the *Levels* tool, but *Fill Flash* provides a speedy and controllable alternative.

2 To get to *Fill Flash,* click on the *Quick Fix* icon in the *Menu Bar.* Select *Brightness* as the *Adjustment Category,* and *Fill Flash* from the *Adjustment* section. In the *Apply Fill Flash* section, you can adjust both the degree of *Lightness* and the level of *Saturation* for the fill flash. Move the sliders to increase or decrease either setting.

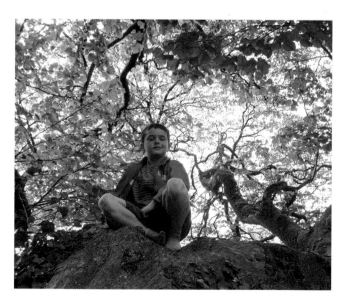

3 For this image, I adjusted the *Lightness* up by 20%. However, while increasing the *Lightness* of the image brought out the details in the shadows, it also made the color look washed out. To remedy this, I also increased the *Saturation* by 20%. This adjustment enabled me to put the strength of color back into the shot.

The makings of a fine picture are lurking in the shadows here, along with this boy in a tree. It's a good composition with a strong pose and plenty of texture. The solution is to apply a software version of fill flash to light the scene anew.

BACKLIGHT ADJUSTMENT

Use the *Adjust Backlighting* option to bring out the details in the background of a photograph, because it darkens brighter areas, except whites, in the image. This is a good option to use on a photograph that has good definition and tonal balance in the foreground subject, but a background that looks bleached out. If the photograph initially lacks contrast, apply *Auto Contrast* from the *Quick Fix* options before applying the *Adjust Backlighting* command. In most cases, the use of two or three remedial features combined may be the best way of sorting out problem images. Every picture is different.

2 Go to the *Quick Fix* tool and select *Brightness* from the *Adjustment Category* column. The *Adjust Backlighting* option sits just below *Fill Flash* in the *Select Adjustment* section. The only control to worry about in the *Apply Backlight* column is the *Darken* slider.

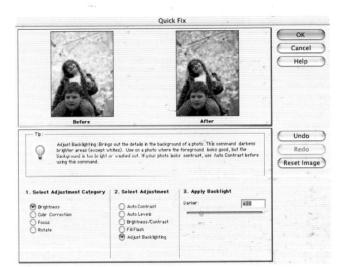

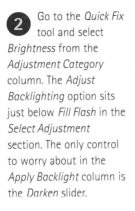

1 This shot shows exactly the sort of qualities where *Adjust Backlighting* can really help. While a good shot overall, the detail in the background just isn't there.

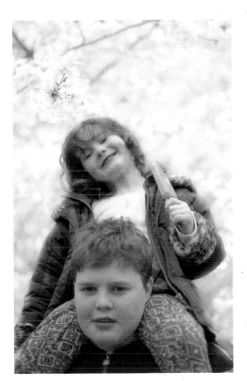

3 In this case, nudging the *Darken* slider up to +20 is enough to do the job. Note how the green leaves and the blossom on the trees have emerged from the pale background, adding detail without distracting from the subjects in the foreground.

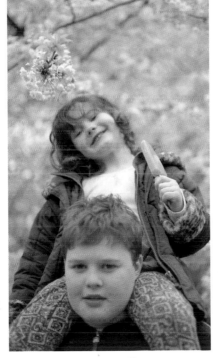

RECAP

A A good foreground image, but the background is bleached out.

B Find *Adjust Backlighting* under the options in the *Quick Fix* menu.

C Nudging the *Darken* slider by up to 20 points pulls the vibrant detail out of the background and brings the image back to life.

Dodging and burning

Dodging and burning are terms borrowed from the photographer's darkroom. In film-based photography, photographers would use bits of card, cut to shape, to mask areas of the print from the light falling from the enlarger lamp. This enabled them to "burn," overexposing areas to create more shadow and detail, and to "dodge," underexposing ones, to create lighter areas. Today digital tools mimic these processes. You need to use the *Dodge* tool when you want to adjust small areas of your images that are too dark, and the *Burn* tool to adjust areas that are too light. The beauty of these tools is that you can adjust the tonal areas in parts of your photographs without affecting other parts.

BURNING EXAMPLE

1 In this image the camera exposed well for the granddaughter who was in slight shadow, but the grandmother is overexposed and bleached out toward white. I needed to darken the tones in the grandmother's face and jacket to balance the tonal values.

2 Click on the *Burn* icon in the Toolbar. Look for the sponge icon, click it, and the cursor will transform into a circle. This circle is the size of the tool, which can be adjusted in the brush options in the *Options Bar*. It is better to work with a brush size that approximates to the size of the area to be burned. In this case I decided a brush size of 97 pixels was appropriate.

3 You also need to set the tool's *Exposure*. If the exposure is too high, the impact will be too drastic and will create an unnatural difference in the image. The aim is to adjust the tone subtly. For this reason you need to work with an *Exposure* of 50% for very light areas and for darker tones lower the *Exposure* to 20% and less. The *Burn* tool enables you to work either on the highlights, the midtones, or the shadows. In the case of this image, both the midtones and highlights needed to be darkened. You can see straight away from the initial results that our overly celestial grandmother has now begun reassuming her more earthly form!

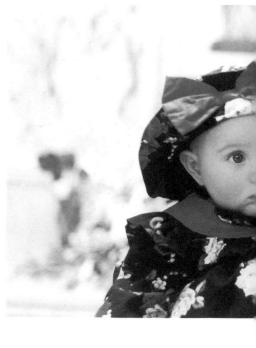

Seascapes with brilliant sunlight and complex reflections create difficult backlighting conditions to get a good exposure on figures in the foreground. You can make subtle corrections in lighting using *Dodge* and *Burn* tools.

4 You need to move the tool gently from side to side to avoid creating noticeable differences between the areas adjacent to the area you are burning. For this reason, it is a good idea to select a brush with a feathered edge. As you burn, keep checking that the image is not over burned. If you overburn, you can step backward in the *Shortcut Bar* or undo your last move in the *Undo History*.

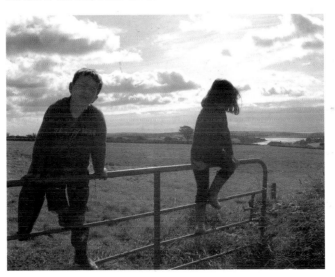

5 With areas of the grandmother's face darkened, there's an improvement in the overall tone and balance of the image, but the child's face and clothing haven't lost anything in terms of color or vibrancy.

DODGING EXAMPLE

1 In this image of children on a farm gate, the camera exposed for the sky and the landscape. Because the children were backlit against the sky, their features are too dark. I needed to lighten the tones in the boy's face in order for the image to work fully. I also used the *Clone Stamp* tool (*see page 98*) to remove the bag at the side of the boy's head by sampling pixels from the sky and painting them in over the bag to get rid of it.

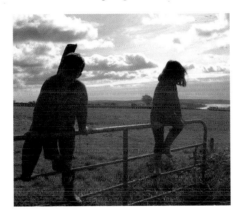

2 Click on the *Dodge* icon in the *Toolbar*. It looks like a lollipop. Click it, and the cursor will transform into a circle. This circle is the size of the tool, which can be

adjusted in the brush options in the *Options Bar*. It is better to work with a brush size that approximates to the size of the area to be dodged. In this case a brush size of 83 pixels was appropriate. As with the *Burn* tool, you also need to set the tools *Exposure*, and choose which tones the tool will work on. Again, if the *Exposure* is too high, the impact will be too drastic and will create an unnatural difference in the image. You want to make a more subtle adjustment. In this case, I chose an *Exposure* of 14% and set the tool to lighten the midtones and shadows.

3 Follow the same tips with dodging as you would for burning. Move the tool gently from side to side to avoid creating noticeable differences between the areas adjacent to the area being burned, and use a brush with a feathered edge. As you dodge, keep checking that the image is not overlightened. If you do overlighten it, you can step backward in the *Shortcut Bar* or undo your last moves in the *Undo History* palette. As you can see here, the process improves the visibility of the childrens' features, but the landscape behind them hasn't lost any of its luster.

Removing color casts

2 Now take a look at the thumbnail buttons below the *Before* and *After* windows. Here, you can decide which thumbnail best represents the way you want your image to look, then click on it. The thumbnails are for each of the channels, either red, green, or blue, and the last thumbnail is for the degree of lightness.

A color cast will often spoil an image. Removing color casts is an essential skill in managing color editing. Color casts occur when the lighting is biased toward a particular color, often toward yellow or red. The most common causes of a color cast are when a scene is illuminated by the setting sun, dulled by the low light at dusk, or when a subject is photographed in tungsten lamplight without using the white balance feature in the camera settings.

1 To get rid of this kind of overtone, open *Color Variations*, represented on the *Quick Fix* bar at the top by three overlapping circles. Start by selecting the *Brightness* value you want to adjust, choosing either the *Midtones*, *Shadows*, or *Highlights*. Then drag the *Amount* slider to increase or decrease the degree of change. In the case of this image, I selected *Highlights* and left the *Amount* slider at the default setting.

SNOW IMAGE
In this image of two friends playing on a toboggan, the low afternoon winter light has created a marked gray-pink color in the snow. I wanted to bring back the brightness of the image and to remove the red tint in the color cast, as it did not look natural.

The color cast in the image, far left, brought a blush to the snow and too much of a wintry glow to these girls' faces. Using *Color Variations*, you can undo the effects of difficult lighting conditions in an otherwise good image.

BOY'S PORTRAIT

In this portrait image of a young boy in his best clothes, lamplight had created a marked yellow color cast. I wanted to correct this color cast to white light and also to increase the brightness of the image. Using *Color Variations*, I selected *Highlights* again and left the *Amount* slider at the default setting. I selected the thumbnail preview for *Increase Green* twice and blue three times to eliminate the orange color cast in the image. I also increased the brightness by clicking on the *Lighten* thumbnail three times.

3 In the case of this image, I selected the *Decrease Red* thumbnail once and the *Lighten* thumbnail twice to arrive at the correct degree of brightness for the image. This got rid of the color cast, but kept the image looking warm and bright. When you are satisfied with your own alterations, click on the *OK* button.

▲ *Here's our original shot: near perfect, but with a wan color cast spoiling it.*

▲ *The* Color Variations *preview presents you with a range of preset options for counteracting color casts. Just click the one that suits best.*

▶ *Here's the corrected portrait after color correction. The differences are subtle, but the image has come to life and looks more natural.*

TIP As you click a thumbnail, you will see the change in the preview windows above the thumbnails. The original image is also shown next to this displaying the alterations.

Simple retouching

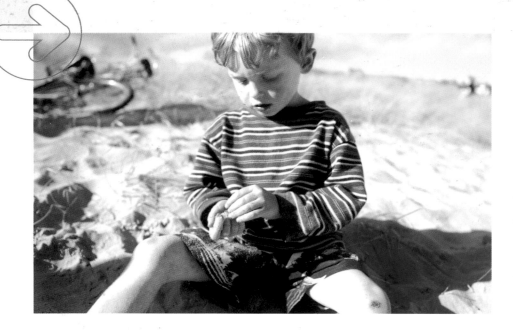

A fine image may be spoiled by a skin blemish, such as grazes, bruising, spots, or other marks, which can be both visually distracting and unflattering to the subject. While sometimes you might want to leave marks, in the interest of creating an accurate record, at other times it may detract from the simple charm of an image. A little discreet image editing can make a big difference, without making too much of a "cosmetic" change to faces or skin tones.

USING THE CLONE STAMP TOOL

The *Clone Stamp* tool copies an area of skin tone (or any other group of pixels), which you can then stamp over the offending area to cover the blemish. This tool has other uses, too, enabling you to remove all sorts of imperfections in the photograph, as well as to copy larger areas, such as trees or clouds, which you can print and even repeat in an image. In this case, we'll just use it to patch up an old war-wound on this young scamp's knee, which is too prominent in the foreground.

1 Before you can get to work, use the *Zoom* tool or the zoom control in the bottom left-hand corner to enlarge the area around the blemish, so that you can work on it comfortably. Now select the *Clone Stamp* tool—not the *Clone Pattern* option—from the *Toolbar* and select a brush with soft edges in the pop up palette in the *Options Bar*. Adjust the brush size, using the slider, to a diameter just larger than the size of the blemish—in this case, 20 pixels.

2 Move the tool onto an area of skin next to the blemish, hold down the Alt button on the keyboard, and click and hold down the mouse—the brush will change shape to a smaller circle with crosshairs in the center, indicating the target area you have chosen to clone. Carefully move the brush onto the area of blemish and release the mouse. When you now click on the area of the blemish, you will see the parallel area under the crosshairs being cloned on top of the blemish. Now, patch up that wound!

3 Keep brushing the cloned texture over the blemish until it's gone. It's often better to reduce the *Opacity* of the clone to ensure a better blend with the surrounding skin tones—there's a control for this in the *Options Bar*. If you're working on a large area, move the clone point from time to time by Alt-clicking on a different area. This avoids recognizable patterns emerging. In this case, the cloning process is quick and easy, and after two minutes the scab had disappeared entirely.

TIP You can apply this tool either aligned, so that the area being cloned is always parallel to the tool, or unaligned, which means that the point you select is more flexible.

DIGITAL DARKROOM TECHNIQUES

Redeye is an ever-present menace to indoor, flash-lit photography, despite the advances in flash technology. But it's bread-and-butter work to fix the problem in even an inexpensive image-editing program. Indeed, there are many presets.

REMOVING REDEYE

Redeye—when the pupils in the eyes glow an unnatural bright red in a photograph—is caused by the light of the camera flash bouncing off the retina in the back of the eye. The redeye effect rarely adds to a photo—more often than not, it's an unwelcome and an irritatingly regular by-product of using built-in flash. Because redeye occurs with such regularity, Photoshop Elements has a simple tool just to solve this one problem.

1 Open your image on the desktop and use the zoom tool to enlarge the eyes to a size big enough to see the pupils and comfortably make adjustments. Select the red eye brush from the *Toolbar* and open a brush in the pop-up palette in the *Options Bar*. Adjust the brush size, using the slider, to a diameter just larger than the size of the pupils of the eyes—in this case, 20 pixels.

2 Move the cursor to the *Options Bar* and click on the button marked *First Click*, which will select the red target color to be replaced, and then move the brush onto the area of redeye and click the mouse button. This will select the redeye color to be replaced. You will see the red color appear in the *Current* patch, and the default color of black in the *Replacement* patch. It is important not to position the little cross at the center of the select brush circle either on the surrounding iris or on any white highlight area, because this will mean that white, rather than the offending red, will be selected.

3 You will also need to set the *Tolerance* of the redeye tool, so that when you alter the redeye area, it does not select and alter the surrounding iris color as well. In the case of blue eyes, you can use a higher *Tolerance* value of 50%, but with brown eyes, which are closer in color to red, you need to set a *Tolerance* of 20% and lower.

4 Move the redeye tool, clicking on the red areas of the eye, and you will see these areas automatically turn from red to black.

5 If the replacement black is not dark enough, you can switch to the *Burn* tool (*see page 94*). Set the brush size to the size of the pupil and the *Exposure* to 20%, and click on the pupil area. With each click, the *Burn* tool will darken the pupils by 20% toward a dense black. When you've finished one eye, repeat the process for the other.

Soft-focus effects

In this photograph of a baby nestling in his mother's arms, I needed to make radical adjustments to the definition of the background. Because the baby was in shade and the background was fully illuminated, the background had sharper definition than the baby in the foreground. This was entirely the opposite degree of focus, requiring a strong application of the *Gaussian Blur* filter.

There are several options in the *Blur* filter submenu: *Blur*; *Blur More*; *Gaussian Blur*; *Motion Blur*; *Radial Blur*, and *Smart Blur*. *Gaussian Blur* is used most frequently, because it primarily adjusts the midrange tones in a selection and also offers you the greatest control over the degree of blur. The other effects are mainly used to simulate certain types of motion, such as on spinning wheels, and fast-moving objects.

Soft-focus effects reduce the amount of focus and definition in areas of a composition. In the camera, you can control focus and definition to a degree through controlling depth of field *(see pages 16–17)*. In this way, you can create a visually soft foil for the sharp definition of the foreground subject. With most digital cameras, however, blurring due to a short depth of field occurs to a lesser degree than in conventional cameras. This is an advantage in shots where you want all of the foreground and background in focus. But when you want a markedly blurred background, especially in a portrait photograph, the *Blur* filter is a very useful tool.

1 Open your image on the desktop, and go to the *Layer* menu. Create a *Duplicate Layer* of the background image and highlight to make this new layer the active layer to work on.

2 Click on the *Select Brush Tool* (A) in the *Toolbar*. Select a brush mode with a soft definition, set the *Hardness* to 5% in the *Options Bar*, and initially select a brush size of 300 pixels (although this will depend on the size of your image).

TIP For final touches use the *Clone Stamp* tool *(see page 98)* to fine-tune adjustments to any edges that need refining.

Layer | Select | Filter | View | Wi
New ▶
Duplicate Layer...
Delete Layer

Rename Layer...
Layer Style ▶

New Fill Layer ▶
New Adjustment Layer ▶
Change Layer Content ▶
Layer Content Options...
Type

Simplify
Group w
Ungrou
Arrange

Duplicate Layer

Duplicate: Background copy
As: Background copy 2

OK
Cancel

Destination
Document: Baby original.psd
Name:

Selection Brush Tool (A)

Enter search criteria | Search | Undo History

Size: 20 px | Mode: Selection | Hardness: 28%

A potentially strong and insightful image, one of those telling glances into the world of frozen motion, is spoiled by the intrusive figure in the background. Blurring the person out creates a depth of focus that draws you into the frame.

3 Select *Mask* from the *Mode* menu in the *Options Bar*, and the *Selection Brush* can now be used to paint a mask. Using the *Color Picker*, select a color for the mask that contrasts sufficiently with the area to be masked, in this case red, and set the *Opacity* to between 70 and 80%. Begin to apply the mask so it covers the mother and baby.

4 As you continue to create the mask, use a smaller brush size of 10 pixels to pick out the contour of the area to blur. If you make a mistake and wander over the edge with the select brush, you can either step backward to a previous state by using the *Shortcut Bar*, or you can reverse the selection procedure by holding the Alt key down as you use the *Selection Brush*.

Filter View Window

Gaussian Blur ⌘F

Artistic ▶
Blur ▶
Brush Strokes ▶
Distort ▶
Noise ▶
Pixelate ▶
Render ▶
Sharpen ▶
Sketch ▶
Stylize ▶
Texture ▶
Video ▶
Other ▶

Blur
Blur More
Gaussian Blur...
Motion Blur...
Radial Blur...
Smart Blur...

5 The foreground area is now protected from the next step, which will be to blur the background area. Select *Filter* from the *Menu Bar* and go down to *Blur*. Select *Gaussian* Blur, and the *Gaussian Blur* dialog opens with a preview.

6 Move the cursor onto the desktop image, and it will take the form of a square. Click on the areas you want to see in the preview window. You can increase and decrease the size of the preview by clicking on the plus or minus symbols at the base of the window. Use the slider control to adjust and increase the *Radius* of the blur to 30 pixels. Click *OK* to apply the filter, and close the window.

7 Before closing the *Selection Brush*, open *Brightness/Contrast* from the *Enhance* menu and lower the brightness of the background by about 32%. Deselect the background, then save and close the image.

Black-and-white and sepia

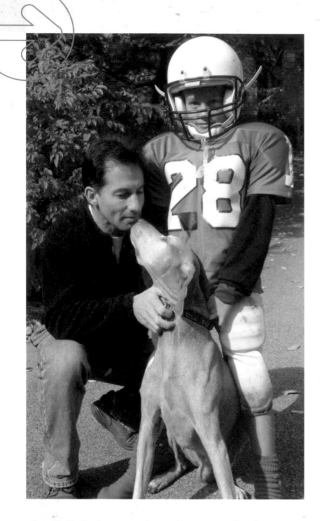

Over the next four steps, we'll take this football-flavored family grouping right from the modern color age, through black-and-white and into antique sepia.

1 Open the image and then select *Layer > Duplicate Layer* to create a copy of the background in the *Layers* palette. Then highlight the new copy layer to make it the working layer.

Layer | Select | Filter | View | W
New ▶
Duplicate Layer...
Delete Layer
Rename Layer...
Layer Style ▶
New Fill Layer ▶
New Adjustment Layer ▶
Change Layer Content ▶
Layer Content Options...
Type ▶
Simplify Layer
Group with Previous ⌘G
Ungroup ⇧⌘G
Arrange ▶
Merge Layers ⌘E
Merge Visible ⇧⌘E
Flatten Image

Duplicate Layer

Duplicate: Background
As: Background copy

Destination
Document: AMERICAN FOOTBALL FATHER AN...
Name:

OK
Cancel

Enhance | Layer | Select | Filter | View
Quick Fix...
Auto Levels ⇧⌘L
Auto Contrast ⌥⇧⌘L
Auto Color Correction ⇧⌘B
Adjust Lighting ▶
Adjust Color ▶
Adjust Brightness/Contrast ▶

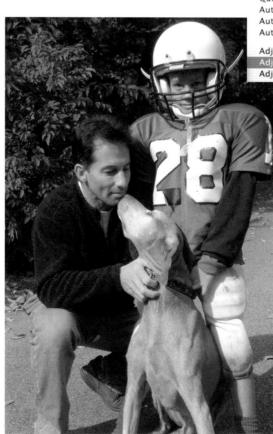

2 To turn your color photograph into a black-and-white image, *Select All* and then go to the menu bar and open the *Enhance* menu. Move down the menu to *Adjust Color*, and the submenu will open. Select *Remove Color* and release the mouse. You can alternatively just press Shift + Command + U (or Shift + Crtl and U if you're using Windows).

In digital photography, color saturation has tremendous impact, but working with the full color range will sometimes run counter to the more complex feelings you have toward a subject. Subtlety of expression in photography is achieved through the quality of the light and shadow and the nuances of warm and cool colors in a scene. These atmospheric qualities can be added to a photograph by gradually desaturating color. More radically, you can completely desaturate a color image to monochrome (black-and-white).

Switching from the full-color intensity of a fine digital image to the stark contrasts of black-and-white throws our attention onto form, light, shadow, and texture. Then softening the image to sepia tones adds an old-style warmth.

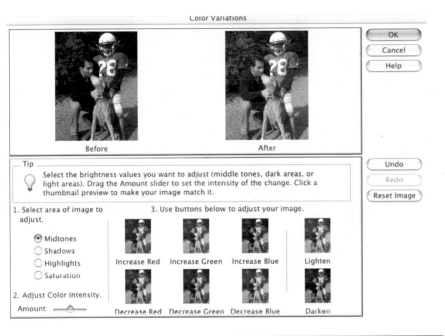

In photography, when you remove one visual element, another is heightened, and by removing color, attention is completely focussed on the shape and rhythm of the forms and their relationships in the light and shadow. In addition, awareness of detail, texture, and patterns is also heightened. Often there will be a good balance of forms in a scene, but the colors are of contrasting or dissonant hues that distract from the forms. If you reduce such an image to black-and-white, you can choose to add color back gradually as a sepia tone, in order to create a gentle warmth of atmosphere. Sepia reduces the harshness of a black-and-white image, and also evokes the photography of a past age.

3 To create a sepia effect using Photoshop Elements, pick *Enhance > Adjust Color > Color Variations*. In the *Color Variations* dialog, you will see *1. Select area of image to adjust*, which offers a choice of either *Highlights*, *Midtones*, or *Shadows*. Sepia requires you to select and work on the *Midtones*. You will also see *2. Adjust Color intensity* with a slider bar. For an image like this, leave the slider in the middle of the scale.

3. Use buttons below to adjust your image.

Increase Red · Increase Green · Increase Blue · Lighten

Decrease Red · Decrease Green · Decrease Blue · Darken

4 Now use the thumbnail buttons to adjust your image. To create a Sepia effect, click on the I*ncrease Red* thumbnail once and then click on the *Decrease Blue* thumbnail once. Now lighten the image by clicking on the *Lighten* button once. Check the effect by examining the preview in the window, and once you are satisfied with the adjustments click *OK* to apply the effect to the image.

Filter effects

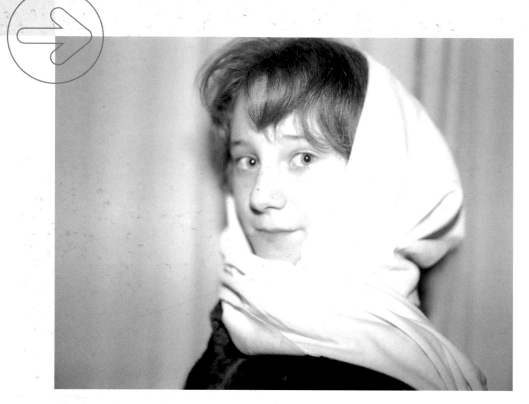

1 Open your selected image and make a duplicate copy in the layers menu. Open the *Layers* palette on the desktop, and click on to it highlight it and make the duplicate layer the active layer.

Creative film-based photographers have long used a diversity of filters to create artistic color and lighting effects in their images. Programs such as Photoshop Elements have digital filters to do the same job, but with an even greater range of possibilities, from subtle overlays of lighting, to radical artistic effects, through to dramatic distortions and transformations. Some replicate the way film-based filters work, and others do much more, creating visual effects borrowed from the world of graphics, painting, and printmaking.

We'll take a look at working with filters by running through an example. The Artistic *and* Sketch *section of the* Filter *submenus contains a large selection of painting and drawing effects. Here, we'll use the* Watercolor *filter to transform a simple portrait.*

USING FILTERS

The list of filters in Photoshop Elements boasts a daunting array of possibilities. However, the filters are organized in submenus of related and similar effects, under headings of *Artistic, Distort, Blur, Render, Texture,* and so on. As you open the filter effects window from the *Menu Bar,* the filters are shown as thumbnail examples. While these thumbnails give a moderate idea of the filter effect, it is only through experimenting and play that you will begin to understand the potential and impact that these ranges of filters can have on an image. In time, you will find it is best to use them subtly, as they can become overfamiliar.

2 Go to the *Window* menu in the *Menu Bar* and select *Filters.* A window will open, showing example thumbnails of the various filters. Select *Artistic* from the *Options Bar* and scroll down the list to *Watercolor.* The *Watercolor* filter window will now appear with a preview. Here you can adjust the scale and the portion of the image seen. Below that are the actual filter controls, which vary according to the precise filter which you have elected to use in your work.

You can transform a simple portrait that you feel needs a bit of added impact by making subtle, rather than dramatic changes to the image, adding lighting effects, artistic filters, and other effects and blending them into the image.

3 We're going to go for what initially looks like an extreme effect. Set the *Brush Detail* to 2, *Shadow Intensity* to 1, and *Texture* to 2. Click *OK*. It's a strong graphic image, but underlying detail has been lost.

4 As we ran the filter on a layer, however, we can fade the filter layer and let more of the image beneath show through. With the *Opacity* turned down to 20%, the effects of the filter are far more subtle and complementary.

FACT FILE

Filters and blend modes

You can get even more control over filters and effects by applying them to duplicate layers and using blend modes—selected from the pop-out in the top-left of the *Layers* palette. In this example, I took the same image and used the *Neon Glow* filter on it. I kept the *Opacity* for the filter layer at 100%, but changed the blend mode. With the blend mode set to *Normal* (1), the effect is too heavy for real use. Set it to *Difference* (2), however, and the glow turns into a more controlled neon overlay. With the blend mode set to *Soft Light*, the result is a subtle effect that complements the image.

Filter effects

TEXTURE FILTERS

The *Texture* section of the *Filter* window contains a selection of useful filters, such as *Texturizer*, *Grain*, and *Mosaic*, which you can overlay onto an image. *Noise* is particularly useful for adding the appearance of rough grain to an image, while you can use the *Texturizer* filter to create an impression of a rough or natural surface behind your image.

1 Start by selecting *Window > Filters* to display the thumbnail view. Choose *Texture* from the pop-out in the *Options Bar* and pick the *Texturizer* from the thumbnails. The *Texturizer* window appears, with a preview (you can adjust the scale and the portion of the image seen) and controls. Explore different effects by selecting textures from the *Texture* menu and adjusting the *Scaling* (which affects the size of the texture used) and the *Relief* (which controls the "depth" of the texture).

2 On its own, the *Texturizer* effect is often too strong to be useful—it can make it difficult to see the image among the texture. To fade the texture, go to the *Layers* palette. Leave the blend mode set to *Normal*, but reduce the *Opacity* to 10% or less.

3 The image now looks as if it has been projected or painted onto a rough canvas surface. This effect can be particularly useful if you're trying to give a photo a handdrawn or a painted look—you can layer the faded canvas texture over an image already treated with one of the *Artistic* filters (*see pages 108-109 for details*). Doing this can fool the eye that it is looking at a painting on a canvas. In a sense, the eye is right: image-editing is as much about painting with light on the screen canvas as it is about fixing faults and glitches.

TIP Use filters and textures very subtly to suggest effects rather than draw undue attention to their use and familiarity.

Spread heading

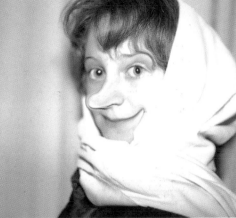

RENDER FILTERS

The *Render* section of the *Filter* window contains a selection of special effects, including *3D Transform*, *Clouds*, *Lens Flare*, and *Lighting Effects*. Here, I have selected the *Lighting Effects* filter to create an image with a directional spotlight. Again, I applied the filter to a duplicate layer. Effects such as these enable you to fix poor lighting.

THE DISTORT FILTERS

The Distort section offers a similar range of special effects, including *Diffuse Glow*, *Glass*, *Liquify*, *Wave*, *Ripple*, *Pinch*, and *Shear*. These tend to create quite surreal or exaggerated effects, as seen in this use of the *Liquify* filter to create what seems like a cartoon distortion of the features. The *Liquify* filter is quite simple to use—you only have to select a brush size and pressure, then you can drag the features around. Play with the forms, using the option to *Undo*, until you are satisfied with the effect.

TIP A good way of making sense of all the filters available is to select one image and apply the different filters in turn. Keep notes of any useful settings, so you can recreate effects later.

 1 The *Lighting Effects* controls are complex, so experiment with the settings and watch what happens in the preview window. By clicking and dragging the handles on the ellipse in the preview window, you can adjust the lighting direction and width. By dragging the center point, you can drag the effect to a new area. Use the sliders to adjust the *Focus* and *Intensity* or alter other properties of the light. Click *OK* to apply the filter.

2 If the results seem harsh, move to the *Layers* palette and adjust the *Opacity* to 30% to create a more subtle merging of the spotlight filter layer with the background layer. As you adjust the *Opacity*, examine the effect in detail on the desktop image.

"Painted" portraits

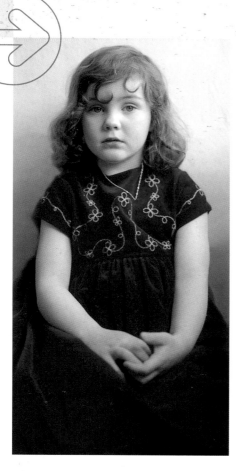

In this photograph of a little girl, I was struck by the seriousness of her expression — it reminded me of the enigmatic sobriety of the Mona Lisa (without the smile!). I wanted to enhance the association of this image with classical painted portraits. Having already made several adjustments to the image by cropping and editing out blemishes in the background, I explored different filters. I applied two related painting effects from the *Artistic* section: *Underpainting* and *Paint Daubs*. For added realism I then used *Texturize* to apply a canvas texture to the image.

When used in layers, filters can add delicate artistic textures and so enhance the atmosphere of an image. One of the great advantages of layers is that you can put each filter onto a separate layer and play with different combinations of effects. By turning layers on and off in the *Layers* palette and adjusting each layer's *Opacity* settings, you can make precise adjustments to the balance between several filter effects.

1 Open the image and then select *Layer > Duplicate Layer* from the *Menu Bar* to create a background copy in the *Layers* palette. Highlight the copy layer as the working layer in the *Layers* palette.

2 Open the filter menu and scroll down the list to *Artistic*, then choose *Underpainting* from the submenu. The window for the filter will open and you will see a preview of the effect in the display window and a selection of controls underneath. You can adjust the scale of the preview up to 100% by clicking on the plus or minus signs at the base of the display window.

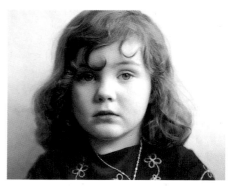

3 Highlight the new copy layer in the *Layers* palette and scroll down the blend mode options to select *Overlay*, which creates a simple merging of the filter effect and the original image. Select the *Zoom* tool in the *Toolbar* and zoom in to examine the effect in detail, then adjust the degree of *Opacity* of the overlaid effect down to 50%. This enables you to integrate the effects on the various layers with real precision.

There are so many types of effect, texture, and filter which you can apply to a picture, that you also need to be able to decide when your work is finished. Usually, it'll be finished when the image leaps off the page without artifice.

Paint Daubs

OK
Cancel

100%

Brush Size 8

Sharpness 7

Brush Type: Simple

4 Repeat the same process as before by creating a new duplicate layer of the original image and title this layer "Paint Daub." With this layer selected, open the *Paint Daub* filter from the *Artistic* set with the *Brush Size* set to 8 and the *Sharpness* to 7. Apply the filter, then return to the *Layers* palette and set the blend mode to *Overlay*. View the two filter layers against the background and highlight each in turn to fine-tune each layer's *Opacity*.

TIP → When using tools such as Texturizer, subtlety is the key to making truly convincing images.

7 Again, highlight this layer in the *Layers* menu and set the blend mode to *Overlay*. Now you can view all three texture filter layers overlaid. Use the *Zoom* tool to examine the final image and highlight each of the layers in turn to fine-tune *Opacity*.

5 Create one more duplicate copy of the background layer and title this layer "Texturize." Highlight the layer in the *Layers* menu and select *Texture* from the *Filter* menu, then Texturize. The Texturizer dialog will open and you will see that there are several different options, including *Brick, Burlap, Canvas,* and *Sandstone*. As with all digital textures, these are best applied subtly to suggest an effect without calling undue attention to its artificiality. With filters, there is always a risk of creating an effect that overpowers the original image.

Texturizer

OK
Cancel

100%

Texture: Brick

Scaling 100 %

Relief 4

Light Dir: Top
☐ Invert

6 Select *Canvas* and click *OK* to apply this last filter. Adjust the texture *Scaling* and the degree of texture *Relief* by moving the slider along the bar for each adjustment. You can also adjust the light direction across the texture to fall from the top, bottom, or side. Once you click *OK*, the window will close and the program will apply the filter to the layer.

Texturizer

OK
Cancel

100%

Texture: Canvas

Scaling 100 %

Relief 4

Light Dir: Top
☐ Invert

8 Once you are satisfied with the combination, merge the images down to a single layer by selecting *Merge Visible* in the *Layers* menu. You can significantly reduce the size of the file by applying *Flatten Layers* from the *Layers* menu.

Hand-coloring pictures

2 Go to the *Enhance* menu, then move down to *Adjust Color* and select *Remove Color*. Release the mouse and the image will automatically desaturate to black-and-white. The order of the layers in the *Layers* palette, from the top down, determines which layer is in front. For this image, you need to pull the color layer to the top. To do so, drag it to the top of the layers list. The color layer is now the layer in front of the black-and-white layer.

In the early days of black-and-white, photographers aimed to make pictures as lifelike as possible. They would take notes on the eye and hair colors, complexion, and clothing, and try to recreate the original colors by using watercolors or dyes over black-and-white prints. You can simulate the appearance of these early hand-tinted photographs by overlaying a color copy layer onto a black-and-white copy layer, and then using the painting tool to add some simple color washes. The process does not involve a great deal of drawing skills but rather the easier process of picking out areas with the *Selection Brush* tool.

1 Open the image and select *Layers > Duplicate Layer* to create a copy of the background layer. This will be our color layer. Now create another duplicate layer, which will be the black-and-white layer. Next click on the eye symbols next to the color and background layers to make them inactive. This means that the black-and-white layer is now the active layer.

TIP → It is often good to acknowledge the heritage of different effects and imaging techniques—it shows you understand your craft.

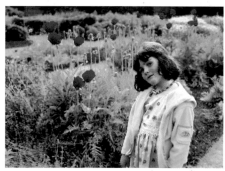

3 For a proper hand-tinted effect we need to give the colors a heightened, less-realistic effect. Increase the *Saturation* of the colour layer by selecting *Enhance > Adjust Color > Hue Saturation* from the *Menu Bar*. Move the cursor to the *Saturation* slider and drag the slider to plus 50% and click *OK*.

Taking an image through all of these processes is like a random tour of the history of color reproduction: the turn of the last century, the golden age of Technicolor, the 1920s, the 1970s... all part of our journey of discovery.

Hand-coloring pictures

4 With the *Saturation* adjusted, return to the *Layers* palette and make sure that the color layer is still highlighted and active. Now adjust the layer's *Opacity*, moving the slider down to 48%. This makes the color layer semitransparent, and creates the effect of a bright color wash overlaying a black-and-white image.

5 For a really convincing hand-tinted effect, we need to go one step farther. Use the *Zoom* tool to zoom in on the face, then select areas of the composition where you should increase the color saturation. Open the *Selection Brush* from the *Toolbar* and set the brush size to 10 pixels. Now select the lips and irises. Move across the image and select the blue beads on the necklace. Then, using a larger brush size (28 pixels), use the *Selection Brush* to select the flowers on the dress.

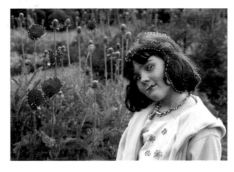

6 Continue to select areas of the composition, increasing or decreasing the brush size of the *Selection Brush*. Open *Enhance > Hue/Saturation*, and increase the *Saturation* of the colors simultaneously in all the selected areas by 50%. This will increase the appearance of overpainted color on the underlying black-and-white layer.

7 Further color washes need to be added to the image using the spray tool. Continue to work on the color layer. Click on the paintbrush in the tool box and then on the spray icon in the *Options Bar*. Set the spray *Size* to 30 pixels and the paint *Opacity* to 40%. Click on the foreground color at the bottom of the tool box and the *Color Picker* window will open. Select red on the color slider and a pink tint in the color field and carefully apply a light spray of pink color to the cheeks.

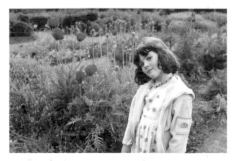

8 Using the same procedure, select a shade of yellow/brown to spray areas of the hair, then select a shade of turquoise blue to add color to the jacket and finally a bright shade of green to spray areas of the grass and surrounding foliage. With each of these operations, you need to carefully judge the density of the spray and adjust its *Size* in the *Options Bar*.

9 When you're satisfied, take one last look at your work and make any final tweaks to the *Opacity* of your color and black-and-white layers. Flatten them down, and you should have a convincing hand-tinted photo.

Changing backgrounds

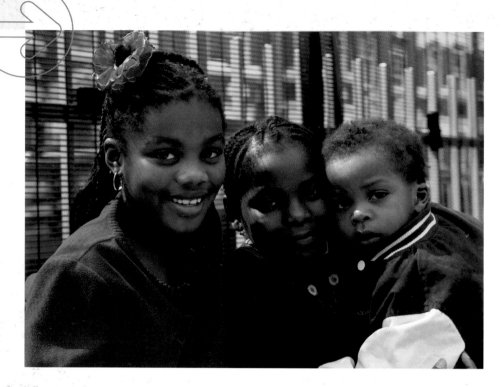

2 Enlarge the image on the screen using the *Zoom* tool so as to view the children in close-up. You can switch to the *Hand* tool in the *Toolbar* to drag the image across the screen as you work your way around the contours. Once the main work is done, use a smaller brush of 10 pixels to work around the edges. When completed, switch from mask mode to selection mode and the contour of the children will be surrounded by the "marching ants" dots.

This is a creative area of photography that has been radically transformed by the advent of digital editing software. You can improve a photograph by getting rid of an unsympathetic background and replacing the original with a better setting, or exchanging a dull setting for a more lyrical landscape.

In this portrait of a group of children, the original photograph was taken against an inappropriate setting of railings. I needed to find a gentler setting to match the tenderness and affection of the children caring for their baby brother. I selected an image of flamingos at the zoo as a happy image of childhood, and also for the green color of the water that complemented the pink of the flower.

1 Open your image on the desktop and open the *Layers* menu. Create a duplicate copy of the background image and highlight it to make this new layer the active layer to work on. Click on the *Selection Brush* tool (A) in the *Toolbar*, then select a brush with a soft definition and set the size to 200 pixels. Once you click on the *Mask* in the *Options Bar*, the *Selection Brush* can be used to paint a mask over the children.

3 Go to *Select > Feather* and add a 10 pixel soft edge to the selection. Then choose *Select > Invert*, which will reverse the mask selection area to the background. Press the Delete button on the keyboard and the background will be deleted.

DIGITAL DARKROOM TECHNIQUES

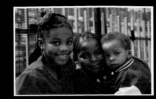 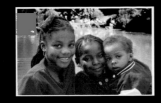

Removing an urban background and moving the subjects to a more tranquil scene changes the whole atmosphere of a photo. By putting family groups into new visual environments, you enhance or reveal aspects of their character.

RECAP

A Create a duplicate copy of the background image, and paint a mask over the foreground image you want to remount.

B Soften edges with the *Feather* option and the *Eraser* tool.

C Paste the new background onto a new layer of the foreground image.

D Rescale the new background to fit the canvas.

4 Examine the contour of the selection and tidy the edges, using the *Eraser* tool set to a resolution of 20%. Pay particular attention to areas such as the edges of hair, so that when the image is placed over the new background, the contour will not appear as a sharp-edged cutout. The eye will quickly detect an obvious fake.

5 Open the new background image of the flamingo lake. Press Command + A (Ctrl + A) to select all of the image, then Command + C (Ctrl +C) to copy it. Go back to the image with the children and select *Layer > New Layer* to create a new layer. Drag the new layer to a place underneath the layer with the children in the *Layers* palette. Then click on the new layer to make this the active layer, and press Command + V (Ctrl + V) to paste the flamingo lake into it. Make sure that the two layers are visible, and you will see the new background appear behind the children.

6 Because the new background layer is smaller than the image of the children, it has to be rescaled to fit the canvas. Turn off the visibility of the children layer by clicking on the eye icon next to that layer. Now, only the new background layer is visible. Make sure this is the active layer by clicking on the brush icon next to this layer. Select *Image > Transform > Free Transform*, and a bounding box will appear around the new background. Grab the handle at the top left of the bounding box and drag the image out to the corner of the canvas.

7 In this case, I dragged the image beyond the boundary of the canvas to make the flamingos sit higher in the image and visible behind the children. When you're finished, confirm that the rescaled background looks well-balanced by making the children layer visible again, clicking on the eye icon in the *Layers* palette. It's important to make sure that the elements fit together, so *Undo* and redo the *Free Transform* command if you need to.

TIP If you make a mistake and wander over the edge with the *Selection Brush*, you can either step backward in the short cuts bar to a previous state, or alternatively reverse the selection procedure.

Removing unwanted picture elements

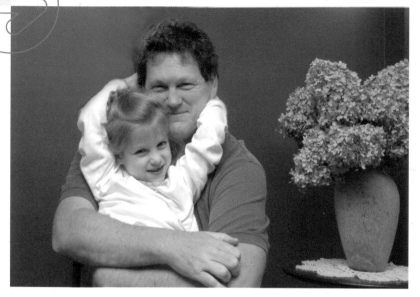

In this indoor image of a father and daughter, the portrait needs to have a distracting mirror removed from behind their heads.

Some otherwise great shots can be ruined by an irritating flaw or an unwanted picture element. Perhaps you didn't see it at the time, or perhaps you couldn't avoid getting it in shot. When shooting outside, it might be an unwanted shadow or objects in the distance such as telegraph poles. At other times, strangers step into shot at the moment you are catching the action. So, discreetly edit them out!

The most commonly used tool for minor changes is the *Clone Stamp* tool, which every digital photographer finds indispensable because it enables you to get rid of any unwanted element by copying and cloning an area nearby and pasting it onto the area that you want to get rid of or disguise.

1 Open the image on the desktop, then go to the *Layers* menu and create a duplicate layer of the background. Then highlight it to make it active.

Use the *Zoom* tool to enlarge the area of the image to be altered to a size large enough to see in detail.

2 Select the *Clone Stamp* tool from the *Toolbar* and select a brush with soft edges from the pop-up palette in the *Options Bar*. Using a soft edge tool is important so that the overlaid clone blends into the surrounding tones. You also need to set the clone option to *Aligned*, which means that the *Clone Stamp* will be cloning an area parallel to the brush. Using the *Aligned* option ensures that you are copying the nearest color and tone values of the surrounding area so as to create smooth transitions which will not be visible. Adjust the brush size to 200 pixels to clone the larger areas of the background wall. Move the tool onto an area of the wall which is next to the mirror, then hold down the Alt button on the keyboard and click and hold down the mouse. Then move the brush onto the area of the mirror and release the mouse. Now click on the area of the mirror and you will see the area you are copying, indicated by the crosshair, being cloned on top of the mirror.

The simple act of taking out unwanted elements by cloning and painting with replacement pixels has turned a workaday shot into a much more eye-catchingly bold composition that bears repeated viewing.

3 You will need to reset the area you are cloning from several times. As you move around the mirror, clone the nearest area to the left, then clone from the area above the mirror and then from the area to the right. As you move the cloning closer to the edge of the hair, you will need to switch to a smaller brush size and move carefully so as not to clone over the hair. If you make a mistake, you can step backward in the *Shortcut Bar* to a previous state.

4 As you move the cloning tool around the contour of the hair, you should reduce the *Opacity* of the clone to 20%. This ensures a subtle transition between the wall and the hair tones.

FACT FILE

The Skew tool

In this image there was also a noticeable slant to the wall on the right-hand side of the image, which needed to be adjusted back to the vertical by using the *Skew* tool. This is a very simple tool to use and is particularly useful when dealing with edges of buildings and walls which appear to converge due to photographing the subject at an acute angle. You can use this tool to pull converging or diverging lines back to being parallel.

A Grab all of the image using Command + A and then select *Image > Transform > Skew* from the *Menu Bar*. Now move the cursor to the bottom right-hand handle on the bounding box and pull the handle to the right until the slanting line of the wall becomes vertical and parallel to the edge of the image. Then hit the Return key to apply the change.

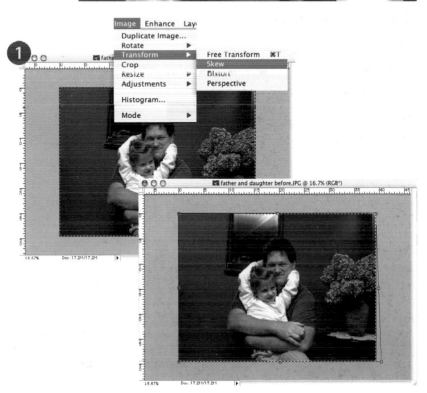

Retouching like the experts

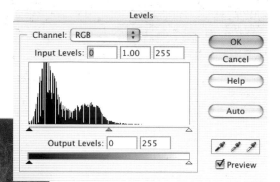

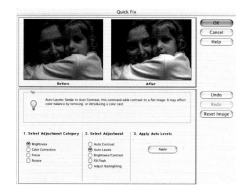

There are many moments in family life when an impromptu gesture of affection prompts a spontaneous photo-call. The use of autofocus and exposure is a real boon to catching the moment without having to make any decision, other than to zoom in and compose the shot. With digital photography, you know the camera will perform well in relatively low-level lighting and that you can adjust any color cast once you have downloaded the images to your computer. Here, an informal close-up image of mother and child needs overall adjustment for contrast and color, and more precise adjustments to enhance individual features in the eyes and mouth.

1 As before, create a duplicate layer—the background copy—and give it a working name. Then, with the new layer active, open the *Quick Fix* tool from the *Menu Bar*. Choose *Brightness* in the *Adjustment Category*. Select *Auto Levels* and click *Apply*. This command adds contrast to a flat image and in this case also removes the yellow color cast, restoring areas of pure white to the picture. Compare the *Before* and *After* images and, if you are happy with the result, click *OK*.

2 Select the *Zoom* Tool and zoom in to examine the detail of the mother's and child's faces. The shadow under the mother's eye is too dark. Choose the *Selection Brush* tool, with *Mode* on *Selection* and *Hardness* at 5% with the brush size set to 40 pixels. Drag the *Selection Brush* so that it captures the dark tones under the eye. Open the *Levels* adjustment dialog box (*Enhance > Adjust Brightness/Contrast > Levels*) and slide the midtone arrow to the left to gradually increase the brightness of the selected area to match the surrounding skin tone. Click *OK* and deselect using Command + D (Ctrl +D).

3 The crow's feet under the mother's eye need softening. Select the *Blur* tool and set the brush size to 80 pixels, *Mode* to *Normal*, and *Strength* to 50%. Drag the *Blur* tool across the area of the crow's feet to gradually soften the lines. Be careful not to overdo the *Blur,* as it will create a noticeable patch of flat texture on the skin.

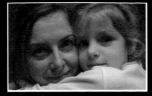
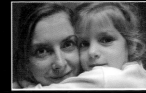

The before and after shot, a brighter, more contrasted image, but with softer lines in the face, more striking use of color, and brighter, more vibrant eyes. Compare it with the original and see which one your eye naturally falls on.

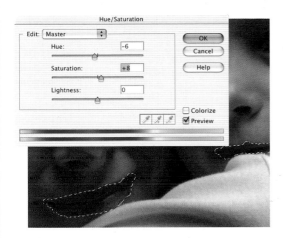

4 It's a matter of taste, but I think both the mother's and child's lips need some subtle color enhancement. Again use the *Selection Brush* tool, with *Mode* set to *Selection*, *Hardness* at 5%, and the brush size set to 30 pixels. Drag the *Selection Brush* so that it captures the area of the lips. Then go to *Enhance > Adjust Color > Hue/Saturation*, and slide the arrow on the *Hue* bar toward Magenta (-6) and increase the *Saturation* to +8. Click *OK* and deselect the area by pressing Command + D (Ctrl +D).

5 The image would be helped if both the mother and child's eyes were brightened. To adjust the brightness of the whites of the eyes, use the same procedure as in step 2. Select the *Selection Brush* Tool, with *Mode* on *Selection*, *Hardness* at 5%, and the brush size set to 20 pixels. Drag the *Selection Brush* to capture the white tone in each of the eyes. Open the *Levels* adjustment dialog box in *Enhance > Adjust Brightness/Contrast > Levels*, and slide the midtone arrow to the left to gradually increase the brightness of the selected area to whiten the eyes. Click *OK* and deselect using Command + D (Ctrl +D).

6 Now the color and tone of the irises needs lifting. Apply the same procedure as in the previous operation, the *Selection Brush Tool*, with *Mode* on *Selection*, *Hardness* at 5%, and the brush size set to 20 pixels. Drag the *Selection Brush* to capture the area of the irises. Go to *Enhance > Adjust Color > Hue/Saturation*, and slide the arrow on the *Hue* bar toward yellow -11 and increase the *Saturation* to +20 and *Lightness* to +4. Click *OK* and deselect using Command +D (Ctrl +D).

RECAP

A Correct contrast and remove color cast
B Remove dark areas and lines around eyes and add color to lips
C Brighten, adjust color, and sharpen eyes

7 Finally, the definition in the eyes needs improving with some subtle sharpening. Select the *Selection Brush* tool, with *Mode* on *Selection*, *Hardness* at 5%, and the brush size set to 20 pixels. Use the *Selection Brush* to capture the area of the eyes and lashes. Choose *Sharpen* by scrolling down the list of options in the *Filter* menu and apply it. Check the result. You can repeat this process until you achieve sufficient sharpness—although, if you overdo it, you will create unwanted visual noise.

Sharpen	⌘F
Artistic	▶
Blur	▶
Brush Strokes	▶
Distort	▶
Noise	▶
Pixelate	▶
Render	▶
Sharpen	▶
Sketch	▶
Stylize	▶
Texture	▶
Video	▶
Other	▶
Digimarc	▶

Retouching like the experts

There are many occasions when you will want to make some alterations to the skin tone. An inappropriate shadow may fall on the face, or the lighting may glance across the face, exaggerating creases or a skin blemish. We are all very aware of any deviation in the form or texture of a face. So getting accurate skin tones is a process that requires considerable care, because any change, even quite a subtle one, can be surprisingly noticeable to even the non-expert observer and photographer.

In this double portrait of husband and wife, a number of minor details detracted from the composition. There are noticeable stray hairs and creases in the background drape. I also needed to reduce the skin blemishes of the moles on the man's cheek, which had been emphasized by the side light, as well as a small spot on the woman's face. Finally to add extra vitality to the image, I wanted to enhance the whiteness of teeth and eyes.

1 Use the *Zoom* tool to enlarge the area of skin blemish to a size big enough to make adjustments comfortably. Select the *Clone Stamp* tool—not the *Clone Pattern* option—from the *Toolbar* and select a brush with soft edges in the pop-up palette in the *Options Bar*. Adjust the brush size, using the slider, to a diameter just larger than the size of the blemish, in this case 10 pixels.

2 Move the tool onto an area of skin next to the blemish, then hold down the Alt button on the keyboard and click and hold down the mouse (the brush will change shape to a smaller circle with crosshairs in the center, indicating the target area you have chosen to clone). Carefully move the brush onto the area of blemish and release the mouse.

3 Now click on the area of the blemish and you will see the parallel area under the crosshairs being cloned onto the blemish. Sometimes it is better to reduce the *Opacity* of the *Clone Stamp* to ensure a better blend with the surrounding skin tones. Make sure that the tool is set to *Aligned*, or the skin textures will be repeated as you clone over the blemish.

To create a gentle fade on the edges of the image, select the *Marquee* tool in the *Toolbar*. You can fade the hard edges of the selection by clicking on the *Feather* box in the *Options Bar*. In this case, the feathering was increased to 20 pixels. Position the cursor (which will be in the form of crosshairs) to the top right of the image and drag the *Marquee* diagonally across and down to frame the image. Now choose *Select > Inverse*, then press the Delete key.

4 Repeat the same process to clone the backcloth, using a larger brush size of 100 pixels to remove the large creases. Next, clone the backcloth onto areas of untidy hair around the heads to create a much neater and more orderly image.

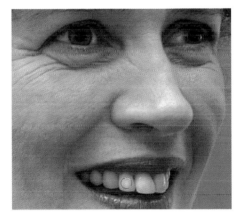

5 Select the *Dodge* tool from the *Toolbar* and set the *Exposure* to 10%. Select *Highlights* from the *Range* options and a tool size of 20 pixels, then click on the mouse to lighten the teeth and whites of the eyes, being careful not to overdo the *Dodge* because this will create an unnatural glow.

FACT FILE

Altering hair color and removing gray

Gray hair can look very distinguished, and in some lights it will add to the attractiveness of a sitter. At other times, particularly in a harsh light, any grayness can be exaggerated, adding years to a subject's appearance. In the digital editing suite, however, you can subtly alter hair color, modifying the gray to a darker tone in areas, without producing an artificially dyed look. In this couple, I wanted to reduce the brightness of the man's gray hair and add back some of the brown hair color, and to do this, I used the *Color Picker* tool and the *Burn* tool (*see page 94*).

Create a duplicate layer— the background copy— and give it a working name. Select the *Color Picker* from the *Toolbar* and position the point of the *Color Picker* on a patch of brown hair close to the gray hair area. Click and the picker will select that color sample.

Select the *Paintbrush* tool from the *Toolbar* and switch the brush to the spray option by clicking on the spray icon in the *Options Bar*. Select a soft brush and adjust the spray size to 200 pixels and an *Opacity* of 10%. Position the spray tool over the gray hair and give short bursts of spray over the gray hair colour, keeping the spray tool moving so as not to create noticeable patches of difference in application. Reduce the brush size to 30 pixels and lightly spray the eyebrow to reduce the gray; further reduce the brush size to 7 pixels and carefully spray over the pronounced stray gray hairs catching the light.

Select the *Burn* tool from the *Toolbar* and set *Exposure* to 20%, select *Highlights* from the *Range* options, and a tool size of 100 pixels. Then click on the mouse to *Burn* and darken these areas of hair. As usual, it's best to do this on a duplicate layer.

Montages

A montage is created by using layers to combine images into a single composition. Usually the aim is to make an image that looks natural, but there are occasions when you want to bring different picture elements together for a more obvious effect. A good example of this is the image here, where we bring four generations of a family together into a montage of a great-grandmother, grandmother, mother, and daughter.

1 Start by opening the image of the double portrait of mother and daughter. Make a copy of the background layer and make this the active layer. Enlarge to view the image in detail and select the *Background Eraser* from the *Toolbar*, then set a soft-edged brush at a size of 100 pixels and a *Tolerance* level of 20%. Use the tool to erase the background around the contour of the heads.

2 Switch to the eraser tool set at 100% *Tolerance* to remove the rest of the background. Use the *Marquee* tool to select the mother and daughter, then copy and paste the selection into a new document and save. Next, close the original document without saving the changes so as to preserve the original image.

Canvas Size

Current Size: 14.1M
Width: 0.803 inches
Height: 1.07 inches

OK
Cancel
Help

New Size: 42.4M
Width: 300 | percent
Height: 1.07 | inches
☐ Relative
Anchor:

3 The new document *Canvas Size* needs to be increased to create space to montage the two remaining images. Select *Image > Resize Canvas*. In the *Canvas* Size dialog, click the down *Anchor* arrow to anchor the image at the bottom, and change the *Height* to 150% and the *Width* to 300%. Click *OK* to apply. Save the document, leaving the image of the mother and daughter open on the desktop.

This simple composite image is a charming reminder of the power of digital photography to create the world as you wish it would sometimes be. And it's a fun way of using some spare images in a new context.

4 Create a new layer and position this below the layer of the mother and daughter in the *Layers* palette and make this the active layer. Now click on the *Foreground Color* in the *Toolbar* and the *Color Picker* window will open. Select a pale pink and click *OK*, then click on the *Paint Bucket* from the *Toolbar*, and click anywhere to tip the pink color in to fill the new background.

6 Now repeat the same process to remove the background, then crop, copy, paste, and position the image of the great-grandmother into another new layer. Having positioned the grandmother and the great-grandmother, select the *Eraser*, set a soft-edged brush at a size of 100 pixels and use it to carefully remove and round off the lower portions of each of the portraits by clicking on and making active each of the layers in turn. Now select *Layers > Flatten* from the *Menu Bar*.

7 To merge the images at the bottom, create a *Gradient Fill* layer. Start by selecting the *Marquee* tool and drag the *Marquee* to create a bounding box which covers the lower 50% of the composition. Use the same pink color displayed in the foreground color in the *Toolbar*. Now, select *Layer > New Fill Layer > Gradient* to open the *Gradient Fill* layer window. Reset *Opacity* to 50% and click *OK* to apply. Now flatten the layers again.

Finally select the *Elliptical Marquee* from the *Toolbar* and set the *Feather* option to 20%. Drag and move the *Marquee* to frame the image, then copy, open a new document, and paste the selection to finish off the image.

5 Open the image of the grandmother and repeat the process of removing the background. Now move back to the mother and daughter image and open the *Layers* palette. Create a new layer and drag it so that it fits below the mother and daughter layer. Now paste the copy of the grandmother into this new layer. With both layers visible, and the new layer as the active layer, use the *Move* tool to position the grandmother next to the mother and daughter. Open *Image > Resize* from the *Menu Bar* to adjust the size of the image by dragging on the corner handles.

Montages

Montaging images really is digital editing's forte. You can build a perfectly composed image from several photographs of a subject, take out a figure, put another figure in its place, and then transpose the composite group to another perfect background. The digital-editing possibilities are really invaluable when it comes to editing a group of figures.

In this example the family wanted to be grouped together against a background scene of a lake and cottage where they had enjoyed a very happy vacation. I took several shots of the group in their family home and had a good shot of the background scene. The eldest daughter was missing from the best image of the family group, but there was an attractive image of her in another photograph from the same photo session, which I could use.

2 Next select the *Magic Eraser* tool from the *Toolbar*, selecting a soft brush with a size of 100 pixels from the *Options Bar*. Set the *Tolerance* level of the tool to 30% and then work your way round the image, erasing the background up to a few millimeters from the profile of the hair.

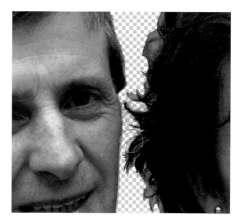

TIP When a montage uses photos taken in different conditions, use *Levels* to balance the shots, and the *Blur* or *Noise* filters to hide the joins.

1 Open the image of the family group. Create a duplicate layer and make this the active layer. Use the *Marquee* to select the background above the figures and press the delete button on the keyboard to erase this area. Zoom in to see the image in detail.

3 Now switch to the *Background Eraser* and set the tool to a *Tolerance* of 20%, then carefully erase the colors around the hair line. You will see that this tool works as a circular eraser with the crosshair in the middle, deleting the colors that the crosshairs are positioned on and leaving other colors untouched. This makes removal of the background from a complex contour of hair much faster.

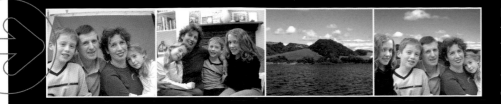

If you have a range of group shots that you like, plus backgrounds that could make for a colorful image, then montage is a good way of combining elements to change the story.

4 To enlarge the image and make space for the missing figure, open *Resize Canvas* from the *Image* menu and set the width of the canvas to 120%, anchoring the image to the bottom right-hand corner of the canvas. Leave the image open on your desktop.

Canvas Size

Current Size: 20.3M
Width: 45.025 inches
Height: 30 inches

New Size: 24.4M
Width: 120 percent
Height: 30 inches
Relative

Anchor:

OK
Cancel
Help

5 Open the image of the daughter and copy her out of the photograph using the *Marquee*. Paste the selection into a new document, then go to *Image > Adjust > Flip Horizontally*. Select the Magnetic Lasso from the *Toolbar*, setting the tool to an *Edge Contrast* of 10% and a *Frequency* of 50 pixels. Start at the lower left point of the daughter and work your way round, clicking to anchor the *Lasso* boundary as you go. When you return to the starting point, double-click and the boundary will turn to marching ants.

6 Choose *Select > Feather* from the *Menu Bar*, set the *Feather* to 5 pixels and use *Select > Invert* to invert the selection. Convert the Selection to Mask mode to check that your selection is defining the contour, then press delete to make the background disappear. Lastly, use the *Background Eraser* with a brush size of 50 pixels and a *Tolerance* of 20% to erase any small areas of the background around the contour of the hair.

Layers

Normal Opacity
Lock:
Layer 5
Layer 1
Layer 3
Layer 0

7 Now copy this image and paste it into a new layer above the family group image in the *Layers* palette. Making this new layer the active layer, open *Image > Rescale* from the *Menu Bar* and, using the handles on the corners of the bounding box, drag the corners out to put the daughter in the right scale. Now use the *Move* tool to position her so that she sits at the left of the family group.

8 Open the image of the lake, then copy and paste this image into a new layer. Drag this layer below the group layer in the *Layers* palette. Making sure this is the active layer, open *Image > Rescale* from the *Menu Bar* and use the corner handles of the bounding box to pull the image of the lake into position behind the figures. Finally, flatten the layers and save the completed image.

4 Sharing your pictures

Above all else, family photographs are there to be shared. In many respects, digital photography hasn't changed the way we do this. We can still frame photographs, paste them into albums, or hang them on the wall. At the same time, there are new, exciting, and very immediate ways of sharing your family shots. You can take a digital photo and—within minutes of doing so—send it via e-mail to someone halfway across the world. You can also showcase images on the web, or collect them on a CD. Read on to learn more.

Perfect prints

Zoom in on a digital image (left) and you can see the pixel structure. Zoom in on the same image printed (right), and the dot patterns become visible.

The Image Size window is where you can resize and shape your image and change its resolution in pixels per inch.

Once you have taken a set of photographs that please you, it's only natural that you will want to make prints to show off or share your images. While the digital equivalent of the high-street film processor is now widely available in most cities, part of the satisfaction of digital photography is the ability to do it yourself with complete control over size and quality.

PRINTING FROM COMPUTER

For most of us, photo printing means an inkjet printer—a color laser printer is out of reach of most pockets, and modern inkjets are difficult to beat in terms of quality. If you have bought a printer in the last 18 months, it will be capable of producing images of photographic quality, although you will see more accurate colors and better definition from the better, more expensive models. All printers create colors from a mix of Cyan, Magenta, Yellow, and Black inks, but these printers will use extra inks—often a light blue and light magenta—to achieve more lifelike, photo-quality prints.

PIXELS AND IMAGE RESOLUTION

The size and quality of the image you can print corresponds directly to the file size of the in-camera image. The bigger you want to make your print, the higher the resolution of the digital image, and the larger the file size. When you take a photo, this will be determined by the megapixel count of your camera, and the quality settings you use.

Every digital image is made up of pixels (picture elements); tiny blocks of color that, when viewed at the right scale, look like a continuous tone image. If you take a full-color photograph with a 5 megapixel (five million pixel) camera at its highest possible quality setting, the grid might consist of 2560 columns of pixels and 1920 rows. Without compression, the file that contained this image would be 15 megabytes (Mb) in size.

This is not the same as resolution. Resolution is a way of describing the number of pixels that fit into an inch of space, measured for the screen in pixels per inch (ppi). When we look at an image onscreen, we only need to view it at a resolution of 72ppi. But for a printed image to look good, it needs to have 300 pixels for every inch.

As a result, you could take that image from your 5-megapixel digital camera, then print it out on an A3 sheet (16 x 10 inches) and get an acceptable result. But a 2-megapixel camera would supply less than half the number of pixels, so the image would look blocky when stretched over that area—there are not enough pixels to fill it.

Image Size

Pixel Dimensions: 19.3M (was 17.2M)

Width:	3000	pixels
Height:	2254	pixels

Document Size:

Width:	10	inches
Height:	7.514	inches
Resolution:	300	pixels/inch

Set the document resolution

☑ Constrain Proportions
☑ Resample Image: Bicubic

Basically, to make a photo-quality image you need to have a minimum of approximately 150 ppi in your image at the size you want to print, and ideally 300 ppi for photo quality prints. When it comes to choosing a digital camera, the table below summarizes the maximum size of image you could reasonably expect to print from an image taken with it:

MEGAPIXEL RATING	PRINT SIZE
1 to 2 million pixels	6 x 4 inches
2 to 3 million pixels	7 x 5 inches
3 to 4 million pixels	8 x 10 inches or A4
5 to 6 million pixels	16 x 10 inches or A3

Just because something looks good on screen, it won't always look as good when printed out. A basic understanding of the difference between screen and printed resolution is vital if you want to make successful prints.

Perfect prints

PRINT PREVIEW

When you try to print your image from your photo-editing application, you will end up with some sort of *Print Setup* or *Print Preview* window. This lets you select the size of your paper and the format of the print: most printers default to an A4 portrait setting, so you will need to change this for a landscape shot. You also need to set the dimensions of your image by either typing in the size numerically or increasing or decreasing the image by percentage. Then you need to specify the paper type that you are using, and finally you will need to select the printer resolution of the image by scrolling through the various preset options.

DOTS PER INCH AND PRINT RESOLUTION

Print resolution, measured in dots per inch, works slightly differently to the ppi image resolution we talked about earlier. Inkjet printers work by spraying imperceptibly fine dots of ink onto the page, creating mixtures of colors by overlaying these dots on top of each other or by arranging them in microscopic patterns. The dpi figure stands for how many dots are sprayed per inch. The higher the dpi setting, the finer the quality and detail of the print—if you have formatted an image to a

high ppi pixel resolution and then print it at a low dpi print resolution, you would lose some of the high definition. The ideal is to take a 300 ppi resolution image and select a high dpi option on the printer. 720 dpi is adequate for medium to fine resolution, but for best results use a 1440 dpi photo quality setting or a superfine setting of 2880 dpi.

Don't get dpi and ppi confused, even if many manuals, magazines, and interested parties on the Internet do so on a regular basis. Keep thinking pixels for screen and dots for print! That way you'll always be right.

INKJET INKS AND PAPER TYPES

The quality of your final print will also depend on the quality of the paper you choose to print on. Normal photocopier paper is not suitable, as the inks bleed into the paper and produce a dull, fuzzy image. Inkjet papers are specially coated so that the ink stays sharp on the paper surface, and you should find varieties suitable for 360 dpi resolution printing, matt paper for 720 dpi printing, and photo-quality paper for high-quality, 1440 dpi prints. As you might expect, the photo-quality paper is a lot more expensive, so it's best saved for images that you want to place in special albums, frame and display, or send to your family. This truly puts professional processing into the home.

As an alternative to sheets, you can also buy glossy photo paper in a roll. You feed this into the printer, then trim the photographs from the roll after printing. Paper isn't the only media available: you can also print onto specially prepared canvas sheets, textured materials, or transparent film—and even transfer papers that enable you to iron images onto T-shirts.

USING COLOR MANAGEMENT WHEN PRINTING

When you view and edit a color image on the computer screen, the colors you see are made up of pixels composed of red, green, and blue light (we call this RGB mode). When you tell the computer to print, the colors need to be translated into a rather different system, the Cyan, Magenta, Yellow, and Black (CMYK mode) that your printer uses. Because of this switch, the image can look very different when it is printed—how different depends on how your software does the translation. Photoshop Elements does the job automatically, but in other applications, including Photoshop 7, you should make the switch yourself by selecting *Image > Mode > CMYK* from the *Menu Bar*. This will show you the color as it will be printed, so that you can make alterations before sending the image to print.

In the Print *window, you can set output quality as high as 1440 dpi or higher for glossy paper to get true "photo quality" reproduction. But remember: you must have a high-resolution image to start with. The* Print Preview *window lets you line up the shot before you output it.*

Copies & Pages	90(USB)
Layout	lard
Output Options	
✓ Print Settings	
Color Management	
Summary	ium Glossy Photo Paper

Ink: ⦿ Color ◯ Black

Mode: ◯ Automatic
◯ Custom
⦿ Advanced Settings

Print Quality: Photo - 1440dpi

☑ MicroWeave
☑ High Speed
☐ Flip Horizontal

Print Preview

☐ Show More Options

Tp:
Sets image position and size on the current paper size, which you select in the Page Setup dialog box. To reposition the image, deselect Center Image and drag the image in the preview. Setting Scale greater than 100% may result in poor image quality.

Position
Top:
Left:
☑ Center Image

Scaled Print Size
Scale: 20% ☐ Scale to Fit Media
Height: 19.967 cm
Width: 15.028 cm
☑ Show Bounding Box
☐ Print Selected Area

OK
Cancel
Print...
Page Setup...
Help

Greetings cards and invitations

One of the most exciting attributes of image-editing software is the way you can format images for different uses, from photo-quality prints to images for the internet, family newsletters, and personalized stationery. In this example, I wanted to create a birthday invitation card for my daughter's party. I montaged an image of her in her tutu onto a section of an image I had photographed from her favorite book of fairy tales.

1 Open the image of the girl and make a background copy. Make this the active layer in the *Layers* palette. Then using the *Magnetic Lasso*, with a *Tolerance* of 20% and a *Frequency* of 50 pixels, draw a contour around the girl and double-click the mouse to make the selection. Choose *Select > Inverse* to invert the selection, then erase the background using the Delete button on the keyboard.

2 Open the fairy tale image, then *Crop*, copy, and paste a selection from it into a new layer. In the *Layers* palette, drag this new layer to sit below the layer image of the girl. Make sure both images are visible and make the fairytale image the active layer. Use *Image > Rescale* to scale the image to fit behind the girl.

3 Now merge the two layers by selecting *Layers > Flatten Layers*. Select the *Elliptical Marquee* tool from the *Toolbar* and set a *Feather* in the *Option Bar* of 20 pixels. Make a careful crop of the image so as to frame the girl in a balanced composition.

4 Now click on the foreground color in the *Toolbar* and select a light pink tint, then use the *Paint Bucket* to tip this color into the area surrounding the oval image.

Making a card from a favorite image and her favorite book is not just a good challenge for your new image-editing skills, it's a great compliment to a loved one. Make an occasion of it: take some special shots to fit with the background.

8 To create an inside for the card, use the *Elliptical Marquee* to select and copy the image from the front of the card and then paste this into a new document. Set the new *Canvas Size* to the same width and height as the front cover, anchoring the image of the girl to the right-hand side. Reduce the *Opacity* of the image in the *Layers* palette to 50%, before flattening the image. Add some text using the *Text* tool, with the *Font Style* set to *Regular*, *Font Family* to STSong, *Font Size* to 16 pt, and the *Font Color* set to a golden brown. Select *Left Side* alignment and type in your invitation text, pressing the Return key to move to the next line. Flatten, save, and you're ready!

Warp Text

Style: ☆ Arc	OK
● Horizontal ○ Vertical	Cancel
Bend:	+50 %
Horizontal Distortion:	0 %
Vertical Distortion:	0 %

5 To add text, select the Text tool from the *Toolbar* and select the *Horizontal Type* option. In the *Option Bar*, set the *Font Style* to *Regular*, *Font Family* to STSong, *Font Size* to 50 pt, and the *Font Color* to violet. Select *Center* alignment, then double-click the symbol for *Warp Text* and select *Arc Upper* from the *Style* options. Set the *Bend* to 50% and click *OK*.

TIP To print the card, you will be printing on the back and front of the paper, so use double-sided coated paper, with a heavier weight closer to card.

6 Position the cursor to the center above the image and type out the word "party." Now move the cursor to the center point below the image and double-click the symbol for *Warp Text* again. Select *Arc Lower* from the *Style* options, then type the word "invitation." Align the position of the text as a block using the *Move* tool.

7 To turn the image into a card, go up to the menu bar and select *Image > Resize Canvas*. Anchor the image to the right-hand side of the canvas and set the width to 200% and click *OK*.

Dear

Please come to my party

on Saturday the 23rd May

at the Mulbery Centre

3.00 pm to 6pm.

R.S.V.P

Tel.

Love from Lucy

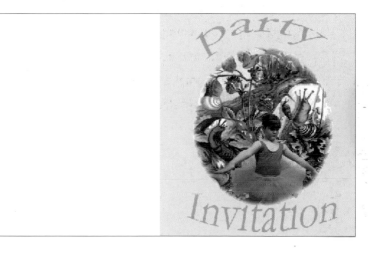

Family newsletters

Dear Mum

I thought you would appreciate this photograph of Dan asleep. A rare moment of peace! I have done a little creative work on the photo.

Stephen wants to send you a little note and a photo as well. Love from mike

Daddy took this picture of me and Puss when we came to see you. I like it a lot and so I am sending it to you.

Lots of love from Stephen
xxxx

Formatting Palette

Font

Style: Heading 1

Name: Andale Mono

Size: 24 Font color:

B *I* U S A² A₂

Alignment and Spacing

Horizontal:

Line spacing:

Orientation:

Paragraph Spacing

Before: 0 pt After: 0 pt

Indentation

Left: 0 cm Right: 0 cm

First: 0 cm

The beauty of the newsletter format is that you can print it out and send it as a letter by post or by e-mail. It is especially useful for contacting members of the family who don't have computer skills or access to the internet. With digital photography, adding images to a newsletter is a simple process of copying and pasting images into a page of text. It used to be the case that to do this kind of image- and text-editing you needed to buy expensive desktop publishing software, but now most of the popular word-processing packages have the facility to add digital images.

One of the great advantages of making a family newsletter is that once you've put your news and images together you can copy the pages, and with some extra text editing you can customize the letter for different people. The family newsletter can be a great way to thank a lot of people—for instance, after an event like a wedding. As well as giving them the pleasure of showing them images of the event, it also saves you a great deal of time and effort in not having to repeat an individual letter to everyone.

The word-processing software of recent years has been radically upgraded to incorporate many new functions, particularly with increase in internet usage. Word-processing software now does a great deal more than simply word process. There are also drawing programs and features for making screen and web-based presentations, all of which are integrated and enable you effortlessly to compose images and text. Most of the better word-processing programs now carry a selection of the essential image-editing features of digital imaging software, enabling you to crop, rotate, resize, and adjust the color and brightness of the image. You can add borders and change how the text moves around your images.

1 Open your word-processing software and select either a landscape or a portrait format for your newsletter in *Page Setup*. Next, select the font type, size, and color for your text. Type your letter and save this document as "Newsletter." Leave the document open on the desktop.

Newsletters don't have to come from just one member of the family, such as an adult. You can give your children a regular slot in a quarterly publication, perhaps, letting them add messages to pictures of themselves that they like.

3 Now adjust the size of the image by double-clicking on it and pulling on the handles at the corner of the image bounding box to stretch or compress it. You can also move the image around on the page or reposition it by dragging the image from its center point and releasing the mouse at the point in the text where you want to reposition it. Repeat the process for the remaining images. In some appplications you can further modify the images in the word-processing software by opening an option like *Format Picture*. This will bring the picture editing window down and you can then further adjust the size of the image and use other options which offer different ways in which the image can be arranged in the text. These will depend on your word processor, but you should be able to specify whether images are aligned to the left, right, or center.

2 Next create a file in your image-editing software with the selected images for your newsletter. Open your first image, then go to the tool box and select part of the image using the *Marquee* of your choice, or just choose Select All or press Command + A (Ctrl + A) to select the whole. Copy the selection using Command + C (Ctrl + C). Now move back to the word-processing software and move the cursor to the point in the text where you want to insert the image, and paste it in using Command + V (Ctrl + V).

4 When you have completed the family newsletter, print it out. Examine the document in the *Print Preview* dialog first to check that the images and text are composed in a coherent and pleasing arrangement. You will also need to select the paper size and type of paper you want to print on and the number of copies you want to print. Bear in mind that you will need to use matt coated papers, rather than basic quality photocopy paper, to produce a decent quality of definition for the imagery in the newsletter.

Digital photo albums

On your cataloging system, you could consider creating a "Groups" folder for each part of your extended family, and then set up cross-references, so you can find this picture in any folder set aside for each family member too.

In this day and age, the term "family album" can take on a variety of new and exciting meanings and guises. With digital cameras, image-editing software, photo cataloging systems and databases, word-processing programs, and desktop publishing packages all available in the market, today's family album could be a book, a CD, a website, a slideshow, or a series of dedicated folders on your desktop or palmtop. But let's take things one step at a time. All you really need is your camera, your computer, your printer, and a simple brand-independent photo management package, such as Adobe Photoshop Album or Apple's iPhoto.

ORGANIZING IMAGES FOR RETRIEVAL AND PRINTING

When you purchase your camera, you will receive a program on CD that you will need to install so as to be able to import the images from your camera and view them on your PC or Mac. These digital-editing programs work only with your brand of camera. However, there are also programs such as iPhoto, which work with any make of camera and include some more advanced editing features.

Whichever program you use, it will include an easy-to-use system for importing, storing, and retrieving images, cataloging and arranging them into folders by title, date, or subject, as well as basic editing tools for cropping, adjusting tone, redeye, and resizing.

Using a cataloging program such as iPhoto is a good idea, as you will quickly amass many images. Your camera will automatically date your photographs, and when you download them to the software they will be recorded according to the date. Generally, though, it's better to organize your images by subject. Once you've placed your images in folders and given them titles, the software can then be asked to do picture searches by subject, such as holidays, or by an individual family member's name. The software will then find all the related images from all the folders.

CREATING BOOKS AND ALBUMS

Software systems such as iPhoto offer you a simple and easy program for turning a folder of images into a book or an album, for formatting photos, and they also enable you to arrange the images in a sequence of pages ready for printing. This is a wonderful feature that not so long ago would have required the expense of high-end desktop publishing software and a serious amount of specialized design training. Formatting images for this kind of printing was time-consuming, involving fiddly resizing and positioning. Now it is done for you at the click of a button.

CUSTOMIZED ALBUMS

Once you've printed the images, you can either store them in one of the many types of bought albums which incorporate plastic wallets or you can easily make your own album by using a hole punch and a ribbon to bind the pages together. You can also use different types of card and paper or even canvas type papers to print your images on. This makes an attractive presentation and turns your photographs into a very special gift.

I wanted to present a set of photographs to friends of the family. They had kindly sat for me as models for this book and an album of images seemed an appropriate "thank you."

SHARING YOUR PICTURES

You might remember downloading this image onto your computer for safe-keeping, and what the picture looked like, but will you remember when you took it, or where you stored it? It's wise to develop a cataloging system early.

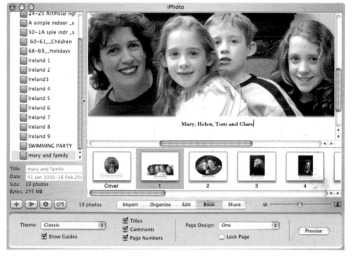

3 Move the cursor onto the *Text Bar* and type in a simple title for each image. You might also want to type an introduction to go in on the introduction page.

1 Select a set of images to form the album and place them in a titled file in iPhoto. Next, organize the images into an order of viewing from first to last by dragging and releasing them into a sequence.

TIP

You can buy selections of different kinds of textured papers, including glossy, matt, and canvas textured types in different weights. Experiment with these to achieve a real presentation quality album.

2 Next click on the *Book* button in the *Options Bar* and select from options that include *Picture Book*, *Classic*, and *Album*. The images will automatically be organized into a front cover. Each subsequent image page is numbered and centered on the page with a text bar.

4 Open the *Print* window in the *Print Preview* to select the orientation of the images on the page, and allow for a border at either side of the images. As it is customary to have the binding to the left, select *Right* from the *Image Orientation* options. Next set the size and paper weight, whether photo, glossy, or matt, and click *OK* to print out the finished album.

E-mail and CD-ROM

O ne of the advantages of digital photography is that you can photograph an event and download the files to the computer, and within minutes, e-mail the images to anywhere in the world.

E-mail images let friends see clearly onscreen, but they won't be able to print them at such high quality.

Saving images as JPEGs is a trade-off between quality and download time.

FILE SIZE

Key to sending images over the internet is the size of your files and the time they will take to be transferred over the Web. In digital photography, the aim is usually to create images of several megabytes so that you can achieve high-resolution photographic prints. However, many computers are still connected to the internet via the phone line, and work with 56K modems through which a Megabyte file will take three minutes to download. As many images will occupy 2 megabytes or more, that adds up to a long time to wait for the photos to download. Of course, Broadband enables much larger files to be sent and downloaded at a speed ten times faster than the 56K modems. If you have a broadband connection, you will be able to work with large files, but bear in mind that others may not.

COMPRESSING FILES

Digital-editing software provides a very easy-to-use solution, which is to reformat and compress your images to a much lower file size for faster downloading. Although there are a variety of formats in which to save your images, only a few are suitable for opening on the internet through a web browser. JPEG is the best for sending photographs as it is extremely efficient at compressing a picture file—specifically, it compresses continuous tone and supports the full range of colors in a photographic image. JPEG is referred to as a "lossy" format because some information is lost and discarded in the compression. You can, however, control the degree of compression when saving an image in JPEG format by selecting either a high, medium, or low quality setting. What you need to consider is whether you are sending images to be printed or whether they will just be viewed as images onscreen. Images on screen don't need the detail or resolution of printed shots.

PREPARING IMAGES FOR THE INTERNET

In Photoshop preparing an image for e-mail is a simple command—open the image, go to *File* in the *Menu Bar*, move down to *Attach to E-Mail*, and release the mouse. A window will automatically open in which you just need to click *Auto Convert* and the image is downsized automatically. This command also automatically opens your e-mail software and places the image on a new page. You can repeat the process to add additional images to the e-mail and add text above or below the images in the e-mail document.

RESIZING IMAGES

Alternatively, if you want to have full control over the degree of compression, you can open and copy the image and go to *Image > Resize* and resize the image to a lower pixel count by changing the image size by either measurements or resolution. You need to make sure that you set the options to *Bicubic* and also that the *Resample* and *Constrain* proportions buttons are ticked. As you alter the dimensions, you will see the resolution alter. When resizing an image for e-mail, make sure that you have initially saved the image in JPEG format and aim to resize the image to around 300k which will give you reasonable image definition and a fast speed of transfer.

When saving images for the web, you need to save the images at a resolution of just 72 ppi for monitor display at a range of standard sizes.

SHARING YOUR PICTURES

If you want to send pictures of your close family to more far-flung relatives or friends, it's often best to select the more informal ones, rather than highly posed portraits or mood shots. Your family simply want to keep in the loop!

CREATING SLIDESHOWS

The images that you have organized into folders can be viewed as a slideshow using iPhoto or Photoshop Elements. With iPhoto simply click on the file with your selected photos arranged in order, then click on the slideshow symbol. You can modify the rate of change, choose music, and alter the transitions between images.

In Photoshop the software translates your images into Adobe Acrobat PDF files that can be read by Adobe Acrobat Reader software, version 5 or later. You can run a slideshow with this. (Acrobat Reader is free to use.)

1 To create a Photoshop Elements PDF slideshow, select *File > Automation Tools > PDF Slideshow,* and a dialog box will open. Click on the *Browse* button to a new window, from which you can then select the images you want to include in the slideshow. Highlight these images and they will appear in the dialog as a list. You can then drag the files to re-arrange them into a preferred order of display.

2 Go to the *Output* section and click on the *Choose* button. Type in a name for the slideshow in the dialog box and click *OK.*

3 Now select the options to set the timing of the changeover from one slide to the next from either one to five seconds. If you want the presentation to repeat, click on the *Loop After Last Page* option. Select the kind of *Transition* you want from the dropdown list (dissolve, blinds, etc.) and finally click *OK.* The software will create a PDF slideshow, in the place and with the name that you specified in step 2. To run the slideshow, simply double-click on the document and it will automatically open in Acrobat Reader.

FACT FILE

Burning CDs

The great advantage in burning images to CD is that it is, by far, the cheapest storage method for saving images, holding 700 megabytes worth. It is a good idea to burn copies of any images you want to print in a high-resolution format. Alternatively, you can make copies of your images and send them to the family as a slideshow.

Open your CD burning software and title the new CD. Select *Data* as the burn mode. Drag the *PDF Slideshow* document into the CD Burner window and then click on the *Record* button. Set the *Write Speed* and click on *Write Session.* The CD burner will ask you to insert a CD and will then automatically burn (record) it.

Putting pictures on the web

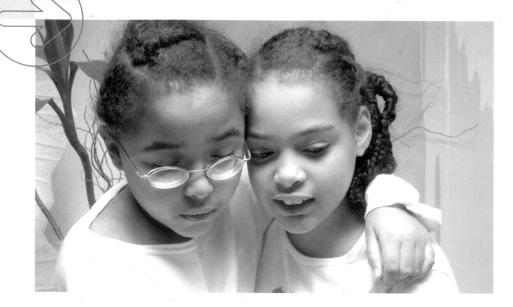

The beauty of a website is that your friends and relatives can access it at any time to see your latest images and you can update the images at regular intervals. Creating a website was until recently quite specialized, requiring some of the knowledge of a computer programmer, but as with everything else associated with digital photography, the system has rapidly evolved to be more user friendly.

TIP If you really don't feel confident enough to use dedicated website designing software, even common word-processing programs such as Word will save documents as simple HTML files for the Web.

FORMATTING FOR THE WEB

Images, as we have seen for e-mail, need to be formatted for use on the Internet. The Web Photo gallery will automatically format your images, so you don't need to do any more. However, if the file sizes for your images are very large or if you want to set a specific file size, you can optimize your images individually.

Photoshop Elements incorporates a very simple and easy-to-use program, which helps you to organize a Web photo gallery—a website that features a home page with thumbnail images and gallery pages with full-size images. Each page contains links that enable visitors to navigate the site. The Photoshop Elements *Web Photo Gallery* feature provides a range of options for presenting your images professionally. You can customize the gallery to different ways of displaying the images from the simple to the stylish, reserved and discreet to the imaginative and humorous, using styles such as *Antique Paper*, *Horizontal Dark*, *Museum*, *Office*, and *Theater*.

1 Open your image in Photoshop Elements and then go to *File* in the Menu Bar and move down to *Save for Web*. A dialog box will open. You will see two views of the image: on the left the original quality and to the right the optimized quality. As you set the new image quality, you can zoom in using the magnifying glass to see the photo in detail. You can also pan the image using the *Hand* tool to examine across the image.

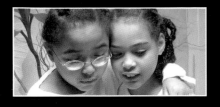

Images like these can quickly become part of a web gallery for family visitors to browse. You could select a range of similar shots within each subject, tell a simple photo story in three or four frames, or mix groupings and individuals.

2 To the right of the screen, you can set the image properties. This enables you to choose from a variety of JPEG settings and resize the image to a specific pixel size or by a percentage value. You can also see a preview of the image in your web browser by clicking the *Preview In* button at the bottom.

3 When you are satisfied with the result, click the *OK* button and a new dialog box will open, asking you to title and save the optimized image. Click and close the dialog box and the image will be optimized and saved with the name and format specified.

CREATING A WEB PHOTO GALLERY

Creating a web photo gallery is similar to creating a slideshow; it's very easy as the process is completely automated. All you have to do is select the folder with your images in, set the kind of display you want to use, and select the destination folder. The software will prompt you with a whole range of preset choices and options, such as a selection of preformatted gallery styles. It will also do most of the difficult stuff for you in the background, so you can relax and make esthetic choices, not technical mistakes!

1 Open Photoshop Elements and select *File > Create Web Photo Gallery* from the *Menu Bar*. The dialog box will open. Your first task is to select a gallery style from the *Styles* pop-up menu. You can see a small preview of each of the styles to the right of the dialog box.

2 You can enter your e-mail address in the text box if you want visitors to contact you. Then, in the folder section click the *Browse* button to select the folder containing the images you want to use for the web gallery. Highlight each one and simply hit *Choose* to copy the images over into the gallery folder.

3 Click the *Destination* button and then either select or create a new folder to contain the optimized images and the HTML pages for the gallery and click *OK*. You can also type in information in the text banner that appears on each page of the gallery and set the font and font size. There are additional options you can apply to the images, such as creating a border around each of the images, using the *Border Size* text box. On completion, click the *OK* button and the program will format the images into HTML and JPEG files and place them in your destination folder. To preview the gallery, double-click on the HTML document. It will open in your Web browser.

Glossary

aliasing The jagged appearance of diagonal lines in an image, caused by the square shape of pixels.

alpha channel A grayscale version of an image that can be used in conjunction with the other three color channels for storing a mask or selection.

anti-aliasing The smoothing of jagged edges on diagonal lines created in an imaging program, by giving intermediate values to pixels between the steps.

aperture The opening behind the camera lens through which light passes on its way to the CCD.

application Software designed to make the computer perform a specific task. An image-editing program is an application, as is a word processor.

artifact A flaw in a digital image.

ASA American standard for film speed, roughly equivalent to the ISO rating.

aspect ratio The ratio of the height to the width of an image, screen, or page.

autofocus A system used in most traditional and digital cameras to ensure that the subject of a photo will be in focus at the moment the exposure is taken.

backup A copy of a file kept for safety reasons, in case the original becomes damaged or lost. Make backups on a regular basis.

bit (binary digit) The smallest data unit of binary computing, being a single 1 or 0. Eight bits make up one byte. See also Byte.

bit depth The number of bits of color data for each pixel in a digital image. A photographic-quality image needs eight bits for each of the red, green and blue color channels, making for a bit-depth of 24.

bitmap An image composed of a grid of pixels, each with their own color and brightness values. When viewed at actual pixel size or less, the image resembles a continuous tone shot, like a photograph.

blend mode A setting in the Photoshop/Photoshop Elements layers palette, which controls how the pixels in one layer affect those in the layers below.

brightness The level of light intensity. One of the three dimensions of color. See also Hue and Saturation

byte Eight bits—the basic data unit of desktop computing. See also Bit.

calibration The process of adjusting a device, such as a monitor, so that it works consistently with others, such as scanners and printers.

CCD (Charge-Coupled Device) A tiny photocell, made more sensitive by carrying an electrical charge before it is exposed, and used to turn light into an electronic signal. Used in densely packed arrays, CCDs are the recording medium in some scanners and most digital cameras.

CD (Compact Disc) Optical storage medium. As well as the read-only CD-ROM format, used by most computers to install applications, there are two recordable CD formats. On a CD-R (Compact Disc-Recordable), each area of the disc can only be written to once, although it's possible to keep adding data in different "sessions." On a CD-RW (Compact Disc-Rewritable) the data can be overwritten many times.

channel Part of an image as stored in the computer; similar to a layer. Commonly, a color image will have a channel allocated to each primary color (e.g. RGB) and sometimes one or more for a mask or other effects. See Alpha channel.

cloning In an image-editing program, the process of duplicating pixels from one part of an image to another.

CMOS (Complementary Metal-Oxide Semiconductor) An alternative sensor technology to the CCD, CMOS chips are used in ultra-high-resolution cameras from Canon and Kodak.

CMS (Color Management System) Software (and sometimes hardware) that ensures color consistency between different devices, so that at all stages of image-editing, from input to output, the color balance stays the same.

CMYK (Cyan, Magenta, Yellow, Key) The four process colors used for printing, including black (key).

compression Technique for reducing the amount of space that a file occupies, by removing redundant data.

continuous-tone image An image, such as a photograph, in which there is a smooth progression of tones between black and white.

contrast The range of tones across an image, from bright highlights to dark shadows.

cropping The process of removing unwanted areas of an image, leaving behind the most significant elements.

default The standard setting or action used by an application, unless deliberately changed by the user.

depth of field The distance in front of and behind the point of focus in a photograph in which the scene remains at an acceptable level of sharp focus.

dialog An on-screen window in an application that is used to enter or adjust settings to complete a procedure.

diffusion The scattering of light by a material, resulting in a softening of the light and of any shadows cast. Diffusion occurs in nature through mist and cloud cover, and can also be simulated in professional lighting setups using diffusion sheets and soft-boxes.

digital A way of representing any form of information in numerical form as a number of distinct units. A digital image needs a very large number of units so that it appears as a continuous-tone image to the eye; when it is displayed, these are in the form of pixels.

dithering A technique used to create an illusion of true color and continuous tone in situations where only a few colors are actually used. By arranging tiny dots of four or more colors into complex patterns, the printer or display produces an appearance of there being more than 16 million visible colors.

dMax (Maximum Density) The maximum density — that is, the darkest tone — that can be recorded by a device.

dMin (Minimum Density) The minimum density—that is, the brightest tone—that can be recorded by a device.

download Sending a data file from the computer to another device, such as a printer. This has come to mean taking a file from the Internet or a remote server and copying it to a desktop computer.

dpi (dots-per-inch) A measure of resolution in halftone printing. See also PPI.

drag To move an icon or a selected image across the screen, normally by moving the mouse while keeping its button pressed.

dynamic range The range of tones that an imaging device can distinguish, measured as the difference between its dMin and dMax. The dynamic range is affected by the sensitivity of the hardware and by the bit depth.

feathering The fading of the edge of a digital image or selection.

file format The method of writing and storing information (such as an image) in digital form.

fill-in flash A technique that uses the on-camera flash or an external flash in combination with natural or ambient light to reveal detail in the scene and reduce shadows.

filter (1) A thin sheet of transparent material placed over a camera lens to modify the quality of color or light that reaches the film or sensor.

filter (2) A feature in an image-editing application that alters or transforms selected pixels for some kind of visual effect.

focal length The distance between the optical center of a lens and its point of focus when the lens is focused on infinity.

focal range The range over which a camera or lens is able to focus on a subject (for example, 0.5m to infinity).

focus The optical state where the light rays converge on the film or CCD to produce the sharpest possible image.

fringe A usually unwanted border effect to a selection, where the pixels combine some of the colors inside the selection and some from the background.

f-stop The calibration of the aperture size of a photographic lens.

GB (gigabyte) Approximately one thousand megabytes or one billion bytes (actually 1,073,741,824).

gradation The smooth blending of one tone or color into another, or from transparent to colored in a tint. A graduated lens filter, for instance, might be dark on one side, fading to clear on the other.

graphics tablet A flat rectangular board with electronic circuitry that is sensitive to the pressure of a stylus. Connected to a computer, it can be configured to represent the screen area and then be used for drawing.

grayscale An image made up of a sequential series of 256 gray tones, covering the entire gamut between black and white.

GUI (Graphic User Interface) Screen display that uses icons and other graphic means to simplify using a computer.

handle Icon used in an imaging application to manipulate a picture element. They usually appear on-screen as small black squares.

histogram A map of the distribution of tones in an image, arranged as a graph. The horizontal axis goes from the darkest tones to the lightest, while the vertical axis shows the number of pixels in that range.

hot-shoe An accessory fitting found on most digital and film SLR cameras and some high-end compact models, normally used to control an external flash unit.

HSB (Hue, Saturation, Brightness) The standard color model used to adjust color in many image-editing applications.

hue The pure color defined by position on the color spectrum; what is generally meant by "color" in lay terms. See also Brightness and Saturation.

Glossary

image-editing program Software that makes it possible to enhance and alter a digital image.

interpolation A procedure used when resizing a bitmap image to maintain resolution. When the number of pixels is increased beyond the number of pixels existing in the image, interpolation creates new pixels to fill in the gaps by comparing the values of adjacent pixels.

ISO An international standard rating for film speed, with the film getting faster as the rating increases. ISO 400 film is twice as fast as ISO 200, and will produce a correct exposure with less light and/or a shorter exposure. However, higher-speed film tends to produce more grain in the exposure, too.

JPEG (Joint Photographic Experts Group) Pronounced "jay-peg," a system for compressing images, developed as an industry standard by the International Standards Organization. Compression ratios are typically between 10:1 and 20:1, but data is lost permanantly in the process. Higher levels of JPEG compression mean more loss, therefore a lower quality image.

KB (kilobyte) Approximately one thousand bytes (actually 1,024).

lasso A selection tool used to draw an outline around an area of an image for the purposes of selection.

layer One level of an image file, to which elements of an image can be moved or copies, allowing them to be manipulated or edited separately.

luminosity The brightness of a color, independent of its hue or saturation.

macro A mode offered by some lenses and cameras that enables the lens or camera to focus on objects in extreme close-up.

mask A grayscale template that hides part of an image. One of the most important tools in editing an image, it is used to limit changes to a particular area or to protect part of an image from alteration.

MB (megabyte) Approximately one thousand kilobytes or one million bytes (actually 1,048,576).

megapixel A rating of resolution for a digital camera, directly related to the number of pixels forming or output by the CMOS or CCD sensor. The higher the megapixel rating, the higher the resolution of images created by the camera.

memory card The storage format used by most digital cameras, where images are saved to solid-state memory embedded in some form of small plastic housing. Common types include Compact Flash, SmartMedia, SD Memory Card, and XD Memory Card.

menu In an application, an on-screen list of choices and commands used to access features or change settings.

microdrive Miniature hard disk designed to fit in the memory-card slot of a digital camera and so increase the storage capacity.

midtone The parts of an image that are approximately average in tone, falling midway between the highlights and shadows.

mode One of a number of alternative operating conditions for a program. For instance, in an image-editing program, color and grayscale are two possible modes.

noise Random pattern of small spots on a digital image. Generally unwanted and caused by non-image-forming electrical signals.

paste To place a copied image or digital element into an open file. In image-editing programs, this normally takes place in a new layer.

peripheral An additional hardware device connected to and operated by the computer, such as a drive or printer.

pixel (PICture ELement) The smallest unit of a digitized image—the square screen dots that make up a bitmapped picture. Each pixel carries a specific tone and color.

plug-in Software produced by a third party and intended to supplement a program's performance.

ppi (pixels per inch) A measure of resolution for a bitmapped image.

RAM (Random Access Memory) The working memory of a computer, to which the central processing unit (CPU) has direct, immediate access.

RAW A file format created by some high-end digital cameras, containing all the pixel information with no compression. Usually requires proprietary software supplied with the camera to view, adjust, and convert the files.

resampling Changing the resolution of an image either by removing pixels (lowering resolution) or adding them by interpolation (increasing resolution).

resolution The level of detail in an image, measured in pixels (e.g. 1,024 by 768 pixels), lines per inch (on a monitor), or dots per inch (in a halftone image, e.g. 1200 dpi).

RGB (Red, Green, Blue) The primary colors of the additive model, used in monitors and image-editing programs.

saturation The purity of a color, going from the lightest tint to the deepest, most saturated tone.

scanner Device that digitizes an image or real object into a

bitmapped image. Flatbed scanners accept flat artwork as originals; slide scanners accept 35mm transparencies and negatives.

selection A part of the on-screen image that is chosen and defined by a border, in preparation for manipulation or movement.

shutter The mechanical device inside a conventional camera that controls the length of time during which the film is exposed to light. Many digital cameras don't have a shutter as such, but the term is still used as shorthand to describe the electronic mechanism that controls the length of exposure for the CCD.

shutter lag The time delay between pressing the shutter release on a digital camera and the exposure being made. The length of this delay was a problem with early digital cameras.

shutter speed The time the shutter (or electronic switch) leaves the CCD or film open to light during an exposure.

SLR (Single Lens Reflex) A camera that transmits the same image via a mirror to the film and viewfinder, ensuring that you get exactly what you see in terms of focus and composition.

spot meter A specialized light meter, or function of the camera light meter, that takes an exposure reading for a precise area of a scene. This is particularly useful for ensuring that vital parts of the scene are correctly exposed.

SuperCCD A CCD in which the pixels are oriented as diamonds. Processing the readout of each line of pixels requires some degree of interpolation, but gives a resolution higher than the pixel count.

telephoto A photographic lens with a long focal length that enables distant objects to be enlarged. The drawbacks include a limited depth of field and angle of view.

thumbnail Miniature on-screen representation of an image file.

TIFF (Tagged Image File Format) A file format for bitmapped images, which can use lossless LZW compression (no data is discarded). The most widely used standard for high-resolution digital photographic images once they have been downloaded from the digital camera and edited.

tool A program specifically designed to produce a particular effect on-screen, activated by choosing an icon and using it as the cursor. In image-editing, many tools are the equivalents of traditional graphic ones, such as a paintbrush, pencil, or airbrush.

toolbar An area of the screen used to provide immediate access to the most frequently used tools, settings, and commands.

USM (Unsharp Mask) A sharpening technique achieved by combining a slightly blurred negative version of an image with its original positive.

vector graphic A computer image in which the elements are stored as mathematically defined lines, curves, fills, and colors. Vector graphics can be scaled up or scaled down at will without any effect on resolution.

white balance A digital camera control used to balance exposure and color settings for artificial lighting types with a different color temperature than daylight.

zoom A camera lens with an adjustable focal length, giving, in effect, a range of lenses in one. Drawbacks include a smaller maximum aperture and increased distortion over a prime lens (one with a fixed focal length).

Index

Acknowledgments

Many thanks go to Alan Buckingham for all his help in the preparation of this title, and to all at the Ilex Press for their help and support during its creation.

And of course I'd also like to thank the many friends and families who have patiently modeled and given permission for their pictures to appear in this book.

Useful Addresses

Adobe (Photoshop, Illustrator)
www.adobe.com
Agfa www.agfa.com
Alien Skin (Photoshop Plug-ins)
www.alienskin.com
Apple Computer www.apple.com
Association of Photographers (UK)
www.the-aop.org
British Journal of Photography
www.bjphoto.co.uk
Canon www.canon.com
www.powershot.com
Corel (Photo-Paint, Draw, Linux)
www.corel.com
Digital camera information
www.photo.askey.net
Epson www.epson.com
Extensis www.extensis.com
Formac www.formac.com
Fractal www.fractal.com
Fujifilm www.fujifilm.com
Hasselblad www.hasselblad.se
Hewlett-Packard www.hp.com
Iomega www.iomega.com
Kingston (memory) www.kingston.com
Kodak www.kodak.com
LaCie www.lacie.com
Lexmark www.lexmark.co.uk
Linotype www.linotype.org
Luminos (paper and processes)
www.luminos.com

Macromedia
www.macromedia.com
Microsoft www.microsoft.com
Minolta www.minoltausa.com
Nikon www.nikon.com
Nixvue www.nixvue.com
Olympus www.olympusamerica.com
Paintshop Pro www.jasc.com
Pantone www.pantone.com
Philips www.philips.com
Photographic information site
www.ephotozine.com
Photoshop tutorial sites
www.planetphotoshop.com
www.ultimate-photoshop.com
Polaroid www.polaroid.com
Qimage Pro
www.ddisoftware.com/qimage/
Ricoh www.ricoh-europe.com
Samsung www.samsung.com
Sanyo www.sanyo.co.jp
Shutterfly (Digital Prints via the web)
www.shutterfly.com
Sony www.sony.com
Sun Microsystems www.sun.com
Symantec www.symantec.còm
Umax www.umax.com
Wacom (graphics tablets)
www.wacom.com